Teach Yourself VISUALLY

Digital Photography, 4th Edition

by Chris Bucher

Wiley Publishing, Inc.

Teach Yourself VISUALLY™ Digital Photography, 4th Edition

Published by Wiley Publishing, Inc. 10475 Crosspoint Boulevard Indianapolis, IN 46256

www.wiley.com

Published simultaneously in Canada

Copyright © 2010 by Wiley Publishing, Inc., Indianapolis, Indiana

No part of this publication may be reproduced, stored in a retrieval system or transmitted in any form or by any means, electronic, mechanical, photocopying, recording, scanning or otherwise, except as permitted under Sections 107 or 108 of the 1976 United States Copyright Act, without either the prior written permission of the Publisher, or authorization through payment of the appropriate per-copy fee to the Copyright Clearance Center, 222 Rosewood Drive, Danvers, MA 01923, 978-750-8400, fax 978-646-8600. Requests to the Publisher for permission should be addressed to the Permissions Department, John Wiley & Sons, Inc., 111 River Street, Hoboken, NJ 07030, 201-748-6011, fax 201-748-6008, or online at www.wiley.com/go/permissions.

Library of Congress Control Number: 2010932455

ISBN: 978-0-470-58946-5

Trademark Acknowledgments

Wiley, the Wiley Publishing logo, Visual, the Visual logo, Teach Yourself VISUALLY, Read Less - Learn More and related trade dress are trademarks or registered trademarks of John Wiley & Sons, Inc. and/or its affiliates. All other trademarks are the property of their respective owners. Wiley Publishing, Inc. is not associated with any product or vendor mentioned in this book.

Manufactured in the United States of America

10 9 8 7 6 5 4 3 2 1

LIMIT OF LIABILITY/DISCLAIMER OF WARRANTY: THE PUBLISHER AND THE AUTHOR MAKE NO REPRESENTA-TIONS OR WARRANTIES WITH RESPECT TO THE ACCU-RACY OR COMPLETENESS OF THE CONTENTS OF THIS WORK AND SPECIFICALLY DISCLAIM ALL WARRANTIES. INCLUDING WITHOUT LIMITATION WARRANTIES OF FITNESS FOR A PARTICULAR PURPOSE. NO WARRANTY MAY BE CREATED OR EXTENDED BY SALES OR PROMO-TIONAL MATERIALS. THE ADVICE AND STRATEGIES CONTAINED HEREIN MAY NOT BE SUITABLE FOR EVERY SITUATION. THIS WORK IS SOLD WITH THE UNDER-STANDING THAT THE PUBLISHER IS NOT ENGAGED IN RENDERING LEGAL, ACCOUNTING, OR OTHER PROFES-SIONAL SERVICES. IF PROFESSIONAL ASSISTANCE IS REQUIRED. THE SERVICES OF A COMPETENT PROFES-SIONAL PERSON SHOULD BE SOUGHT. NEITHER THE PUBLISHER NOR THE AUTHOR SHALL BE LIABLE FOR DAMAGES ARISING HEREFROM. THE FACT THAT AN ORGANIZATION OR WEBSITE IS REFERRED TO IN THIS WORK AS A CITATION AND/OR A POTENTIAL SOURCE OF FURTHER INFORMATION DOES NOT MEAN THAT THE AUTHOR OR THE PUBLISHER ENDORSES THE INFORMATION THE ORGANIZATION OR WEBSITE MAY PROVIDE OR RECOMMENDATIONS IT MAY MAKE. FUR-THER, READERS SHOULD BE AWARE THAT INTERNET WEBSITES LISTED IN THIS WORK MAY HAVE CHANGED OR DISAPPEARED BETWEEN WHEN THIS WORK WAS WRITTEN AND WHEN IT IS READ.

FOR PURPOSES OF ILLUSTRATING THE CONCEPTS AND TECHNIQUES DESCRIBED IN THIS BOOK, THE AUTHOR HAS CREATED VARIOUS NAMES, COMPANY NAMES, MAILING, E-MAIL AND INTERNET ADDRESSES, PHONE AND FAX NUMBERS AND SIMILAR INFORMATION, ALL OF WHICH ARE FICTITIOUS. ANY RESEMBLANCE OF THESE FICTITIOUS NAMES, ADDRESSES, PHONE AND FAX NUMBERS AND SIMILAR INFORMATION TO ANY ACTUAL PERSON, COMPANY AND/OR ORGANIZATION IS UNINTENTIONAL AND PURELY COINCIDENTAL.

Contact Us

For general information on our other products and services please contact our Customer Care Department within the U.S. at 877-762-2974, outside the U.S. at 317-572-3993 or fax 317-572-4002.

For technical support please visit www.wiley.com/techsupport.

Wiley Publishing, Inc.

Sales

Contact Wiley at (877) 762-2974 or fax (317) 572-4002.

Credits

Acquisitions Editor

Aaron Black

Sr. Project Editor

Sarah Hellert

Technical Editor

Dennis R. Cohen

Copy Editor

Scott Tullis

Editorial Director

Robyn Siesky

Editorial Manager

Rosemarie Graham

Business Manager

Amy Knies

Sr. Marketing Manager

Sandy Smith

Vice President and Executive Group Publisher

Richard Swadley

Vice President and Executive Publisher

Barry Pruett

Sr. Project Coordinator

Kristie Rees

Graphics and Production Specialists

Andrea Hornberger Jennifer Mayberry

Quality Control Technician

Jessica Kramer

Proofreader

Penny Stuart

Indexer

Christine Karpeles

Screen Artist

Jill A. Proll

Illustrators

Ronda David-Burroughs

Cheryl Grubbs

About the Author

Chris Bucher is an award-winning, Indianapolis-based commercial, editorial, and fine art photographer, and the author of *Lighting Photo Workshop*. His work is seen in publications throughout the country and his documentary fine art photography has been exhibited in many galleries in the United States and internationally. He has also been a technical editor for numerous Wiley titles and also has written for projects attached to his editorial photography. Chris is an avid mountain biker, and, along with his wife Jennifer, works with the foster care program of the Humane Society of Indianapolis.

Author's Acknowledgments

Special thanks go to Aaron Black, Sarah Hellert, Scott Tullis, and Dennis Cohen for their work, guidance, and patience in working with me on this project. Without their help and suggestions this book would not have happened. I would also like to thank the Wiley graphics team for making my vague ideas into great illustrations explaining difficult concepts.

Extra special thanks to Enrique Lima for bailing me out of difficult, last minute, and panicked Windows problems and questions. He willingly went above and beyond what he needed to do, and always with a smile. Thanks EEL!

I also have to thank Kenneth Rhem and Nicole Fraga for their assistance.

And I especially need to thank my wife Jennifer for always being helpful, patient, and supportive in all the projects that we enter together.

How to Use This Book

Who Needs This Book?

This book is for the reader who has never used this particular technology or software application. It is also for readers who want to expand their knowledge.

The Conventions in This Book

Steps

This book uses a step-by-step format to guide you easily through each task. Numbered steps are actions you must do; bulleted steps clarify a point, step, or optional feature; and indented steps give you the result.

2 Notes

Notes give additional information — special conditions that may occur during an operation, a situation that you want to avoid, or a cross reference to a related area of the book.

3 Icons and buttons

Icons and buttons show you exactly what you need to click to perform a step.

Tips

Tips offer additional information, including warnings and shortcuts.

6 Bold

Bold type shows command names, options, and text or numbers you must type.

6 Italics

Italic type introduces and defines a new term.

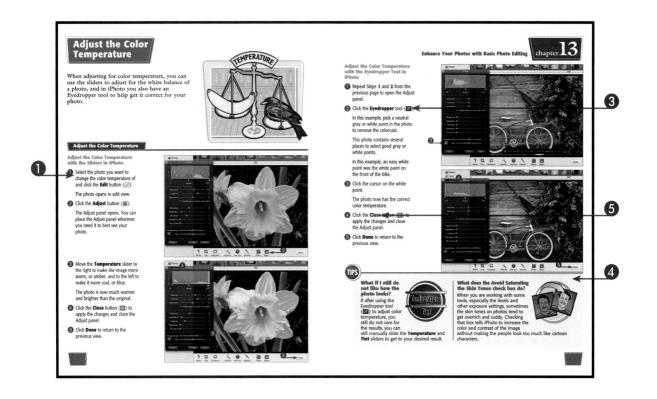

Table of Contents

Understanding Digital Photography

Why Go Digital?	17
Discover Digital Cameras	
From Start to Finish: The Digital Workflow	

What You Need to Get Started

Choose a Digital Camera	4
Consider Digital Camera Accessories	6
Build a Digital Darkroom	20
Choose a Photo Printer	22

chapter 3

Controlling Exposure and Focal Length

Learn About ISO
Learn About Aperture
Control Depth of Field
Understanding Shutter Speed
Discover Exposure Modes
Learn About Focal Length
Use a Wide-Angle Lens
Use a Telephoto Lens
Use a Zoom Lens
Learn About Digital Camera Lenses

Learn About the Color of Light		
Measure and Correct Light for Color	44	1
Learn About Light Quality		
Use a Flash	50	

Learning About Focus

Understanding Focus Systems	54
Focus on an Off-Center Subject	56
Use Focus Modes	58
Discover Focus Techniques	59

Composing Pictures like a Pro

Visualize Composition	62
Consider Design Principles	64
Discover Rules of Composition	66
Learn to Control Composition	68

Table of Contents

Putting It All Together

Experiment with Depth of Field	12
Mix and Match Settings	74
Change Shutter Speed for Effect	76
Focus Selectively	77
Compose Creatively	78
Explore Different Lighting Options	30
Try Creative Techniques	32

chapter 8

Taking Your First Digital Photos

Set Up a Digital Camera.	36
Take Test Pictures.	38
Troubleshoot Problems	90
Transfer Pictures to Your Computer	92
Evaluate Your Photos	94
Fine-Tune Camera Settings	96

chapter 9

Taking Advantage of Your Camera's Settings

Match the Scene to the Setting	100
Be Aware of In-Camera Settings	101
How Do the Scene Settings Change the Images?	102
Use the Settings Creatively	104
Evaluate Your Photos	106
Better to Change Things Later?	107

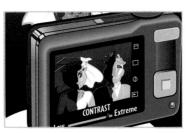

Avoiding Digital Photography Pitfalls

Avoid Taking Unfixable Pictures
What Is a Histogram?
Use a Histogram as You Take Pictures
Compensate for Shutter Lag
Avoid Blowouts
Keep Your Camera Steady
Avoid Undesirable Colorcasts
Never Use Digital Zoom
Reduce Digital Noise

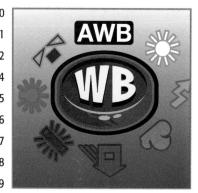

Capturing Unique Photo Opportunities

Photograph Products to Sell on eBay	122
Take Great Close-Up Photos	124
Take Photos at Night without a Flash	126
Capture Firework Displays.	127

Table of Contents

chapter 12

Organizing Your Photos

Why Use Image Editing Programs?
What Is a Digital Editing Workflow?
Photo Editing Options
Understanding Metadata in Your Photos
What Are RAW Digital Photos?
Import Photos to Your Browser
Review, Sort, and Tag Your Photos
Tag Photos
Find Images Using Tags
Lise Tags to Sort 148

chapter 13

Enhance Your Photos with Basic Photo Editing

Learn about Global and Local Changes
Zoom In with the Zoom Tool
Rotate an Image
Straighten an Image
Crop an Image
Adjust the Exposure
Adjust the Color Temperature
Adjust the Tint
Adjust the Saturation
Adjust Noise and Sharpness
Remove Red Eye

Retouch Spots on Your Photos	190
Retouch Spots on Your Subjects	192
Apply Photo Effects	194
Use the Auto Enhance Button	198

chapter 14

Advanced Photo Editing with Photoshop Elements

Why Calibrate and Profile Your Monitor?
Open the Photoshop Elements Quick Fix Workspace
Get Familiar with the Quick Fix Workspace
Open a Photo to Fix in the Quick Fix Workspace
Open a RAW Photo File
Zoom In and Out
Move Around the Image
Rotate an Image
Select a Comparative View
Improve Composition by Cropping
Use the Quick Fix Auto Buttons
Try an Auto Fix for a Quick Improvement
Remove Red Eye with One Click
Undo Changes
Convert a Color Photo to Black and White
Add a Colored Filter Effect to Any Photo

Table of Contents

chapter 15

Printing Photos and Other Projects

Archive Your Photos to CD or DVD Media
Create a Contact Sheet
Understanding Resolution
Digital Photo Printing Options
Get the Best Prints
Choose a Photo Printer
Match Prints to Monitor Display
Optimize Printer Settings and Print a Photo
Print One Photo as a Traditional Picture Package
Use the Create Tab for Fun Photo Options
Create a Greeting Card
Print to an Online Photo Service

chapter 16

Sharing Photos Electronically

Add a Personal Copyright to Protect a Photo	254
Save a JPEG for the Web	256
Preview an Image in a Web Browser	258
Create a Web Photo Gallery	260
Send an Image with E-mail	264

Customize the Panel View
What Are Layers and Why Use Them?
Find Your Way Around the Layers Panel
Straighten a Crooked Photo
Make a Creative Crop
Select an Area of a Photo
Whiten Teeth Digitally
Duplicate the Background Layer
What Are Photoshop Elements Filters?
What Is the Filter Gallery?
Understanding Styles and Effects
Colorize a Black-and-White Photo
Create a Sepia-Toned Photo
Remove Blemishes with One Click
Fix Skin Tone
Adjust a Photo before Applying Filters
Convert a Photo into a Sketch
Convert a Photo into a Painting
Create a Digital Photo Collage
Create a Digital Panorama
Understanding Type Layers
Add and Edit Text
Move and Resize Type to Fit a Photo
Add Text and Match the Color to the Photo
Rotate Text
Warp Text
Stylize Text

Understanding Digital Photography

Are you confused about how digital photography works? This chapter introduces you to the advantages of digital photography, the different types of digital, and how easy it is to work with and use digital pictures.

Why Go Digital?

With digital photography, you can do more than take snapshots for your family album. You can use a digital camera to quickly and significantly improve your photography skills. You can e-mail your digital pictures to family and friends, share your photos on social networking sites, or create interesting Web pages about your hobbies, family, or even home business. You can also simplify everyday tasks, or take part in documenting your family history with a digital scrapbook.

Improve Your Photography Skills

Because digital pictures do not require film and processing, you can experiment with lighting, composition, camera modes, and creative techniques at no cost. Because you see images immediately, you can modify your setting or approach, and try new things, then evaluate all your images when you get home. The best way to become a better photographer is to take many pictures.

Simplify Everyday Tasks

A digital camera allows you to share and convey information easily. For example, you can capture special moments such as birthdays and anniversaries and almost immediately send the pictures to your friends in an e-mail message, or share them on a Web site. You can also take digital pictures of club members for a visual directory. Other tasks include creating a home inventory for insurance records, and photographing items you are selling online.

Understanding Digital Photography

Share Pictures Online and in E-mail

Within minutes of taking a picture, you can share it in an e-mail message, or upload it to an online photo site to share with family and friends. By doing it this way, those loved ones who want prints of the photos can buy them online and receive the prints in the mail. There are countless online options for sharing photos and having prints made quickly.

Our Family Vacation "graces" "vacations"

Create Photo Slide Shows on CDs or DVDs

You can use programs such as iPhoto, Windows Live Photo Gallery, and Photoshop Elements to create digital image slide shows on recordable CDs and DVDs. Then you can add voice narration, captions, music, digital movie clips, and transitions to finish the slide show. Photoshop Elements and iPhoto also let you organize your digital images by assigning each photo a keyword. If you want, you can even add a rating, color, or flag to help select your favorites. You can use these keywords or ratings to find and select a particular photo for your slide show or just see all your best photos with a click of a button.

Discover Digital Cameras

When you understand how digital cameras work, you can take that knowledge and make an informed decision when it comes time to purchase your first digital camera or to upgrade your existing one. Knowing how digital cameras work also enables you to get better images from your camera.

How Digital Cameras Record Pictures

Digital cameras record pictures using an image sensor array a grid composed of millions of light-sensitive pixels. The term pixel describes a picture element. The pixels are the building blocks of all digital images. A red, green, or blue filter covers each pixel on the sensor so that it responds to only one of the primary colors of light. Each pixel reads the brightness and color in a scene to produce an electrical signal. The signal is then converted to a digital number that represents the color and brightness of the pixel. The camera's onboard computer processes the information to build a final image before storing it in memory.

Understanding Digital Photography

Types of Image Sensors

Most digital cameras use one of two types of image sensors: a charge-coupled device (CCD) or a complementary metal-oxide semiconductor (CMOS). Although each type of sensor has technical differences in how the light energy is transferred into electronic signals, both produce high-quality images.

Resolution and Image Quality

Resolution is a measure of pixel density; higher-resolution images have more pixels per inch and the possibility of greater detail. On a digital camera, the greater the number of pixels on the image sensor, the larger you can print the photo. There are consumer cameras with sensor resolutions of up to 15 megapixels. Digital cameras with 6 to 8 megapixels offer excellent image quality for prints larger than 8×10 and can be very affordable. Cameras with higher resolution allow for more creative cropping and often come with more advanced features.

From Start to Finish: The Digital Workflow

A digital workflow is a step-by-step process that helps you get the best digital images and also manages your collection of images. The workflow includes taking, editing, sharing, organizing, and storing digital pictures. You can use the digital workflow described here as an introduction to and ongoing guide for working with your digital images.

Capture Images

The digital workflow begins by choosing camera settings that will produce the best photo. You can choose a preset scene mode (portrait, landscape, sunset, for example), use a fully automatic setting, or set the camera to operate in manual shooting mode. To learn more about exposure, see Chapter 3.

Confirm that the camera's white balance matches the light in the scene or is set to auto. For more information on white balance, see Chapter 8.

Then compose the image in the frame, adjust the zoom, ensure the autofocus has the subject in focus, and take the picture.

Understanding Digital Photography

Verify Exposure and Composition

Next, review the picture on the camera's LCD screen to ensure that the exposure and composition are acceptable. As you review the image in your LCD, look for distracting background elements, closed eyes, and other elements that you can improve. If the picture is too light (overexposed), or too dark (underexposed), most cameras set to automatic allow you to easily correct that by adjusting the exposure using exposure compensation. When in doubt, retake the picture and try new things — as many times as you want.

Use the LCD

The LCD screens on today's cameras are getting ever bigger, brighter, and clearer, but it still may be difficult to determine how good the photo is. Learn how to zoom the LCD display to get a closer look at the details of your photo. Unless the picture is hopelessly flawed, do not delete it. Instead wait and evaluate it on your computer — you may be able to save the picture or use the information in the photo to help you learn.

Transfer Pictures to a Computer

You can transfer pictures from your camera to your computer with a USB cable, a card reader, or a docking station. The fastest way to transfer pictures is by using a card reader. Card readers come in many forms, they are inexpensive, and they do not drain your camera battery — which happens when you hook your camera to the computer.

From Start to Finish: The Digital Workflow (continued)

Edit Pictures

You can use image-editing software that comes with your camera or computer, or software that you purchase to edit pictures. Image-editing programs enable you to rotate, adjust color and saturation, correct red eye, remove unwanted elements (even people), crop, resize, sharpen, combine, and add text to digital pictures. There is no end to the things you can do to your digital photos. See Chapters 12 and 13 to learn more about working with image-editing software.

Print and Share Pictures

After you edit, crop, and sharpen your pictures, you can print them on a home photo-quality printer, or at a commercial printing service - either online or at your local photo lab and even grocery stores. In many ways it is just like dropping film off to be processed, but now you only have to print the photos you know that you like. You can also share them in e-mail messages, on social networking Web sites, or on a photo-sharing Web site. For more information about printing and sharing pictures, see Chapters 15 and 16.

Organize and Store Digital Negatives

You should not alter the original image, which is the equivalent of a film negative. If you need to make changes to an image, get in the habit of making changes to a copy and keeping the original file untouched. This is not as hard as it sounds. Some image editors automatically apply your changes to a copy rather than to the original.

It does not take long until your picture collection will become large, so take advantage of the photo organizer programs that are available. Even with a photo organizer program, take some time

to come up with a smart way to label and organize the folders of photos — either by date or event, or whatever makes sense to you and you can stick with. You can always find a particular photo quickly without spending hours searching for it if you consistently assign keywords and descriptions to your photos using programs such as iPhoto, Windows Live Photo Gallery, Photo Organizer, or Photoshop Elements.

Clear the Memory Card

After your pictures are on your computer, you can safely delete pictures from your memory card. Many image editors offer to delete pictures after they have been transferred, but you should be sure that the images have been successfully placed on your hard drive because when the images are deleted from the card, you cannot get them back. The optimum choice is to delete all the photos in the camera by formatting the card using your camera after you have downloaded the photos. The card format option is typically found as a menu option accessed from the menu on the LCD screen of your camera. Using this method also helps to maintain the internal file structure of the memory card, which should keep it working smoothly.

CHAPTER

What You Need to Get Started

Knowing the basics about digital cameras, resolution, lenses, batteries, and accessories helps you choose the right camera for you. Having the right equipment for your digital darkroom enables you to edit and print your images faster and easier.

Choose a Digital Camera

When choosing a digital camera, consider the size of camera, the resolution, how much control you want to have over the camera settings, the quality and focal range of the lens, the shooting modes you use most often, the life of the battery, and the type of storage media available.

Compact

Compact, or point-and-shoot, digital cameras typically capture photos with image resolutions ranging from 10 to 14 megapixels. They include a built-in flash and zoom. Although compact cameras offer limited manual controls, they often provide a number of handy shooting presets that allow you to optimize the settings for better pictures more easily.

Advanced Non-SLR Cameras

Advanced non-SLR (single lens reflex) digital camera resolution ranges from 8 to 15 megapixels. Also called *prosumer* (professional/consumer) cameras, they feature more exposure control and greater zoom ranges than compact cameras but are also larger, heavier, and more expensive. These cameras often have exotic features like extreme telephoto and wide-angle lenses, high-speed shutter, and high-definition video all built into one.

Digital SLR

Resolutions for digital SLR (dSLR) cameras range from 10 to 25 megapixels. These cameras offer all the features and controls found on film SLR cameras. The choice of professional photographers and serious hobbyists, dSLR cameras offer a wide variety of high-quality interchangeable lenses and flashes and nearly limitless control. Image quality on these cameras is noticeably better because of their larger sensor size.

Lens Considerations

Most compact cameras come with a 4× zoom lens with a 35 to 135mm range. Getting the largest optical (not digital) zoom factor allows you a lot of flexibility. The optical zoom factor is the amount of magnification produced by the internal lenses in the camera. The digital zoom is created by enlarging the pixels that make up the image, producing an image that appears slightly out of focus and grainy. Lenses that go wider are great for landscapes and groups; lenses that are more telephoto are used for sports and wildlife. The drawback of a large optical zoom is that it makes the camera physically larger. You can learn more about lenses in Chapter 3.

Batteries

At this point, most digital cameras use product-specific rechargeable batteries. These cameras' rechargeable batteries are very reliable and long-lasting. A few cameras still use disposable and rechargeable batteries interchangeably. This is convenient because you can use disposable batteries when you cannot recharge your batteries and use rechargeable batteries all other times. It is very important to buy the right type of battery, and get at least one extra set of batteries to ensure uninterrupted shooting.

Evaluate Exposure and Scene Modes

A camera that has both automatic and semiautomatic exposure modes allows you more flexibility and creativity. Most compact cameras include scene modes that automatically set the camera's aperture, shutter speed, and flash based on the scene mode that you choose. The scene modes help take the guesswork out of setting your exposure, especially at the extremes — photos of the beach at noon are very different than a sunset party.

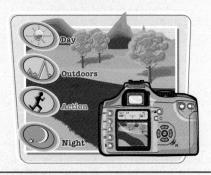

Storage Media

Digital cameras store pictures on removable memory media called memory cards, of which the most used are SD (Secure Digital), SDHC (Secure Digital High Capacity), CF (CompactFlash), Memory Stick, and XD. These cards come in a variety of capacities and can be used in your camera as well as MP3 players, cell phones, and PDAs (Personal Data Assistants). If you currently have one of these, it is possible to share the cards between the devices and your camera. The size you need depends on how many images you want to get on a card and the resolution of your camera, and the type you need depends on the camera you buy. The cards are physically small, but can store a lot. It is preferable to have a larger-capacity card than trying to manage several smaller cards.

Consider Digital Camera Accessories

Although most digital cameras come with everything you need to take your first pictures, you can add helpful accessories. Accessories include higher-capacity memory cards, a card reader, extra or better batteries, an accessory flash, accessory lenses, and a tripod.

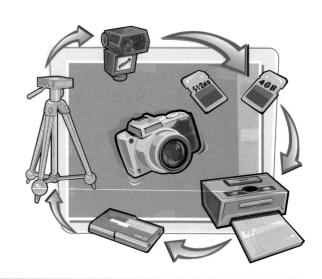

Photo Storage Devices

Laptop computers are great photo storage devices, and with all of the WiFi hot spots at schools, libraries, coffee shops, and public common areas, not only can you easily get your photos onto your computer, you can also quickly get them to your e-mail or Web site. If you are taking your camera with you but do not want to deal with a laptop, you may want to consider a photo storage device. These devices come in a variety of shapes and prices. Some are designed specifically to store and preview photos; others are MP3 players or even video players that provide the option of storing photos. These have large built-in hard drives but limited computing functions.

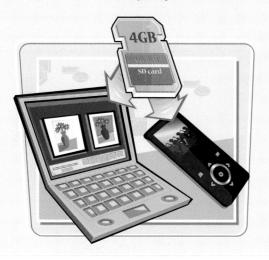

Memory Card Capacity

The number of images a memory card can hold depends on the resolution of the camera, and the file format and compression you set using the image-quality menu on the camera. Memory cards are relatively inexpensive. 1GB and 2GB cards are plentiful, and a 4GB card can hold nearly 600 highest-resolution JPEG photos from a 12-megapixel camera. To see how much it will hold on your camera, plug it in and format the card. Your camera's instruction manual should also have a listing of how many images you can get on a card at different resolutions.

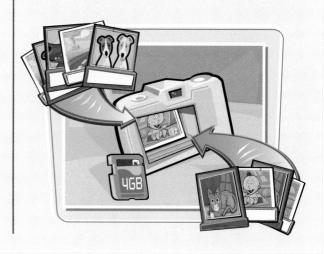

Card Readers

You can easily transfer pictures from your camera to your computer using a USB cable or camera dock. However, a memory card reader provides a faster and inexpensive way to transfer images. Most card readers connect to the computer using a USB cable, and some card readers accept multiple types of memory cards. Virtually all new card readers use a USB 2.0 connection, which is currently very common and very fast. Many cameras are now able to use the high-capacity SDHC cards. If those are the cards you are using, make certain that your card reader has that capability. For owners of a notebook computer, memory media—specific PCMCIA (PC Card) readers are available.

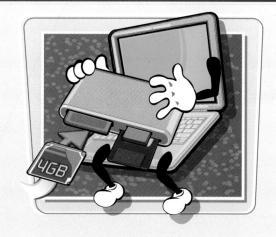

Accessory Lenses

If your camera accepts accessory lenses, the lenses offer you additional photographic flexibility and are typically wideangle or telephoto lenses. Look for accessory lenses from the manufacturer of your camera and from aftermarket suppliers. For compact digital cameras, accessory lenses may require step-up or step-down rings. The ring attaches to the camera's lens, and then the accessory lens attaches to the other side of the ring. For dSLR cameras, make sure that the lenses you buy will work with your camera; after that the sky is the limit! Each brand of camera has many different lenses designed to work optimally with your camera. Aftermarket lenses also do a good job and may save you a little money.

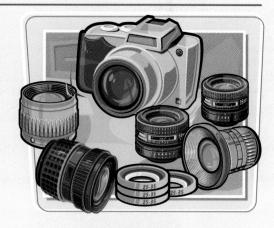

Accessory Flash Unit

If your camera has a flash mount, or *hot shoe*, you can add an external flash unit. The advantage of an external flash is that it has more power, offering greater distances for flash shots. Because it is higher above the camera, it dramatically reduces red eye in the photos you take. Using your camera-branded flash will maximize all the automatic flash technology in today's digital cameras. For some cameras this even allows multiple flashes to communicate wirelessly for creative lighting in your photographs. To learn more about lighting and flash photography, see Chapter 4.

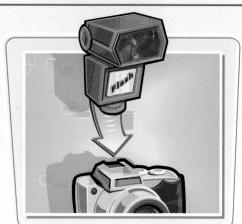

Consider Digital Camera Accessories (continued)

Travel Accessories

If you are traveling to another country, check what power and power connectors are used in that country. If you are sure your battery charger works with that power, check for the proper adapter. Voltage is rarely a problem but frequency is. A charger that works only on 60 Hz will burn out in a few minutes if plugged into a 50 Hz power outlet. So it is best to have one that works on 50/60 Hz plus have the proper power connection for the country you are visiting.

Tripods

You can take sharp pictures in lower-light conditions if your camera is absolutely stable, and if the subject does not move. You can stabilize your camera by using a tripod. Tripods range from small tabletop versions, which are suitable for small digital cameras, to full-size tripods suitable for large digital cameras. It is great to use a small tripod for your compact digital camera for parties and family get-togethers, so you can be in the photos by using the timer or a remote control.

Camera and Accessory Bag

There are many brands and styles of camera bags, which range from backpacks to sling bags and even ones that look like purses. Bags range in size from small pouches to full-size bags with compartments for flash units, lenses, and spare batteries. Remember that a camera bag is there to: keep your stuff together, keep it organized, and keep it protected.

Some photographers like water-resistant camera bags, and some like to keep their camera and accessories in everyday bags, like book bags, messenger bags, and even diaper bags — all of which have plenty of room and pockets and do not get a second look from thieves. Just make sure your camera is in a well-padded place in the bag and that things do not rub against each other.

To protect easy-to-lose memory cards, you can buy hard- or soft-sided memory card cases that hold multiple memory cards.

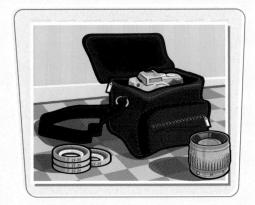

Filters

Filters, including a *UV filter or Skylight*, can protect the lens of some digital cameras and help in cutting down on haze. You can also use a *polarizing* filter on some digital cameras (if the camera lens had threads to accept a filter) to reduce reflections and to make colors more vibrant. If you are buying a polarizing filter, make sure it says "circular polarizer" on the filter case. Linear (noncircular) polarizer filters confuse autofocus systems. Although digital cameras do not require color-correction filters, you can use some color filters.

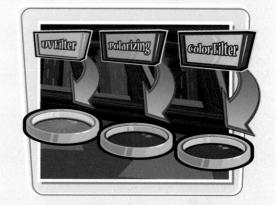

Creative Filters

You can use filters to add all sorts of effects to your photographs. There are filters that add starbursts and halo effects to lights. A *diffuser* filter creates a light fog effect by using a soft focus. Color filters alter or enhance the colors of your picture. *Graduated* filters or *grads* affect only part of the image and are great for affecting the sky in a photo. You can also reproduce the effects of some creative filters in most image-editing software.

Cleaning Supplies

To clean your lens, you can use microfiber lens-cleaning cloths and a blower brush. You can also use a lens pen. A lens pen has a brush on one end to sweep away particles, and a circular pad with lens-cleaning fluid to wipe away smudges on the other end. You can clean the exterior of your camera with a clean, soft cloth like you would any other electronic equipment.

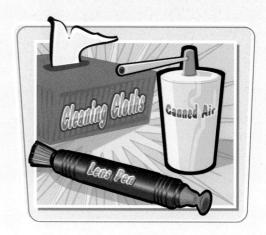

Build a Digital Darkroom

Unlike film photography, digital cameras do not require chemicals and a room without light to develop photos. Your digital equivalent of a darkroom is your computer in combination with your image-editing software and maybe even your photo printer. Armed with this equipment you can ensure that your pictures have great color and contrast, and that they are precisely cropped. To create this virtual digital darkroom, you need a computer, monitor, and software for editing images.

Computer

Digital photo files and photoediting tasks require more hard drive space and RAM than text files and processing requires. To speed up digital photography work, it is helpful to have a computer with sufficient RAM (at least 1GB), a hard drive with free space to store photos, and a reasonably large monitor that you can calibrate for accurate color.

Minimum System Requirements

A good way to determine if your computer RAM and hard drive space is adequate for image editing is to check the system requirements for both the image-editing program and the operating system. You can find this information on the software product box.

CD or DVD Archiving

As your digital image collection grows, it is good practice to archive images on CDs or DVDs. A recordable CD stores 700MB at a cost of 10 cents or less per CD. A recordable DVD stores 4.7GB of data. DVD prices vary by brand and DVD format, but they cost a little more than CDs. The newest high-capacity storage is Dual Layer (DL) DVD, which offers more than 8GB of storage. Make sure you check your computer to determine which DVD format you need: DVD-R or DVD+R.

Hard Drive Archiving

The cost of external hard drives continues to go down, making 250GB, 500GB, and even 1TB-plus drives ever more reasonable. External hard drives are connected via USB cords, or FireWire (IEEE 1394), or even via a network, making it much easier to access your archived info on a hard drive than going back to find a single disc with your photos. Some of these drives are very compact and are powered by the USB cord, making them extremely portable. Setting up a routine backup of your photos to an external hard drive is very simple.

Choose an Image-Editing Program

An image-editing program allows you to adjust the contrast and color, and to rotate, crop, and add text and special effects to your pictures. In addition to basic image editing, most software helps you organize your images, e-mail them to friends, print them, and even helps you assemble impressive slide shows — which can be used for digital scrapbooking.

Monitor Types, Sizes, and Settings

Both CRTs and LCD flat-panels display digital images accurately. Nearly all displays sold today are flat-panel displays. 20-inch monitors are practically standard issue on new computers today. Screen resolution should be at least 1024×768 pixels. Digital photo editing requires that the color depth be set to 24- or 32-bit depending on your graphics adapter. If you purchased your computer in the last few years, it is already set up at an adequate resolution and color-depth setting. Larger monitors help by displaying more of the image at a larger magnification, and multiple monitors allow you to have your photo on one monitor and your toolbars and panels on the other monitor.

Choose a Photo Printer

High-quality, affordable photo printers, along with premium photo paper, enable you to easily print your own photos that are indistinguishable from your photo developer's. You can choose from a wide variety of dedicated photo printers that produce fade-resistant prints in a large variety of sizes. Most printers also sell a diverse selection of media ranging from preprinted cards to museum-quality paper, for those special photos.

Inkjet Printers

Inkjet printers, the most common printer type, use four or more ink colors — as many as twelve ink colors for the very best photo printers. They spray tiny droplets of colored ink (usually organic dyes) onto the paper to print the photo. Depending on the quality of the ink and paper, inkjet prints can last many years without fading. There are also larger desktop inkjet printers that make great enlargements.

Print Directly from Memory Media

Direct printing lets you print pictures without transferring pictures to your computer first. On some printers, you can insert the memory card into a slot, and then print all or some of the images. On direct-print printers, you can attach your digital camera to the printer using a USB cable, and then print all or part of the images.

Dye-Sublimation Printers

Dye-sublimation, or dye-sub, printers apply heat to a printer ribbon, producing a colored gas that bonds with the paper to create the photo. Dye-sub printers produce continuous-tone prints that most closely resemble traditional film prints, and the print life is comparable to high-quality inkjet prints. The disadvantage of dye-sub printers is that they can be expensive to buy and to operate. The most common types of dye-sub printers are for small (4×6-inch) prints and passport-type photos.

Print Speed

Usually the print speed published by the manufacturer is for draft-quality printing, and not for the best photoquality printing. Print speed is measured in pages per minute (ppm). Printers set at the highest quality settings take much longer to print the same size print. Printers are constantly getting faster and quieter.

Paper Size

Printers commonly use 8.5×11 -inch paper to print an 8×10 -inch image. Many printers allow for the use of roll paper, as narrow as 4 inches, letting you make your own 4×6 's — other printers use 44-inch-wide roll paper for huge prints. There are many sizes in between. Paper sizes now reflect proportion of the sensor — 11×17 and 13×19 paper are now common sizes for enlargements.

Connection

Most printers connect to the computer using a USB cable. Some professional printers use either a USB or a FireWire (IEEE 1394) cable interface. Some printers even have network inputs, like a Cat 5 cable, allowing multiple computers access to the printer via a network.

Cost

The manufacturer cost-per-print estimates are usually not figured at the best setting of the printer, which uses more ink. Color print costs range from approximately 18 cents to \$2 or more per 8×10-inch print. Some printers' software is actually able to tell you how much paper and ink you have used to determine your cost. Using the highest-quality settings means using the most ink, which is also more costly.

Print Quality

New inkjet printers usually offer a maximum color resolution of 4800×1200 dots per inch (dpi). When you evaluate printed samples from different printers, look for smooth, continuous tones, fine gradations of color, and color accuracy and fidelity.

CHAPTER 5

Controlling Exposure and Focal Length

There are many settings that affect your digital camera photographs. The camera automatically controls most of these settings in response to the amount of light illuminating your subject and the distance of the subject from you. From aperture to shutter speed to focal length, you can mix and match different camera settings to gain creative control over your pictures. Any change in the light requires a change in the exposure. To learn how to best capture the correct exposure, all you need is an understanding of the basic elements of photography.

Learn About ISO	26
Learn About Aperture	27
Control Depth of Field	28
Understanding Shutter Speed	29
Discover Exposure Modes	30
Learn About Focal Length	32
Use a Wide-Angle Lens	33
Use a Telephoto Lens	34
Use a Zoom Lens	35
Learn About Digital Camera Lenses	36

Learn About ISO

The sensitivity of film to light is described as the *speed* of the film. Film that is very sensitive is called *fast* film and can result in better photos taken in lower lighting conditions than can be achieved with slower speed film. Similar to film speeds, the ISO settings on digital cameras indicate the digital image sensor's speed, or sensitivity to light. The numbers on the camera's ISO approximate the sensitivity of the same ISO number on film.

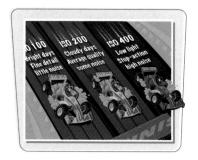

ISO stands for International Organization for Standardization, which created a standard measurement for the film speed of color negative and positive (slide) film. The name ISO replaced ASA (American Standard Association) in 1974, but the measurement system was the same.

What Is Your ISO?

ISO is the first of three parts of the exposure calculation, and just as with film is designated with numbers such as 100, 200, 400, 800, 1600, with each one being twice as light sensitive as the previous. The lower your camera's ISO number, usually 80, 100, or 200, the better the image quality. Even with the advances in digital cameras' high ISO capabilities, it is important to use the lowest ISO possible to maximize your image quality. The drawback to using high ISO settings is that it can result in increased *noise*, small multicolor flecks, in the picture. In many cases though, getting the shot, even if it means more noise, is more important than optimal image quality.

On a sunny day, using 100 or 200 is great, but once you get in the shade or it gets cloudy, or the sun starts to go down, you will need a higher ISO to maintain a good exposure. To get an exposure bright enough might mean using ISO 200 or 400. Indoors the light level is even less. Your eyes automatically correct for the light level, but unless you are going to use a flash, using ISO 400 to 800 makes a lot of sense. At night and indoors, using the flash at these higher ISOs allows the flash to recycle quicker and allows the light level inside to more closely match the flash — so you can see everything in the photo.

ISO Settings

Each step up or down of the ISO is considered a "stop," so changing the ISO from 200 to 400 without changing any other settings creates a photo twice as bright. Although many digital cameras can control the ISO setting automatically, on most digital cameras you can set the ISO either from a dial or from the camera menu. Some digital cameras allow you to increase the ISO to very high numbers — ISO 3200 and higher for some dSLRs. Choosing a faster or higher ISO allows you to take properly exposed pictures even in scenes with very low light.

Learn About Aperture

Controlling Exposure and Focal Length

chapter 3

The camera *aperture*, controlled by a diaphragm mechanism, determines how much or how little the lens opens to let in the light that strikes the image sensor. The size of the aperture also affects how much of the image is in focus.

What Is the F-Stop?

Aperture is shown as f-stop numbers, such as f/2.8, f/4, f/5.6, and f/8. These numbers refer to whether the diaphragm mechanism opens a little or a lot. A wide f-stop, such as f/2.8, allows more light to strike the image sensor. A narrow f-stop, such as f/16, lets in less light. Lenses that offer larger apertures are referred to as fast. They tend to be physically larger and more expensive than the same focal length, offering a smaller aperture due to the larger and better glass it takes to make the lens.

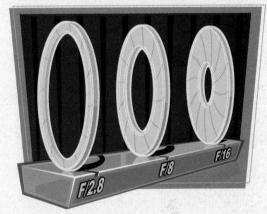

Set the Aperture

An easy semiautomatic exposure mode is aperture-priority, which is usually designated with an A and can be selected through one of the camera's menus or dials. When the camera is set to aperture priority mode, then you can control the aperture by choosing the f-stop, and the camera automatically sets the correct shutter speed. This allows you to easily select how much depth of field is in your photograph.

Control Depth of Field

When the automatic focus mechanism of your digital camera focuses on a subject, you can only be sure that the subject is in focus. Objects closer and farther from the camera may not be in focus. How much of the image is in focus is controlled by the *depth of field*, which refers to the area in front of and behind a subject that is in acceptably sharp focus. In general, the zone of sharpness extends one-third in front of and two-thirds behind the point of focus.

Pictures with a soft background show little depth of field, achieved by setting a wide aperture such as f/4, moving closer to the subject, or selecting portrait mode, if your camera offers it. Pictures with the foreground and much of the background in focus show extensive depth of field, achieved by setting a narrow aperture, such as f/11, moving farther from the subject, or selecting a landscape mode, if the subject is far enough away.

Adjust the Aperture

To increase the depth of field in a photo where you want as much of the scene in sharp focus as possible, choose a narrow aperture such as f/8 or f/11. To decrease the depth of field in a photo where you want the background to be out of focus, choose a portrait mode or select a wider aperture such as f/2.8, f/4, or f/5.6. A good way to remember this is the larger the f/stop number, the more the depth of field.

Change the Camera-to-Subject Distance

Regardless of the f-stop you choose, the farther away you are from a subject, the greater the depth of field. The closer that you focus on a subject, the zone of acceptable focus, or depth of field, gets smaller. So naturally a tight portrait will have more depth of field than a wide landscape shot.

Change Lens Focal Length

Focal length determines how much of a scene the lens sees. A wide-angle lens or zoom-out setting sees more of the scene than a telephoto lens or zoom-in setting. A wide-angle setting provides greater depth of field than a telephoto setting. Depth of field becomes greater, every time you zoom wider, and becomes lesser every time you zoom the telephoto longer.

Understanding Shutter Speed

Controlling Exposure and Focal Length

The shutter speed controls how long the *shutter*, a curtain-like mechanism that covers the sensor, stays open to let light from the lens strike the image sensor. The longer the shutter stays open, the more light hits the sensor, and the less time it stays open, the less light hits the sensor.

Shutter speeds are described by how long they allow light into cameras in fractions of a second. They range from slow (1, 1/2, 1/4, 1/8, 1/15 second); moderate (1/30, 1/60, 1/125 second); to fast (1/500, 1/1000, 1/2000 second). Increasing or decreasing the shutter speed by one setting halves or doubles the exposure respectively.

Set the Shutter Speed

Because changing your shutter affects how long the shutter is open, the shutter determines how much stop action or blur is in a scene. With an action scene mode, the camera selects a fast shutter speed to freeze subject motion. In semiautomatic modes, you can set the shutter speed using one of the camera's menus. To make sure you do not have blur from your hands moving the camera, your shutter speed should be faster than 1/60 second. With shutter speeds slower than 1/60 second you should consider a tripod to stabilize the camera.

Freeze or Blur Subject Motion

To freeze motion in normal scenes, set the shutter speed to 1/250 second or faster. To capture motion as a blur, use 1/30 second or slower and mount the camera on a tripod. Using very slow shutter speeds (1/2 second, 1 second, and longer) you can really show the passage of time, such as with water moving.

Pan-Blur

At a slower shutter speed, such as 1/15 second, you can follow subject movement with the camera and blur the background, as shown here. This technique is called a *pan-blur*.

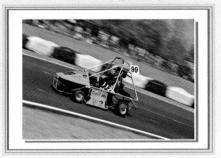

Discover Exposure Modes

Digital cameras offer several ways to control the exposure settings. Ranging from fully automatic (often called P for program or point-and-shoot, as well as the preset scene modes) to specific exposure modes, each method of control offers advantages and disadvantages. Although serious photo buffs eschew the automatic settings, on average, these settings offer the greatest insurance for getting a good photo. Selecting a preset scene mode lets you get a pretty good result — easily, whereas one of the priority auto exposure modes gives you some creative control over depth of field and whether you freeze or blur motion with the aid of all the camera's technology.

Auto Mode

Auto mode, which is often called program mode, works well when you want to just point and shoot. In this mode, the camera selects the aperture, or f-stop, and shutter speed for the correct exposure. Although auto mode may not be the most creative way to use your camera, it works well when your goal is to quickly capture a picture.

Aperture Priority Mode

You can use aperture priority mode when you want to choose the aperture, or f-stop, and have the camera automatically set the shutter speed. Aperture priority mode works well when you want creative control over depth of field. If you choose a narrow aperture (large f-stop number) in a low-light scene, you may need to steady the camera on a tripod due to the slow shutter speed.

Shutter Priority Mode

You can use shutter priority mode when you want to choose the shutter speed and have the camera automatically set the appropriate aperture, or f-stop. Shutter priority mode works well when you want to control how action appears. A fast shutter speed freezes action. A slow shutter speed shows motion as a blur, as shown.

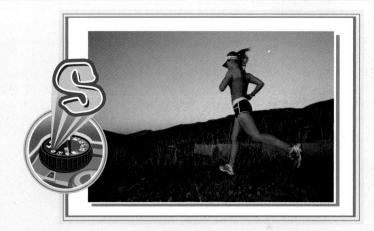

Subject Modes

You can use a subject or scene mode when you want the camera to automatically set the exposure based on a specific scene. Common scene modes include sports, landscape, portrait, and close-up. Newer cameras offer special modes such as sunsets, fireworks, snow, beach, sunrise, and night portrait. Scene modes work well when you want to point and shoot and have the camera's computer take care of the settings when getting the best results might be a little tricky.

Manual Mode

You can use manual mode when you want to choose the shutter speed and the aperture. This gives you the maximum amount of creativity. In most cases the camera's meter tells you what it thinks is the best setting, but then you can adjust the aperture, shutter, and ISO until you get exactly what you are looking for. Manual exposure is typically used when the lighting is relatively tricky and when you want the exposure to be the same no matter how the scene is lit.

Learn About Focal Length

Focal length determines the angle of view, or how much of a scene the camera's lens sees. In addition, focal length plays a role in determining the sharpness or softness of the background and foreground objects in a scene, or the depth of field.

To learn more about depth of field, see the section "Control Depth of Field," earlier in this chapter.

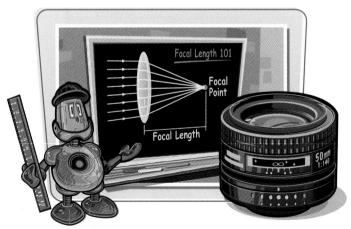

Focal Length Defined

Focal length describes the angle of view of the lens, or how much of the scene the lens sees. For example, on a 35mm camera, a normal lens, like a 50mm, is able to see about 40 degrees of the scene, but it has about the same real view as what we see. A superwide lens like an 18mm lens has an angle of view of 90 degrees, encompassing a broad sweep of the scene, whereas a telephoto lens of 200 has a much narrower view, only about 10 degrees.

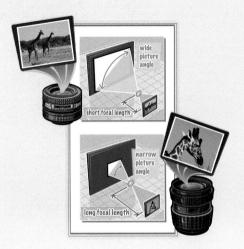

Use a Normal Lens

On a 35mm camera, a 50mm lens is considered a normal lens because it sees approximately the same angle of view as the human eye. In reality our eyes see near 180 degrees of a scene. On most digital cameras, a 35mm lens is closer to normal because the image sensor is smaller than the traditional 35mm film frame, which magnifies the view approximately 1.5 times depending on the camera sensor. This is why all digital camera makers list the focal length as being "equivalent" to a specific 35mm focal length. This is helpful for traditional film photographers because focal length is a term they understand.

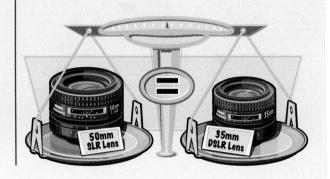

Use a Wide-Angle Lens

Controlling Exposure and Focal Length

chapter 3

A wide-angle, or wider than 50mm lens provides a broad angle of view and extensive depth of field — especially at small apertures. Use a wide-angle lens or zoom setting to photograph landscapes, panoramas, large groups, and small areas where you want to capture the entire scene.

Wide-Angle Distortion

Wide-angle lenses distort the relative size and spacing of objects in a scene. For example, objects close to the lens seem larger than they are, whereas distant objects seem farther away, and farther apart than you remember seeing them. A wide-angle lens, or a zoom lens at its widest setting, can also create a distortion called *barrel distortion*, which is evident in buildings or other tall elements where the edges bend inward, giving straight lines a kind of "inflated" look.

Maximize the Wide

Because wide-angle lens seem to push far-off subjects even farther away, it often helps to place something into the foreground of the scene to give your photos a visual anchor. With the additional depth of field, and a moderate aperture setting, you should be able to get plenty of sharpness throughout the scene.

Aspherical Lens

An aspherical lens has a nonspherical surface. These lenses help to produce better edge sharpness and straighter lines by making sure that all the wavelengths of light focus to the same point. These lenses are also lighter in weight than standard lenses because they do not need additional lens elements, or additional glass, to correct for edge sharpness.

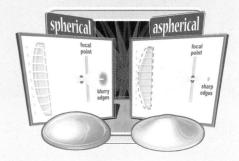

Use a Telephoto Lens

A telephoto lens, or one longer than 50mm in 35mm film terms, provides a narrow angle of view and limited depth of field. You can use a telephoto lens or zoom setting to isolate a subject from the background, bring distant objects closer, and compress objects with the background.

Telephoto lenses and zooms with low-dispersion glass provide increased sharpness, especially at the frame edges, and they provide better color. When you shop for a compact camera or a telephoto lens, look for lenses identified as ED, extra-low dispersion; LD, low dispersion; SLD, super-low dispersion; L, luxury; or APO, apochromatic.

Telephoto Compression

Because telephoto lenses compress perspective, elements in a scene appear closer together than you remember seeing them. You can use this compression to create a layering effect in photos.

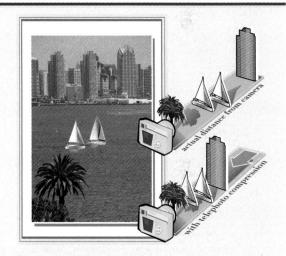

Bringing It Closer

Telephoto lenses are mostly used to isolate and bring subjects that we otherwise cannot see very well closer to us. These lenses are great for sports, wildlife, and portraiture. Telephoto lenses magnify these subjects in relation to the 50mm normal lens — for example, a 200mm lens brings subjects 4× closer, a 300mm lens is 6×, and a 600mm lens makes things appear 12× bigger.

Most digital cameras that are not SLR cameras have a built-in zoom lens. Most dSLR cameras come with a zoom lens included in the kit. A zoom lens enables you to change the focal length of the camera at the touch of a button or twist of a ring. A zoom lens combines a range of focal lengths within a single lens. There are zoom lengths of every sort — wide zooms, telephoto zooms, normal zooms, and all-in-one zooms that go from very wide to very long.

Choose a Zoom Lens

A large zoom range is very helpful because of its versatility. The trade-off of having a large zoom factor is that the camera is typically larger and a little bulky. The ability to zoom in, enabling you to capture details at a distance, is a great advantage. Having a zoom with a wide setting is equally helpful for shooting in small spaces and capturing wide expanses.

Prevent Blurry Pictures

Zooming in on your subject exaggerates even the slightest camera movement, which can result in blurred images, especially with photos at slower shutter speeds. When shooting at slower shutter speeds, you can stabilize your camera by mounting it on a tripod. Many new cameras now offer a built-in vibration reduction that reduces the effects of camera shake. This feature has many names, such as Image Stabilization, Vibration Reduction, and Super Steady Shot. This often allows you to hold your camera 2 to 3 shutter speeds slower.

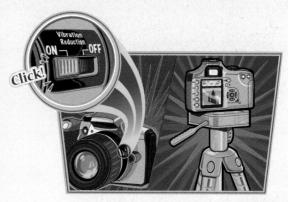

Learn About Digital Camera Lenses

Understanding a Multiplication Factor

Digital cameras with image sensors smaller than a 35mm film frame reduce the angle of view and produce an apparent lens magnification. Magnification varies by factors ranging from 1.3 to 1.5 times. At a 1.5 factor, a 100mm to 300mm lens provides a 150mm to 450mm equivalent angle of view. This gives greater magnification when you photograph distant subjects, but gives a narrower view of the scene at wide-angle settings.

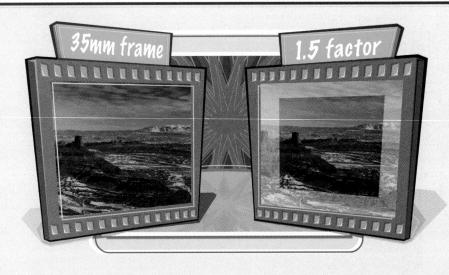

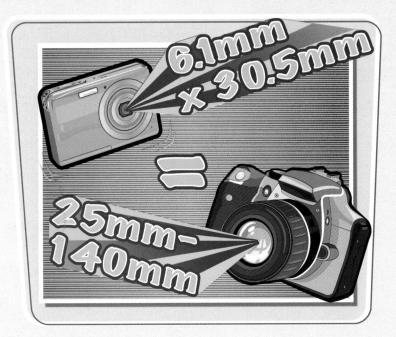

Lenses with Compact Digital Cameras

Compact digitals have even smaller sensors yet. These sensors are roughly 7.2mm×5.3mm — as compared to a 35mm film which is 36mm×24mm. Lenses for cameras might seem impossibly wide, but on a compact digital camera the equivalent to a normal 50mm lens is a 7.4mm lens. Thus a compact digital camera with a very good zoom range might be something like a 6.1mm×30.5mm lens, which would be equivalent to a 28–140 in 35mm terms.

Controlling Exposure and Focal Length

Optical Versus Digital Zoom

Many digital cameras offer optical and digital zoom. Optical zoom magnifies the scene by changing the focal length. Digital zoom crops the scene, which magnifies the center of the frame to make the subject appear larger. Some cameras add extra pixels to round out the image size or resolution. This cropping effect often degrades image quality. Always avoid using digital zoom.

Digital-Specific Lenses

Several companies, including Olympus, Panasonic, Leica, Kodak, and Fujifilm promote the *four-thirds system* that establishes a new common standard for the interchange of lenses developed for digital SLR cameras. The four-thirds system allows the development of dedicated digital camera lens systems with a sensor measuring only half the size of a 35mm film frame. The four-thirds system produces a 2× multiplier for the new digital lenses.

Nikon, Canon, and Sony all have created a significant variety of different lenses for their smaller, APS-C (1.5×)-sized sensor. These lenses are more compact to correspond with the smaller cameras that are made around the smaller sensors, and sometimes have even better zoom range than their 35mm counterparts.

Learn About Digital Camera Lenses *(continued)*

Full Frame Sensors

The size of the sensor in most digital cameras is physically smaller than a 35mm negative, whereas some professional digital SLR cameras have larger, more expensive sensors that are the same size as a 35mm negative, and which are called full frame sensors. The two major advantages of a full frame sensor are the resolution, which results from getting more pixels on the larger sensor, and the larger possible pixel size, resulting from the larger sensor and lessening the amount of noise present in high ISO photos. These cameras and their lenses are also physically larger and heavier. Some full frame sensors are able to create usable photos at well above ISO 6400.

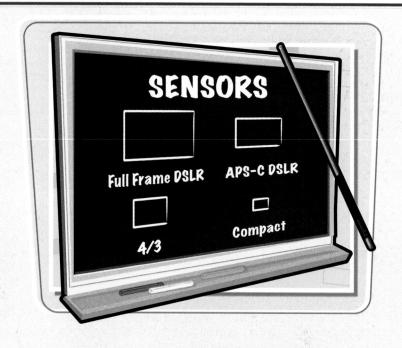

What You See versus What the Lens Sees

Many compact digital cameras feature optical viewfinders, but the viewfinders are separate from the lens. As a result, you do not see in the viewfinder exactly what the lens sees. The closer you move to the subject, the greater the difference, or parallax, becomes. To get an accurate view of what the lens sees, you should use the LCD. Viewing the image on the LCD can be tricky on a bright sunny day, but accessories are available that put a hood over the LCD to allow you to see the LCD on the brightest of days.

Controlling Exposure and Focal Length

Macro Lenses

Macro lenses allow you to focus very close and are specifically designed for the best results when taking photos of very small items such as jewelry, flowers, or stamps. Macro lenses are generally telephoto lenses so that you can focus close to a small subject without being too physically near to that subject. Many telephoto zooms have a macro setting, which also lets you focus close, but not as close as a true macro lens.

Macro Setting on Compact Cameras

Compact digital cameras have a close-up or macro setting, which is generally designated with a flower icon. This macro setting actually adjusts the camera or lens, allowing the lens to focus closer and limits the lens from taking a photo at far distances. On most digital compacts, that setting is maximized at the wide setting.

CHAPTER

Understanding Light

Learn how to use light to create a mood or atmosphere, define a shape or a form, and bring out details in your photographs.

Learn About the Color of Light

You can use the qualities of light to set the mood and to influence a viewer's emotional response to the picture. You can also use light to reveal or partially hide the subject's shape, form, texture, and detail, or use light to show colors in the scene as vibrant or subdued.

Our eyes automatically adjust for the difference in the color of light sources. You can also use the camera's technology to make sure that your photos look how you see them.

Light and Color

All colors within the color spectrum are contained in visible light. The amount of any particular color within the light is determined by its source, and for outdoor light, the time of day. For example, more reddish orange color is seen at sunset when the sun's low angle causes light to pass through more of the heated earth's atmosphere. Midday light on an overcast day produces a bluish color, whereas indoor light, such as candlelight and tungsten light bulbs, creates an amber tone. Knowing how these different light sources affect your photographs helps you make better choices.

Sunrise

Cobalt and purple hues of the night sky predominate during early sunrise. Within minutes, the landscape begins to reflect the warm gold and red hues of the sunrise. Early morning light is produced by sunlight passing through the atmosphere at a low angle, which means that the light is going through much more of the earth's atmosphere than it would if the sun were directly overhead. (This same increase in atmospheric layers has a magnifying effect, which explains why the sun and the moon appear so much larger when they are close to the horizon.) Later in the morning as the sun gets higher in the sky, the light shifts to a rich blue. Most photographers agree the best shooting light for clear skies is an hour after sunrise until around midmorning, and then again when the sun is within a few hours of setting.

Midday

During midday, bright overhead light produces harsh shadows and a bluish colorcast. For some types of photography, particularly portraiture, this is not the time to take the most beautiful photos. Midday light can work well for photographing shadow patterns, flower petals, and plant leaves made translucent against the sun, and for natural and man-made structures such as rock formations and buildings.

Sunset

During the time just before, during, and just following sunset, the warmest and most intense color of natural

light occurs. The predominantly red, yellow, and gold light creates vibrant colors, whereas the low angle of the sun creates soft contrasts that define and enhance textures and shapes. Sunset colors create rich landscape, cityscape, and wildlife photographs.

Electronic Flash

Most on-camera electronic flashes are balanced for the neutral (white) color of midday light, although

sometimes these strobes tend to make their subjects slightly bluish. Electronic flash light is neutral, and in the correct intensities, reproduces colors accurately. On the negative side, using a flash can bring out unwanted details, such as wrinkles, and produce hard shadows; in very dark situations, the flash creates a bright subject and makes everything else too dark.

Household or Candlelight

Tungsten is household light. Tungsten light, like firelight and candlelight, appears warmer than daylight

and produces a yellow/ orange cast in photos taken using a digital or a film camera. Although this colorcast can be easily corrected, in many cases it is desirable because of its warm, inviting feel.

Fluorescent Light

Commonly found in offices and public places, fluorescent light typically produces a green cast in photos taken using a digital camera that has the white balance set to daylight or auto. Typically this colorcast is seldom seen in the photo because when the subject is lit by fluorescents, the light is low enough to cause the camera's automatic flash to fire. The flash produces sufficient light to overcome any colorcast produced by the fluorescent lighting. Fluorescents, compact

fluorescents, mercury vapor, and sodium vapor lights are all common types of lights in buildings and cities at night, and each of these creates its own type of colorcast. The white balance on today's cameras seems to get ever better at figuring out the different color automatically to make for normal-looking photos, but keep your eve out when a lot of different lights are around.

Measure and Correct Light for Color

In film photography, the color composition of the light is controlled by attaching color filters in front of the lens to compensate for or enhance various ranges of color. This is because the color balance of the film is determined by its chemical composition and cannot be changed. Digital cameras allow you to control the color balance of the sensor by manually changing the white balance (WB) setting.

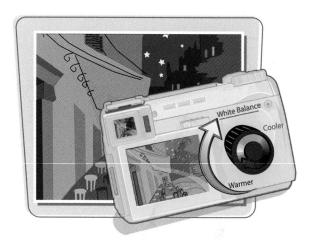

How Light Color Is Measured

In photography, image color is measured as a temperature. Each color of light corresponds to a temperature measured on the Kelvin (K) scale in degrees, with white sunlight being about 5000 K. It works the opposite way you would expect it to. The higher the temperature, the cooler (or more blue) the light, so a heavily overcast day would be about 9000 K. The lower the temperature, the warmer (or more yellow/red) the light — candlelight being about 1000 K. In short, subjects lit by cool, higher-temperature light appear bluer; when lit by warmer light, subjects appear amber.

Light Meters

Camera light meters assume that everything you focus on is neutral gray, which reflects 18 percent of the light and absorbs the rest. Today, the 18 percent gray card is used for metering and for calibrating the white balance setting of a digital camera. When the light meter in a modern digital camera evaluates a scene, it reads hundreds of areas of light and dark in the image frame and adjusts the camera to capture the greatest amount of detail without over- or underexposing the image. In today's cameras the light meter works with the onboard computers to figure the best exposure and white balance automatically even in some very tricky situations.

Why Correct for Light?

The human eye automatically adjusts to changing light color and sees white as being white in different types of light. Digital sensors simply read the light as it is, so as the color temperature of the light illuminating the subject changes, so does the colorcast on the finished photo. To achieve the desired color in a photo, either the white balance of the camera must be adjusted or the color of the photo must be corrected using the computer.

Set White Balance

On digital cameras, you adjust the white balance to tell the camera the temperature or type of light in the scene. White balance options, such as Bright Sun, Tungsten, Shady, and Fluorescent, are set using one of the camera menus. Choose the setting that matches the predominant light in the scene. Some cameras allow you to adjust settings with a + or - to get more precise color. Newer cameras offer multiple scene selections, such as sunset, fireworks, and outdoor action. These scene mode settings not only control the exposure but the white balance settings as well.

Automatic White Balance

There are several ways to achieve desired color rendition using a digital camera. You can manually set the white balance or let the camera set it for you automatically. Automatic white balance is getting better with every new generation of digital cameras, and in many cases it is the best solution, especially when there are multiple light sources. The camera reevaluates the WB with each shot, so inconsistencies have the opportunity to occur.

Manual White Balance

If the auto settings are so good, why would you use the manual settings? Manually setting your white balance is the most accurate way to get your color correct. It is also the most consistent because the auto WB is looking for an average colorcast, but even a slight change in the scene can offset the color in auto WB. Also, you may want to change the WB to a different setting for your own creative purposes.

Learn About Light Quality

Photographers describe light by many names. These names often describe the effect that the light has on the resulting photo. Hard light creates shadows with well-defined edges. Soft light (also called diffused light) creates shadows with soft edges. Understanding the effect that each type of light produces helps you use both types of light, and variations in between, effectively. In addition to types of lighting, the direction that the light is coming from also affects how accurately the automatic light meter can read the scene and produce optimum exposure settings.

Light Quality

Light quality is somewhat hard to quantify because it changes from photo to photo. Light quality helps to build a mood or tone in your photos. An overcast day might be dark and moody or it might help create a soft and gentle-looking portrait. Learning to evaluate the light helps you to better create your own best photos.

Hard Light

Hard, bright light creates a concentrated spotlight effect. Hard light from the bright sun, a flash, or a bare light bulb creates shadows with sharp edges, and obliterates highlight and shadow details. Hard light can be good for landscape and for fall color photography. Hard light can lead to challenging photos of people. To prevent shadows on faces caused by hard light, use a fill flash, or if possible, move the subject to a shady area.

Soft Light

Soft light is diffused light spread over a larger area. Atmospheric conditions, such as clouds, diffuse natural light, creating shadow edges that transition gradually. Open shade is also considered soft light. Soft light works well for easy portraits and close-up photography. Even though an overcast day produces a bluish colorcast, the diffused light it offers allows you to get photos of subjects without harsh shadows.

Front Lighting

The simplest type of light comes from the front of the scene. Front light allows for bright scenes and easy exposures. If you are taking photos outside, try to keep the sun at your back for nicely front-lit photos. Strong front light can sometimes be too bright though, and all the light from the scene can come straight back into the camera. Front-lit portraits might be better if the light is slightly softer.

Learn About Light Quality (continued)

Side Lighting

Side lighting happens when light comes across the scene, and can be called *cross light*. This type of light is usually seen out of doors in the early morning or late afternoon and helps to create great texture and depth within the photograph. Many portraits are done with some side lighting, but once again, are probably most flattering when the light is slightly softer.

Top Lighting

Top lighting illuminates the subject from overhead, such as what happens in the middle of a sunny day. This hard lighting produces strong, deep shadows, especially under the eyes, nose, and chin when shooting people. But if the day is overcast, shooting a portrait in this light is great, with a huge soft-light source from above. Many photographers also adjust their flashes indoors so that the light hits the ceiling and bounces down in a top-lighting situation. Doing this creates more natural-looking flash shots.

Backlighting

Light positioned behind the subject creates a condition called *backlighting*. Depending on the angle, backlight can create a great thin halo of light that outlines the rim of the shape of the subject. Backlight is a tricky lighting situation, but it can be beautiful and dramatic. You may need to overexpose the scene (using exposure compensation) to make sure enough light falls on your subject. Backlight is also used for silhouettes and other dramatic types of photos.

Learn About Fill Light

Sunlight is a very bright light source, and thus the shadows it casts are very dark. The contrast between the light and dark is simply too much for your sensor. To help close the gap between the brights and darks when you have shadows that hide some element in your photographs, you use some other light source like a strobe or some sort of reflector to "fill in" the shadows with light. Many times this is just a tiny bit of light to get some sparkle into the subjects' eyes.

Use a Reflector

A reflector can be just about anything that can reflect some sunlight back into the subject and fill in the shadows. You can get all manner of reflectors at your camera shop, but you can use paper, cardboard, tin foil wrapped on cardboard, a building, mirrors, or even have someone with a white shirt move close to your subject to reflect some light.

Use a Flash

Your electronic flash is a powerful tool. When you need to add light in a low-light scene, the camera automatically fires the flash to provide enough light for a good exposure. When a light source is producing shadows on a subject's face, use the camera's built-in flash unit or an external unit to fill in those shadows to create a well-illuminated photograph.

Flash Distance

To get the best flash pictures, indoors or outdoors, it is important to know the distance that the flash travels, and then to stay within that distance when taking pictures. On most compact cameras, the flash range is 10 to 15 feet. Be sure to check your camera's manual to find the exact range of your flash.

With one of the large hot shoe—mounted strobes, you may be able to angle or twist the flash head so that you can direct and bounce the light. In that case, make sure the flash will make it all the way to the bouncing surface (ceiling or wall) to get enough light on your subject.

Flash Compensation

Today's digital cameras automatically sense when the flash has produced the optimum exposure and adjust the amount of flash for your exposure. Some digital cameras and accessory flash units allow you to control the flash intensity. Use your LCD to determine just how much flash power is being used automatically, and if it is still too dark or too light, use flash compensation. You can set the flash to different levels of power, measured in exposure values (EV). To decrease the flash output and create a softer light, you can set it to a negative EV value, and if you need to increase it, you set it to a positive value. This is particularly helpful when using the flash for daylight fill flash.

Use Flash Outdoors

With your compact digital camera, it might actually help if the default flash setting was to flash in bright sunlight. Shadows on faces and even small still-life subjects can be brought to life with even just a little strobe power. Look for shadows in eye sockets or underneath hats, and use your flash to brighten up the scene. Flash outdoors is even helpful in overcast situations to add some contrast or in a backlit scene like a sunset to help balance the light coming back to the camera.

Without Fill Flash

Harsh overhead (top) lighting and backlighting create problems, such as unattractive shadows in portraits and silhouettes. In this picture, without a fill flash, deep shadows appear under the nose and chin of the subject.

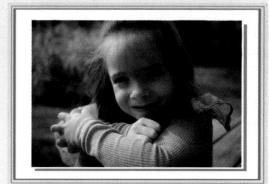

With Fill Flash

In most cameras today, just opening the flash or changing the flash mode to manual produces the necessary flash exposure to work as an effective fill flash. Even though the flash mode may be called manual, the automatic sensor still regulates the amount of power in the flash. In this picture, fill flash lightens the deep shadow areas by adding light to the front of the subject.

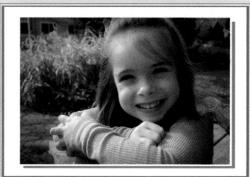

CHAPTER

5

Learning About Focus

Focus is essential to taking good photographs. A blurry or out-of-focus subject makes the picture unusable. Even though all digital cameras have an autofocusing system, focus problems are the leading cause of ruined photos in digital photography. In this chapter, you learn how to focus precisely, and what to focus on in a scene.

Understanding Focus Systems

All digital cameras have autofocus built-in. These systems vary from camera to camera and their abilities range from a simple type of autofocus that focuses the camera on the subject in the center of frame, to more sophisticated systems that can follow and focus on objects moving across the lens; and even more advanced focus systems automatically focus on a face and take the photo only when people smile.

With a little understanding about how the autofocus system on your camera works, you can ensure that your photos are consistently in focus.

Fixed Focus Systems

Fixed focus systems do not adjust the lens to focus, but rely only on having such a great depth of field that everything more than a few feet in front of the camera is in focus. Although the method is simple, fixed focus systems often display only reasonably sharp pictures. Single-use film cameras often use a fixed focus system, as do budget digital cameras such as the ones found at drugstores and discount marts. This is also how focusing works on most cellular phones that have cameras.

Active Autofocus Systems

Many cameras use an active system that uses a short burst of light or infrared to determine distance. These systems measure the amount of time it takes an object to reflect the light back to the camera, and use this distance to set the focus. Active systems can be fast and precise, but often have problems with shooting through windows and other glass surfaces. Most compact digital cameras use active autofocus systems.

Passive Autofocus Systems

Some cameras use passive autofocus systems, which perform analysis of the image as it comes into the camera. This is done through either *phase detection* or *contrast measurement* as the light comes through the lens. To determine camera-to-subject distance, the camera detects differences in dark and light elements, or *contrast*, in the scene, or differences in colors and textures. Passive autofocus works well in most scenarios, but does not focus as well in low-light situations and with scenes possessed of little contrast difference such as a plain wall or clear blue sky. Some dSLRs have an autofocus assist light to help with this.

Multipoint Autofocus Systems

Multipoint autofocus systems let you easily compose with and focus on an off-center subject. To focus, you select one of the autofocus sensors, place the subject within the selected sensor, and then focus by pressing the shutter release button halfway down. Some multipoint systems offer focus tracking to maintain continuous focus on a moving subject, whereas others focus on the closest subject regardless of where it is in the frame. Most modern digital cameras have multipoint AF systems.

When Autofocus Fails

Autofocus does not always focus correctly. The most common failure is the camera focusing on the wrong subject. The next most common cause of failure is when too little light is on the subject, or when the subject is just too close to the camera. Most cameras have an indicator (a small icon or a beep) that lets you know when the camera thinks it is in focus. After you take the photo you can see it in the camera's LCD screen, but be aware that even blurred images can appear sharp when viewed on a tiny LCD screen. For important photos, you should use the LCD's zoom feature and make sure the subject, and not the background, is in focus.

Focus on an Off-Center Subject

When composing an image in the frame, it often looks better to have the subject off-center. But, because the autofocus system of many cameras expects the subject to be in the center, it attempts to focus on whatever is in the center of the frame. This makes focusing difficult with cameras that have a single-center autofocus sensor. To compose an image with the subject off-center, you can use focus lock.

Focus on an Off-Center Subject

Frame your subject in the viewfinder or LCD. Make note of where your focus sensor is in your viewfinder or LCD.

Always set the zoom before focusing.

For multipoint focusing systems, choose the autofocus sensor you want.

Note: See Chapter 3 to learn about using a zoom lens.

The focus system locks using the center autofocus sensor or the sensor you chose.

3 Check the focus indicator on the camera to ensure the focus is good.

Many cameras have a green LED that glows in or near the viewfinder when the subject is in focus.

Learning About Focus

- 4 If necessary, hold the button halfway down, and then shift the camera to recompose the scene.
- **5** Fully depress the shutter release button to take the picture.

Note: If you or the subject changes position, be sure to repeat this process to refocus on the subject.

The camera captures the properly focused picture and saves it to memory.

Should I compose my pictures using the viewfinder or the LCD?

The LCD provides an accurate view of the scene that the camera captures, and the viewfinder on some compact cameras may not show the full scene, but if the camera has a viewfinder, it is more stable to bring the camera to your face. If you use the LCD to compose pictures, be sure that the focus indicator shows that the focus is where you want it before you take the picture. When you compose using the LCD in low-lighting conditions, consider supporting the camera on a solid surface such as a tripod or a table, or brace yourself against a solid object to ensure that you get sharp pictures.

Use Focus Modes

One of the features becoming popular with digital cameras is the ability to select a preset scene mode. Most digital cameras now offer several of these presets. Selecting some of these subject or scene modes affects the focus method used. Make sure to read your camera manual to discover which of the modes affect focus and how they affect it.

Automatic

Automatic is usually the default setting of the camera. It does not affect the autofocus systems and allows you to take photos at distances from a few feet to infinity. Simply place the focus indicator over the subject to be focused on, press the shutter release part way to focus, and then shoot.

Landscape

If you set your compact digital camera to landscape AF mode, then the camera sets the focus at infinity. This is usually set with an icon that looks like a mountain. The advantage of this mode is that it prevents the camera from continually attempting to focus on a subject that is too far away, which takes time and battery power, and also allows you to focus a compact digital camera through glass. Because the landscape scene mode disables autofocus, the only caution when using this mode is to remember to return the mode to normal auto after you take the photo.

Close-Up or Macro

To change the focus for closer distances, switch to close-up or macro mode, which is usually noted with a flower icon. Depending on your camera, switching to macro mode allows the focusing system to focus on subjects as close as .8 inches from the front of the lens. Check your camera manual to see what the minimum and maximum focus distance is for macro mode. In many cameras, the maximum distance for macro is around 30 feet, which also makes it good for portraits.

Focus on a Moving Subject

Moving subjects can be a challenge because many camera autofocus systems do not focus quickly enough. One way to ensure that the subject is in the frame when the photo is taken is to establish the focus before you shoot using focus lock. This way the camera is prefocused and does not waste time hunting for the correct focus. dSLR cameras usually have a continuous focus mode that tracks the subject contained within the focus indicator; you then press the button and hold it down. You end up with multiple images to choose from, and the odds are that one of them will be great.

Choose a Point of Focus

When taking a portrait or group picture, focus on the eyes of the person closest to the camera. When photographing a still life, focus on the most important element in the scene. For example, in this picture the focus is on the knife on the cutting board, not the pitcher or the background. For a landscape photo, fix the focus one-third of the way into the scene.

Focus Tips

- Use a tripod if the lighting is low (see Chapter 2).
- Be sure your focus indicator shows that your camera is in focus.
- Use your camera's LCD screen to make sure the photo is in focus.
- For important images, zoom in the LCD preview to make sure the focus is sharp because even blurry images can appear sharp on a small LCD screen.

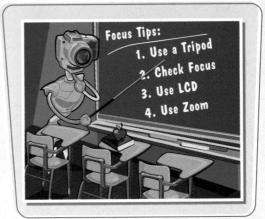

CHAPTER

Composing Pictures like a Pro

Want to quickly improve your digital pictures? Improving composition is a quick way to get better pictures. This chapter explores some simple techniques professional photographers use that will immediately improve the photos you take. You also learn ways to add interest to all your photos using a variety of composition techniques.

Visualize Composition

The best pictures not only catch your attention, but they also hold your attention. To get these kinds of pictures, compose images carefully and tell a story in each picture. Begin by borrowing established design principles and composition techniques that artists and photographers have been using since the camera was invented. As you progress, add in your own personal style to create signature pictures that viewers will remember.

Stand Back and Evaluate

You interpret each scene for your viewers. Your job is to combine your emotional perceptions with the objective viewpoint of the camera. Begin by evaluating all the elements in the scene. Gradually narrow your view to identify individual vignettes. Then look for defining elements, colors, patterns, and textures that can help organize the visual information in the picture.

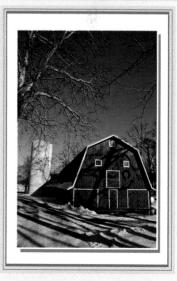

Consider Audience and Occasion

The most important questions to ask during this stage are "Why am I taking this picture?" and "What do I want to tell the viewer?" Answering these questions helps you focus on the important elements in the scene. From there, you can choose to include or exclude visual elements that add to or detract from the message you want to communicate to viewers.

Use Light and Exposure Controls Creatively

When you know the message you want to convey, you can use or modify the light, and choose exposure settings that create the mood, concentrate attention, and provide the perspective of the scene. Once you start visualizing the way the light and shadow works within your photographs, you can begin creating the images that you want instead of just taking pictures. To learn more about exposure, see Chapter 3. To learn more about light, see Chapter 4.

Keep It Simple

Just as with writing or painting, messages are most effectively delivered and retained when they are simple. Strive for a clean shot — an uncluttered visual scene that conveys a single story, or conveys a clear graphic shape, as shown here. To get a clean shot, you can clear away clutter, change your shooting position, or zoom in on the subject.

Evaluate the Result

With a digital camera, you can immediately evaluate the success or failure of your images on the LCD. Take advantage of the opportunity to make adjustments, and immediately reshoot the picture. The more pictures that you take, review, and reshoot, the better you become at recognizing composition problems by looking at pictures on the LCD.

Consider Design Principles

Many principles of photographic composition are derived from the traditional design disciplines of art and graphic design, some of which date back to before the Renaissance. Here are a few of the most widely used principles.

Is Symmetry Good or Bad?

Perfectly symmetrical compositions, images that look the same from side to side or from top to bottom, create balance and stability, but can be viewed as boring compositions. Symmetrical designs, as shown here, sometimes offer less visual impact than photos with some asymmetry and tension. If a composition you are looking at is the same from side to side, look to the top or bottom to add interest.

Create a Sense of Balance

Balance is a sense of "rightness" in a photo. A balanced photo does not appear to be too heavy at any point, or too off-center. When composing your pictures, consider the following: the visual weight of colors and tones — dark is heavier than light; objects — large objects appear heavier than light objects; and placement — objects placed toward an edge appear heavier than objects placed at the center of the frame.

What Lines Convey

Lines have symbolic significance that you can use to direct the focus and organize the visual elements in your picture. Horizontal lines imply stability and peacefulness. Diagonal lines imply strength, as shown in this picture, and dynamic tension. Vertical lines imply motion, curved lines symbolize grace, and zigzag lines imply action.

How the Shapes of Objects Affect Photos

The number and kind of shapes in a photo determine where viewers focus their attention. The human shape or form always draws attention in a picture. A single, small shape attracts attention either as the subject or as a secondary element that helps define the subject. Groupings of similar objects invite the viewer to compare size, shape, and spacing between the objects.

Placement of a Subject within a Picture

Just as symmetry can be visually uninteresting, placing a subject or the line of the horizon in the center of the frame is usually equally boring. Subject placement depends on the scene, but placement should identify the subject and create a natural visual path through the photo. Also, motion and implied action should come into the frame rather than travel out of it.

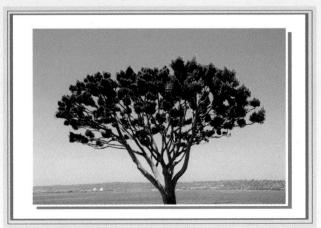

Discover Rules of Composition

There are many established rules and guidelines that you can use to improve your photos. Most of them are simple and easy to remember. There are no binding rules of composition. Some of the greatest artists today broke the rules of composition and technique of their time. The techniques in this section provide a good starting point for designing images. Be sure to experiment and let the subject help define your composition.

Choose the Orientation

The most basic composition begins by choosing either a horizontal or a vertical orientation. Some subjects dictate the most appropriate orientation. For example, you can use a horizontal orientation for a sweeping landscape, and a vertical orientation for a portrait, but do not feel obligated to making only horizontal landscapes and vertical portraits. Use your entire frame to build your composition, even if you are using empty space to build balance.

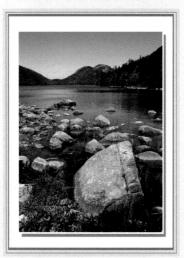

Fill the Frame

Just as an artist fills an entire canvas with a scene, photographers strive to fill the image frame with elements that support the message. Decide exactly what you want in the picture, and then fill the frame with what you choose for the picture. For variation, you can come in very close to the subject to show only part of the subject.

Composing Pictures like a Pro

Check the Background and Surroundings

In a picture, the elements behind and around the subject can become as much a part of the photograph as the subject. As you compose the picture, check everything in the viewfinder or LCD for objects that compete with or distract from the subject. Then see if you can move the objects, the subject, or change your position to add interest or to eliminate distractions.

Practice the Rule of Thirds

A popular photography compositional technique draws an imaginary grid over the viewfinder. With the scene divided into thirds both horizontally and vertically, the photographer places the subject on one of the points of intersection or along one of the lines on the grid. In a portrait, you can place the eyes of the subject at the upper left intersection point, which is considered to be the strongest position.

Frame the Subject

Photographers often borrow a technique from painters, putting the subject within a naturally occurring frame, such as a tree framed by a barn door, or a distant subject framed by an archway or foliage. The frame may or may not be in focus, but for best effectiveness, it should add context to the subject.

Use Other Composition Aids

Other composition techniques include using strong textures, repeating patterns and geometric shapes, and color repetition or contrast to compose images. These elements can create a picture on their own, or you can use them to create visual motion that directs the eye or supports the subject.

Learn to Control Composition

In a perfect world, you could control all the elements within a photograph. In a studio, everything in the photograph can be controlled by the photographer. In the outside world, you must work with existing conditions, backgrounds, and foregrounds. Here are some ways to get the best composition when you cannot control all the elements in the scene.

Select Focus and Control Depth of Field

Because the eye is drawn to the sharpest part of the photo, you can use focus to emphasize the relative importance of elements in the picture, or combine selective focus and depth of field to emphasize or subdue elements within the picture. Here, a shallow depth of field blurs a distracting background. For more information on depth of field, see Chapter 3.

Change the Point of View

Instead of photographing at eye level, try changing your viewpoint. For example, if you photograph a subject from a lower-than-eye-level position, the subject seems powerful, whereas a higher-than-eye-level position creates the opposite effect. Getting on the subjects' level is particularly effective when photographing children and pets.

Use Tone and Contrast

You can use *contrast*, or the difference between light and dark tones, to emphasize your subject. Experiment by modifying the amount and angle of light to create more or less contrast, such as waiting for the sun to be in a position to produce long shadows. Or you can change position so the subject is backlit to add dramatic contrast with the lighting of the scene.

Define Space and Perspective

Some techniques to control the perception of space in pictures include changing the distance from the camera to the subject, selecting a telephoto or wide-angle lens or zoom setting, changing the position of the light, and changing the point of view. In this example, a telephoto lens compresses the dry grasses blowing in the wind.

CHAPTER

Putting It All Together

In this chapter, you can practice and see the results of using different exposure factors, lenses or zoom settings, lighting, and scene modes.

Experiment with Depth of Field

Learning to control depth of field (DOF) in a picture gives you the ability to choose what part of the scene is in focus and what part is blurred. You can also control the amount of blurring, from mild softness to unrecognizable blurs. You can use depth of field to guide the attention of the viewer and to create artistic effects.

Control Viewer Focus

You can control depth of field in several ways. The easiest way, if your camera has one, is to select its portrait or macro scene mode. The portrait mode preset on your camera should not be confused with the term describing the orientation of the photo as in portrait and landscape. The portrait mode sets the camera to use the widest possible aperture to shorten the depth of field. The macro mode also produces a short depth of field because the subject is so close to the lens. You can also use aperture, focal length, and camera-to-subject distance, individually or in combination, to control depth of field. Other than scene mode, increasing the aperture (using a smaller f-stop) or getting closer to the subject is the next best way to decrease depth of field in a photo. Be aware that you cannot always see the correct depth of field when composing the image, only after you have taken the photo and are reviewing it in the LCD.

Limits to Control

Sometimes you cannot use the aperture you want because the scene is too bright. In this picture, the bright afternoon sunlight did not allow the use of a wide aperture to limit depth of field. Because the water on the rock creates a lot of reflection from the sky, by putting a polarizing filter on a dSLR camera, you can help tame the amount of light coming back into the camera, which also allows the use of a larger aperture. The result is a decreased depth of field, singling out the subject from the background.

Get the Effect You Want

The pictures on this page show how small, midrange, and large apertures affect depth of field, or the zone of sharpness from front to back, in a picture. In this picture, taken at a rocky beach on the Pacific coast, the zoom was used at its widest setting, and with the camera mounted on a tripod, a small aperture helped create a wide depth of field, allowing both the closest stones and the farthest seastacks to be in focus.

Focus On the Subject

In this picture, the scene mode of the camera was set to Portrait. This scene mode causes your camera to produce a short depth of field, producing a soft, blurred background. When doing any sort of portrait, make sure the eyes are in focus, and when doing a portrait with many people, make sure all the faces are in focus. When in the portrait mode in close proximity to the subject, sometimes the depth of field is so shallow that focus becomes very critical. In this case, the puppy's eyes are in focus, but her nose is already out of focus and the background is totally soft. Make sure you get the focus right.

Classic Landscape and Portrait Apertures

A general rule of photography has been as follows: For landscape pictures, use a narrow aperture to create extensive depth of field. For portraits, use a wide aperture to decrease depth of field. Today's cameras generally do this for you automatically. Using the portrait mode changes the camera settings to produce a narrow depth of field. Many cameras also have a landscape

scene mode that turns off autofocus and sets the focus to infinity, producing the greatest depth of field possible. It usually is not necessary to use this mode because the camera's autofocus mechanism detects the range and changes the focus to infinity. In many cases though, a moderate aperture of f/5.6 or f/8 is enough to get plenty of depth of field in your photographs.

Use Aperture Priority to Learn

A good way to learn how depth of field works with your photography is to set your camera to Aperture Priority or A. Then take several shots at different apertures, letting the camera make the decision on the shutter speed and see how the difference in apertures changes how the photos look. In some cases, because of how wide or long the lens is and how close you are

focused, it may take a large change in f-stop to make a large viewable difference, and other times, even a 1-stop difference will make your photos look very different.

Mix and Match Settings

Now that you know how depth of field affects pictures, you can apply this knowledge to create different specific effects or to find an acceptable exposure in difficult scenes.

Maximize Overall Sharpness

For maximum detail from front to back in a picture, use the widest setting of your camera's zoom lens that still allows you to keep the composition you envisioned. Next, if your camera allows it, change the aperture to the narrowest setting (largest number). As you increase the f-stop number and decrease the aperture size, you notice that the camera automatically changes the shutter speed to compensate for less light coming through the lens. Do not let the shutter speed drop below 1/60 second if you are hand-holding your camera. Below that speed, the camera movement or the movement of the subject may blur the photograph. To increase the chances that you will have sharp pictures at slow shutter speeds, you can use a tree, wall, or fencepost to help to stabilize you. For the sharpest possible photos, stabilize the camera on something solid, optimally a tripod, and use a remote to eliminate the shake from depressing the shutter.

Maximize Sharpness Up Close

You can use the macro scene mode of the camera, and a close camera-to-subject distance to get acceptable sharpness up close. The macro setting of most digital cameras works within a fixed range of the zoom lens setting. Read your manual to find out how the macro setting works on your model, although it is usually controlled by pressing a button with a flower icon. Be aware that most macro settings have a very narrow depth of field. As shown, both the front and back of a small flower can be out of focus. The only way to ensure that the entire subject stays in focus is to carefully review the image in the LCD after shooting a few test shots.

Get a Limited Area of Sharpness

You can combine a telephoto lens, a wider aperture, and a closer camerato-subject distance for the ideal portrait setting. To emphasize a detail of the subject, move closer to the subject. This allows you to place your people into a scene, but still keeps the focus on your subject and leaves the background just that — background.

Get Maximum Sharpness in Extreme Close-Ups

If your camera does not have a dedicated macro scene mode, you can combine a telephoto lens, a narrow aperture, and a close camera-to-subject distance when you want to photograph close-up, or *macro*, photos. Because the working distance is close, you can get better depth of field by choosing a narrow aperture, but the closer you get the less will be in focus. All these things combine to reduce the amount of light entering the camera. When shooting a photo in early morning or late afternoon light, the reduced light may affect the autofocus, making it necessary to use manual focus. To compensate for the reduced light, the camera reduces the shutter speed, so be sure to use a tripod to ensure a sharp picture.

Get Sharp, Everyday Pictures

The key to getting sharp everyday photos is to ensure that the camera is set to the right mode, that the autofocus indicator shows that the subject is in focus, and that the camera is focused on the subject of the image and not something else in the frame. For everyday shooting, using the auto settings will usually get you great results with good sharpness.

Change Shutter Speed for Effect

The shutter speed on most digital cameras ranges from shutter times of several seconds to up to eight thousandths of a second. Your camera can automatically select the optimum shutter speed based on the available light in the scene. You can select different shutter speeds to stop action or to show action or motion as a blur. You can also experiment with shutter speeds to create unexpected and interesting results.

Stop the Action

You can stop action at shutter speeds faster than 1/125 second. Faster shutter speeds work well for capturing an athlete in midair, or for showing subtle action such as a spinning top that looks as if it is standing still. The problem with freezing images using high shutter speeds is that the feeling of motion is lost. The photo of the jet skier has its trail of water spray frozen in time where you can see each individual water droplet.

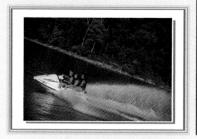

Show the Action

At 1/30 second and slower shutter speeds, you can show action as a blur. With a faster shutter speed, the water looks frozen. By using a slower shutter speed, you can capture the sense of the speed and excitement as the jet skiers skim across the water. Slow shutter speeds are also used to capture moving water, and light trails created by passing traffic at dusk, or for creative light compositions.

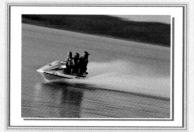

Learn with Shutter Priority

In Shutter Priority, you select the shutter speed and the camera uses the meter setting to automatically set the f-stop. You do this by selecting "S" or "Tv" on your camera. Try different shots with several different shutter speeds to determine how fast or slow your shutter speed needs to be to get the effect that you are looking for. Look at the photos on the computer when you get home and use the EXIF data to check the shutter speeds.

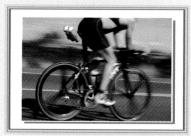

You can use focus as a way to direct the attention of the viewer to the most important or a single element in a picture. In close-ups, you can switch to manual focus to get the best focus.

Combine Selective Focus with Distance

To show a small area with fine detail, use a selective focus. In this picture, a narrow aperture of f/16 and sharp focus emphasize the fine details of the flowers on the left, and yet still show all the detail of the stone and cactus.

Combine Selective Focus, Focal Length, and Aperture

When you combine a wide aperture setting with a telephoto lens, and focus carefully, you can narrow the focus even more. As shown in this picture, a telephoto lens and an aperture of f/4.5 create a very specific focus.

Compose Creatively

You cannot use all these techniques every time you take a photo. As you practice the techniques in this book over and over again, they will become second nature to you. You will get a feel for not only how but when to use them. At that point you can combine exposure, focal length, and composition to take creative pictures that convey a message or tell a story.

Get to the Point

In this image, the focus of the composition was the nearest wine label with a view of the number of bottles and awards. By using a wide aperture and the zoom lens pushed out toward the telephoto end, it was possible to isolate the front bottle and soften the background at the same time, both giving the importance to subject, but also revealing the environment that contains the subject.

Draw the Viewer In

Here the composition guides the viewer through the flowers toward, and into, the rest of the scene. A narrow aperture creates good detail throughout the flowers to the mountains, despite the close camera-to-subject distance.

Capture the Action

In this image, a wide aperture and a slight telephoto were used to create a narrow depth of field, putting a focus on the subject. This allows for enough shutter speed to stop the action of the dad spinning around with his son, and capture the moment of the boy's laugh.

Create Abstract Images

Interesting compositions can come from all sorts of things. In this case, the cut glass window creates interesting shape, texture, and color in the image. Look everywhere around you for interesting abstracts. Sometimes you can use your macro setting to move in close to get an interesting point of view.

Motion Is Good

To show the power of motion, you can combine a slow shutter speed and small aperture, as shown here. To really capture the movement of a race, this image is captured at 1/10 second. This imparts a feeling of time and provides a sense of place.

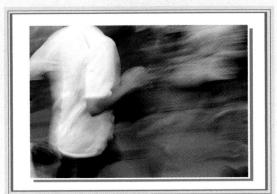

Explore Different Lighting Options

In most cases, the goal is to have sufficient lighting to produce an optimum exposure. Modifying light not only overcomes common problems, like blur in typical scenes, but it can also give pictures a dramatic flair.

Experiment with a Flash

A built-in flash provides the quickest and most convenient way to alter scene lighting. Experiment with the various sync modes, such as slow, front, and rear curtain synchronization sync modes. In the image shown, the light of the fire is mixed with the light from the flash and then captured using slow sync mode. You can use these modes to obtain good exposures at night and to create front or rear light trails of traffic in dimly lit scenes.

Use Fill Flash

Although fill flash works well for portraits, you can use fill flash for other subjects as well. For example, you can use fill flash outdoors to fill in the shadows coming from the sun. For indoor still-life pictures, fill flash reduces deep shadows caused by daylight from windows.

Use a Reflector

You can use a reflector to catch natural light and reflect it back into a scene. In this picture, a gold-colored reflector adds light to the face of the subject and creates a warm glow. Experiment with the position of the reflector; it takes some practice to get the light quality and quantity right with a reflector, but once you get going, it can really help create some fantastic images. You can purchase small, collapsible reflectors at any camera store, and with a little bit of thinking, plenty of household items can be used as a reflector.

Wait for Flattering Light

To get the best pictures, you should wait for the best light of the day. In most cases that means shooting in the time just after dawn and just before sunset. The light at those times of the day is much warmer, and with the sunlight being much lower in the sky, the angle of the light really creates some beautiful drama with your scene.

Watch for the Best Light Plays

It is a good habit to always have your camera with you to capture some of the beautiful plays of natural light. Using a hazy sunset, you can place people and things in front of the light, creating fun silhouettes. Watch for interesting contrasts of shapes and light in your subjects.

Try Creative Techniques

After you practice using standard photography techniques, you can use other variations that can be fun and create interesting images.

Pan Using a Slow Shutter Speed

At a shutter speed of 1/30 second or slower, you can pan with a subject as it moves, making the background appear blurred. To do this, focus on a place where the subject will pass. When the subject enters the viewfinder, follow the subject with the camera, and then take the picture when the subject reaches the point on which you focused. To maintain a smooth blur, keep the camera in motion as you press and release the shutter.

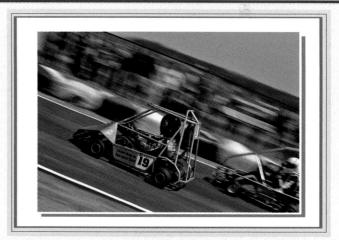

Use Backlighting

In harsh light, you can sometimes turn the light to your advantage by using it to create silhouettes or to enhance vivid color. In many cases, foliage turns to a fiery glow as light passes through it on the way into the camera. Backlight creates some of the most exciting and dramatic photographs, but beware, because it is also the trickiest to tame because of the extreme contrast and tendency to catch lens flare in your images as the light strikes the lens.

Capture Light Trails

You can create cool low-light and night images by switching to low-light or night scene mode. The camera uses a slow shutter speed to capture subjects, such as moving car headlights as streaks of light. If you do not have scene modes, select a shutter speed of 1/30 second or slower, use a tripod, and for shutter speeds of 1 second or greater, use the camera's self-timer to trip the shutter, avoiding any motion to the camera caused by touching the shutter release button.

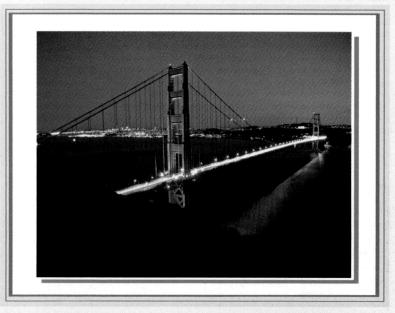

Warm Up Flash Pictures

Some digital cameras compensate for the cool colors produced by the internal flash. You can also use the preset flash white balance to make sure your flash color does not look too blue in your photos. If your flash does not correct the color imbalance, you can warm up the color of your camera flash by placing colored transparent gels or films over the flash.

CHAPTER

Taking Your First Digital Photos

Learn the specifics of setting up a digital camera, and taking, transferring, and evaluating your first set of digital pictures.

Set Up a Digital Camera

To get off to a good start with a digital camera, take time to read the manual and set camera options to ensure that you get the best image quality. Most digital cameras' manuals are now pretty easy to read, although they used to include a ton of information. Spend some time right away going through your manual with your camera next to you to familiarize yourself with all the advanced features now included. If you need to get started right away, read the quick-start guide, if available, or read the quick-start section of the user manual.

Charge Batteries

As a first step, read the instructions in the quick-start guide or the manual on charging the battery. Some batteries require an overnight charging cycle, whereas others charge in a few hours. Be patient and make sure the battery is fully charged before beginning to use your new camera. While the battery is charging, you can read your manual.

Insert and Format the Memory Card

All digital cameras use a removable memory card to store images. If your memory card has a write-protect (locking) mechanism, unlock the card before inserting it into the camera. Then locate the slot for the memory card, which often includes a diagram showing the direction that you insert the card. Most cameras do not accept a memory card if inserted incorrectly, so never force it. After inserting the card, you should make a habit of formatting it, especially if you have used the card before, to remove any old photos or other digital information it may contain. Some cameras also have built-in memory that saves some photos without a card. Make sure to refer to your camera's instruction manual for more information on how to use the built-in memory.

Set the Date and Time

After you have charged the battery, turn the camera on, and then set it to record or picture-taking mode. Follow the instructions on the LCD to set the date and time. You should set the date and time because they become part of the shooting information that the camera stores with images — metadata information that is helpful for organizing and retrieving images later. The term metadata describes a large collection of data that the camera produces and includes with each photo each time a picture is taken. In addition to time and date information, metadata includes the camera settings used during exposure, or the camera make, model, and serial number. More than 200 types of information can be included as metadata, depending on your camera.

Set the Image Quality and Format

You can set image size, quality, and format on a camera menu. For best quality, set it to the largest size and highest quality JPEG. It is much easier to make the photo smaller later, but nearly impossible to make it larger. The higher quality settings provide improved quality but the images require more memory card space. On more advanced digital cameras, you can also choose an image format: JPEG, TIFF, or RAW. Although TIFF is a popular format in graphics design, beware of it filling up your card and slowing down the camera. RAW, a format that stores images with no in-camera processing, provides powerful post-capture options, but you must use manufacturer or third-party software to view and save the images.

Set the White Balance

Most modern cameras now produce acceptable color just using the automatic white balance settings. Auto White Balance does a great job in most cases. When doing a lot of photography under a specific type of lighting, you can set the white balance to match the light in the scene to keep the color consistent. Evaluate the light in your scene and then set the white balance appropriately. If using a flash, in most cases leave the camera in its default automatic mode or whatever mode you normally use. Take some time to try different white balance settings in various situations to determine if these settings make your images even better or more interesting.

Take Test Pictures

The first pictures you take provide a great baseline for evaluating the performance and characteristics of your camera. Because no film is consumed, the only cost is the time it takes you to evaluate the results and delete the unsatisfactory ones. Identifying camera characteristics tells you what camera settings to fine-tune to get consistently good pictures. In addition to identifying the camera's characteristics, it is most helpful to become familiar with the camera controls and operation.

Learn the Basic Controls

Most digital cameras offer a large selection of controls, dials, buttons, and features. Begin by acquainting yourself with the basic controls used for taking and reviewing images. The controls use abbreviations and icons to indicate their function, so learning them is helpful. Several buttons and dials are used for more than one purpose, depending on the camera mode that you select. Locate the zoom control and learn how to use it for composing images. You should also learn to review images and make selections from the camera menus.

Take Pictures

Get started by taking familiar kinds of pictures of family and friends, indoors and outdoors. Also take pictures with and without the flash, both indoors and outdoors. These pictures establish a level of comfort when using your camera, so you can take photos without having to open the manual.

Adjust to a Digital Camera

Although each generation of new digital cameras gets faster and better, you still may need to become accustomed to slower start-up times that some cameras exhibit, and *shutter lag*, which is the delay between the time you press the shutter release button and the time the exposure is made. Image recording time depends on the size of the image file being used and how many photos you take quickly. Larger image files, such as RAW, take longer to save to the card. If an image is still being written to a card when you turn the camera off, the camera continues to record the image until it is complete before shutting down.

Compose Shots in the Viewfinder and LCD

For close subjects, use the LCD to compose images with your compact digital. *Parallax* is the slight offset between what you see in the viewfinder and what you get on the image. Parallax becomes more apparent for subjects closer than 3 feet, and is more pronounced the closer you get, but can be seen in many situations. Use the LCD for getting the camera into more interesting positions. At other distances, you can use the viewfinder to compose images. On a dSLR or a compact digital camera with a viewfinder, you have more stability and better chance for sharp photos if the camera is pressed to your eye as opposed to viewing the camera at arm's length.

Verify Pictures

As you shoot, be sure to check the pictures on your LCD monitor. The LCD indicates obvious composition and exposure problems. If you are planning to take several photos quickly, do not stop to review each one. Check the first one to make sure your settings look good, try different compositions and settings, and then review, reshooting if necessary. Most cameras can be set to display the picture on the LCD immediately after you take it, but to browse through multiple images, switch to a playback mode.

Troubleshoot Problems

Error messages on a digital camera can interrupt your first photo session. However, you can solve the most common problems quickly and easily.

The Shutter Release Button Does Not Take Photo

Several things may cause the shutter release button not to work. The most common is that the camera's autofocus has been unable to determine the correct focus. Another cause is that the memory card is not in the camera or is locked. Take out the memory card and switch the lever or tab to the unlocked position. If you are shooting a lot of images quickly, the camera will not fire when the camera's memory buffer is full while it writes all the photos to the card. If the card is full, the frame counter status usually flashes. You need to replace it with another card, format the card, or delete some images to increase the amount of room on the card. On a dSLR, the lens may not be properly attached to the camera.

The Camera Is On, but the Status Bar Is Blank

To conserve battery power, most cameras go into sleep mode when they are not in use for a while. You can press the shutter release button to wake up the camera, or you can turn the camera off and then turn it back on. Also, check to see if the memory card is full, or if the battery needs to be recharged or replaced.

You Cannot Save Images to an Empty Memory Card

Sometimes, when a memory card is formatted by a computer using a card reader or if the card has images from another camera, the card is formatted incorrectly. The matter is simple to correct. Simply use the camera to format the card by selecting the Format feature (usually from a menu selection). Formatting the card in the camera deletes all the images on the card, so make sure that the photos are saved on your computer.

Flash Pictures Are Too Dark or Too Light

All built-in flash units work within a range specified by the manufacturer, usually up to 15 feet. If flash pictures in the LCD look too dark, the subject may be too far away. Move closer to the subject and check the camera manual for the flash distance range. If the photo is washed out, you may be too close or you may be covering the flash sensor with your finger when taking the photos. A finger or other item closer to the camera can obstruct the flash and flash sensor, preventing it from correctly reading the amount of flash. Check your camera manual to learn where your flash sensor is located.

Pictures Are Blurry

Digital cameras include a focus indicator on the back of the camera or in the LCD status display. Always be sure the focus indicator is placed on your subject and shows that the autofocus is set. A common cause is the autofocus is locked on the wrong subject or is focused past the subject. An indication would be if only one part of the photo was in sharp focus. Place your focus indicator on the subject, press the shutter halfway down to lock focus, and then recompose. Check the scene mode settings; pictures can be blurry if you take a landscape shot with the camera set to macro mode.

Transfer Pictures to Your Computer

When the memory card is full of pictures or after your vacation or event, you can transfer them to your computer for evaluation. By learning the options for transferring and viewing your images, you can quickly and easily move images from your digital camera to your computer.

Why Transfer Pictures to Your Computer?

Even on the newest, best digital cameras, the LCD screen is relatively small. By reviewing pictures on the larger screen of your computer, you can decide whether the camera settings that you used need changing. You can use the software that came with the camera on your computer to view the pictures, or an image-editing program, such as Windows Live Photo Gallery, iPhoto, or Photoshop Elements.

What About RAW Images? 1. Allows for better correction and fine tuning of exposure settings. 2. Must use specific software to open. 3. Maintains the full range of original data that other formats discard.

What About RAW-Format Images?

The Raw conversion program allows you to correct or fine-tune exposure settings including aperture and white balance — the RAW files are the true "digital negative" and give the most image file information and image quality. Not all cameras allow you to shoot RAW files. If you take RAW-format pictures, you need to use the manufacturer's software or the Camera Raw plug-in feature of Photoshop Elements to view and edit your images. After you save the images in TIFF or JPEG format, you can open and continue editing images in programs such as Photoshop Elements, Lightroom, or Microsoft Digital Image Pro.

Transfer Options

How you download images depends on your camera. Your camera may have a dock that plugs into your computer. You can also use a USB cable that connects directly to the camera, a separate memory card reader, or a PC adapter card. Computer operating systems recognize most digital cameras or the memory cards, and then your image software takes you through the transfer process using a step-by-step wizard-style interface automatically; some allow you to just "drag and drop" the files from the camera to the desired folder on your computer.

The Easiest Transfer Technique

If your camera has a docking station, the easiest way to transfer images is to place the camera directly into the cradle of the docking station. The computer to which the station is attached detects the camera and begins the download. If your camera does not have a docking station, the next fastest way to transfer images is to use an inexpensive memory card reader.

Disconnect Your Camera and Clear the Card

To disconnect your camera or card reader from your computer, first ensure that the access indicator light is off, and then click the **Safely Remove Hardware** icon () in the Windows taskbar. Then unplug the USB cable. On a Mac, Control +click the camera or memory card icon and click **eject disc** from the menu that appears. You can also drag the icon to the trash and then disconnect the card or camera.

To clear the card, turn the camera on. You can delete the pictures from the memory card by choosing the **Format Card** option on one of the camera menus. Ensure that the images have been transferred safely to your computer before reformatting the memory card.

Evaluate Your Photos

You cannot tell how good your test pictures are until you see them on a computer. This is your chance to identify any camera settings you may want to change.

Identify Recurring Issues

Evaluating your first images allows you to determine any recurring problems that require a change in your camera settings. Most problems are related to using incorrect settings for a particular shooting situation. In a few cases, the problems you see may represent a consistent pattern of behavior that requires correction in the camera settings to overcome. Make sure to take a look at the exposure info in the metadata in conjunction with your photos. This will best help you to see how changes in the camera affect your photos.

Evaluate Exposure

Different cameras can exhibit different exposure characteristics. If all the pictures look consistently too dark, then the camera may underexpose the images, provided that you use the correct settings when you take the picture. If the pictures consistently look too light, then the camera may overexpose images, or the flash intensity is too strong. Make sure to take a look at the exposure info in the metadata in conjunction with your photos. This will best help you to see how changes in the camera affect your photos.

Evaluate Color

Most cameras evaluate and adjust for white balance correctly. Providing that the camera white balance is set correctly, look for unnatural colorcasts in photos taken on a bright sunny day. The easiest way is to see if the whites really look white, or at least, if they look the way you want them. If you find that the photos consistently produce a colorcast, you can often fine-tune the white balance settings, described later in the section "Fine-Tune Camera Settings."

X grander

Evaluate Saturation and Contrast

Go through your pictures and evaluate the saturation, which is the intensity of color, and the contrast, which is the difference between light and dark tones. Evaluate whether the colors are too intense or unnaturally vibrant, or make sure they are not too dull and washed out. To get the most accurate color, make sure to calibrate your monitor frequently.

Do Not Worry About Sharpness

When you look at some digital pictures on a computer monitor, they may seem *soft*, not as crisp as film prints. Although you can adjust sharpening settings on most cameras, resist the urge. You can sharpen images as the last step in editing. You sharpen images based on the final image size and whether you want to print the picture or use it on the Web.

Fine-Tune Camera Settings

Most digital cameras today produce excellent exposures with good color accuracy. In some cases, fine-tuning your camera settings helps you get better photos without the need to make corrections on your computer.

Make a List of Settings to Fine-Tune

Your first foray into using the digital camera provides an overview of the camera's capabilities in normal shooting situations, using the default settings. Now you know which settings to adjust and which ones to leave as they are. Make a list of the settings you want to adjust, and begin by making small adjustments. Then evaluate the results. Modern cameras typically produce good results, and so you may not need to make any settings adjustments at all.

Why Fine-Tune Your Camera Settings?

Each situation that you come across in your photography is different, and when taking different sorts of photos you will want different feels and looks for these situations. A landscape photo might need some additional saturation and contrast, whereas that same saturation setting on a portrait might tend to produce ruddy, unnatural skin tones. Fine-tuning your camera helps make things go more quickly and smoothly when you start editing your images on the computer.

Fine-Tune the Flash

If flash pictures are overexposed or too light, and the cause is not a finger obstructing the flash sensor, you can adjust the flash intensity by lowering the power with flash exposure compensation. If you do not have a flash adjustment option, you can set a minus exposure value (EV) when you take a flash picture. You can experiment to see which setting produces the best flash photo.

Example 1997

Fine-Tune the Exposure

Scenes with large expanses of very dark or very light areas can fool the camera meter so that pictures are overexposed and underexposed, respectively. You can set exposure compensation, or a plus or minus exposure value (EV), to get a picture with normal tonal values. Sometimes you may even want to use the exposure compensation to more creatively affect your images' exposure in the automatic setting.

Fine-Tune Color, Saturation, and Contrast

Newer digital cameras offer options to increase color, saturation, and contrast. Never adjust settings based solely on the LCD screen on your camera, which, even as they increase in size, is still too small to accurately show all the characteristics. Instead, evaluate a large sampling of representative pictures on a computer and as prints. If the color, saturation, or contrast is not what you want in your photographs, then adjust in small increments until you get the pictures you do want.

CHAPTER

Taking Advantage of Your Camera's Settings

Today's digital cameras are better than ever at helping you to take superior photos easily. With just a twist of a dial or quick run through the menu, your camera can automatically adjust your camera's exposure settings to help you get the photos that you envisioned.

Match the Scene to the Setting	100
Be Aware of In-Camera Settings	101
How Do the Scene Settings Change the Images?	102
Use the Settings Creatively	104
Evaluate Your Photos	106
Better to Change Things Later?	107

Match the Scene to the Setting

To help in creating the best photos possible, digital camera manufacturers offer what are commonly called *scene settings*. These aid you in learning about photography and how your camera works as well as help you create better photographs than the standard automatic settings would give you.

When to Use Scene Settings

Many digital cameras have a series of "scene settings" which automatically change the settings of your digital camera in accordance with the scene in front of your camera. These settings help to take some of the guesswork out of your picture-taking when the scene or the lighting might be somewhat unusual or difficult.

Match the Scenes

Because more than one combination of exposure settings can get the same exposure, the scene settings help you to get the best one mostly by optimizing your shutter, aperture, and ISO. Some cameras' scene settings even affect focus, flash, white balance, and color settings.

Visualize the Scene

These settings should be easy to recognize when you are taking photos, with most of them having the basics: portrait, landscape, sports, and macro. Many digital cameras now have 10 to 20 different scene settings, such as kids, nighttime flash, fireworks, pets, underwater, sunset, party, snow, and beach. Simply set your camera to the scene setting that corresponds to the scene you are shooting, and let the camera do the rest automatically.

Be Aware of In-Camera Settings

Taking Advantage of Your Camera's Settings

Sometimes the settings you make in your camera can be detrimental to your photographs — for example, the more you raise the sharpness level, the more noise you introduce into the image.

Real or Unreal

Any time that you make big changes to the settings in your camera, the effects may become exaggerated. This may lead to extreme contrast and colors that could look artificial. This might be okay at times, but be careful especially with people pictures — skin tones can quickly look unflattering when effects are overdone.

Be Realistic

Because the LCD monitor on your camera is small, you do not always get an accurate idea of exactly what the photo will look like when you make a print. If you are trying to get the most realistic-looking image, it may be better to set your camera to its most neutral settings and then make changes on the computer.

Happy Accidents

Sometimes you take a photo at some random setting — too dark, too light, too much blur, wrong color setting — and it ends up being great. Do not just delete an image because the camera was not set

right; wait until you get home and really check things out before you decide that it needs to be deleted. It might be a technically perfect photo, but it might be something that moves you nonetheless, such as this image which was shot 2 stops underexposed.

Have Fun!

With all the settings you have, and all the rules of exposure and focus and testing to make sure everything looks the way you want it, just make sure that you are having fun with your photos. All these

different automatic settings are there to help take some of the guesswork out of things so that you can just take great photos.

How Do the Scene Settings Change the Images?

Your automatic scene settings make visible changes to the photos. You can maximize these scene settings by matching the icon or name of the setting with the photograph that you want to take.

Change the Exposure

Using the different apertures and shutters changes the look of your photos even when the exposure is the same. So if you are taking photos of your kids playing sports and are using the Sports scene setting, the camera tries to get the fastest shutter speed it can to make sure that it stops the action of the event. For some of the other scene settings, such as the Landscape setting, the aperture is adjusted for maximum depth of field, whereas the Portrait setting uses the aperture to minimize the depth of field.

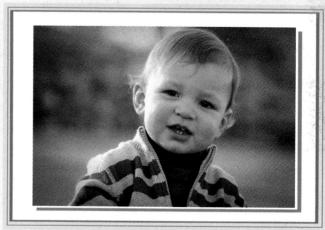

Make Bigger Changes

When you change the different scene settings, your camera also changes the type of focus, white balance, and color settings. For example, a "party" setting might set the camera's focus setting to face priority where the camera automatically focuses on the faces in your scene. A "sunset" setting may use a warmer white balance along with a more vivid color style to accentuate the color in the scene you are going to photograph.

Are They Always Right?

Matching the scene to the setting might not be foolproof, but the technology built into today's digital cameras gets you excellent results in most situations. Try different scene settings when shooting different situations, and if the photo that you are taking is a once-in-a-lifetime situation, make sure the setting and scene match and the photo is the way you want it before you put the camera away.

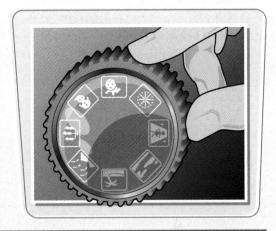

Take Time to Prepare

Spend some time with your camera's manual to learn what all the different settings are and how they affect your photos. Learning what these settings do and do not do might save time, and you might even realize that the scene settings do even more than you thought. Even when you know what you are doing, the scene settings can be great timesavers.

Use the Scene Settings to Learn

After you take your photos using the scene settings, take some time to look at your photos on your computer and check out the EXIF data. Even though these are all fully automatic settings, the exposure information is still there for you to see what the camera thinks makes the best photo out of the scene settings. Compare the information between different photos and different settings to learn how to create the looks you are looking for.

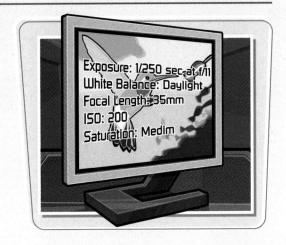

Use the Settings Creatively

Digital cameras also offer additional settings that allow you to make even more interesting images. Use these settings to alter color and contrast to build interest and excitement in your photos.

Use the Presets Creatively

Taking photos in a scenario where you can use one of the presets gives you the freedom to just take photos and compose creatively and not have to worry about the camera settings. Not only do the scene settings allow you to create better photos in certain situations than the standard auto settings, but once you learn what the settings can do, you can try those settings in different situations to see if you like the effects on your photos.

Try Different Color Settings

Most digital cameras have several different creative color options. These are usually accessed through the menu, and can be anything from adding a fun colorcast to the entire photo, to replacing certain colors for others, creating an abstract look, or even making your images look like old or antique photographs.

Taking Advantage of Your Camera's Settings

Digital Film Settings

Many film stocks have their own unique color characteristics. Your digital camera may be able to emulate some of those looks. If your camera has a setting for "positive," it gives your photos the punchy color and contrast of slide film. Other settings might give the soft contrast of the negative film that wedding and portrait photographers might use.

Black and White

Black and white is still a favorite look for many photographers. Creating your images in B&W can often simplify a scene, add a contemporary or nostalgic look, or add a mood that simply would not be available in a color image. B&W allows you to

focus on just the essentials of your photography, yet often creates images that are beyond your hopes. Many digital cameras even have multiple B&W settings, each having different levels of contrast.

Saving Your Favorites

You may spend time going through all of the many options, mixing color, contrast, focus areas, and exposure settings to get exactly what you want for your photography. Many digital cameras have ways to save those settings so that you can easily access them whenever you want. These are usually designated with a name like "Custom" or "My Settings."

Spend Time with a Good Book

Once you have gotten comfortable with your camera, it is probably time to revisit your camera's manual. What seemed like an overwhelming amount of information when you first got your camera probably is much more manageable now. Take some time to go back and see what you forgot or did not understand before. Your camera has so many options that you might have to jog your memory to spark some new creativity in your photo-taking.

Evaluate Your Photos

You have many great options to make sure that the photos you take are the photos you want. Take advantage of all these to get your photos exactly the way you want them.

Check the Image on the LCD

It might seem obvious, but make sure to take some time to check that the image you are shooting is how you want it. Is it composed and exposed the way you want it? Use the LCD zoom to confirm focus if you are unsure. Make sure to check before things change. If you are taking a lot of photos, do not feel like you need to check each one — get your settings right, take several images, and then make sure they are what you want; then either take more or move on to the next photo opportunity.

Download for Scrutiny

As good as today's LCD screens are, they do have limitations. To really scrutinize focus and exposure, you need to look at your images on your computer's monitor. Make sure that you are comfortable with all the settings and functions of your camera before you head out to photograph that once-in-a-lifetime event.

When to Delete

When you delete a photograph off the card while it is in the camera, it is gone forever. Do not delete in a hasty moment or when you are not paying attention and accidentally delete something you cannot reshoot. Deleting images that are obviously no good is fine, but make sure to evaluate them confidently.

Better to Change Things Later?

Taking Advantage of Your Camera's Settings

With all the options available to you with your digital photography, take some time to decide if making creative decisions with your camera or with your computer is better.

Camera or Computer

Just as there are many ways to make changes to your photos with the camera, there are even more ways to affect your photos with the power of your computer. You have more control and can do much more when you make changes with your computer, and those changes can be reversible. The changes that you make to photos in your camera are permanent and limited.

How Much Is Too Much

Many times the settings that you can apply to your photos in the camera can be heavy-handed and overdone. What looks good and cool on the back of the camera may look cartoonish on your monitor or a print. That might be okay, but make sure to try several different things if the photos are important.

Comparison Viewing

Take the time to make some photos with and without the camera's effects and compare them on your computer so you can see what you want and what you do not. Use the software on your camera to make changes to the straight photos and see if you like them better than what the computer does.

Best of Both Worlds

The RAW file has all the photo information, and that file has to be "processed" on your computer. By shooting RAW and JPEG photos with advanced digital compact cameras and dSLRs, you can take a JPEG file with any settings that you want, and still have an untouched RAW file as a blank slate, ready for your changes to be applied on the computer.

Avoiding Digital Photography Pitfalls

In this chapter, you learn how to recognize and avoid the most common problems in digital photography.

Avoid Taking Unfixable Pictures

With all the automatic features in today's digital cameras, you can still take digital pictures that have problems that no amount of computer image-editing can fix. You can learn the most common digital photography problems and how to avoid them.

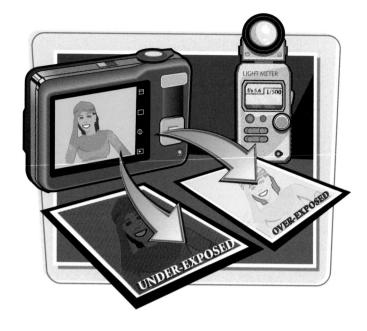

What Are Unfixable Photo Problems?

Unfixable digital photo problems include excessively overexposed or underexposed pictures, pictures with excessive digital noise — unwanted multicolored pixels throughout the image — and blurry, out-offocus pictures. Use the tips in this chapter to avoid taking unfixable pictures as well as to learn about other common digital photography problems.

Many people think that a lot of problems in photos can be solved in the computer with software such as Photoshop Elements. When problems are small, this may be the case, but trying to fix large problems usually ends up in photos that just do not look good.

What Is a Histogram?

Avoiding Digital Photography Pitfalls chapter 10

Your histogram is a graphic representation of the tones in your photo. You can tell if an image is properly exposed by looking at the distribution of light, medium, and dark tones shown on the image histogram on the camera or in an image-editing program. This graph can usually be seen when you are reviewing the images on the LCD screen, and some cameras even have it as part of the live view before you take the photo. The histogram is a tool; it only tells you how the image is exposed. You do not change the histogram because you might change your exposure, which would affect the histogram.

Not all digital cameras offer a histogram feature. Refer to your manual for details.

What a Histogram Shows

A histogram shows the distribution of tones, or the *contrast*, in an image. Brightness from black (on the left) to white, appears on the horizontal axis. The vertical axis shows the number, or weight, of pixels at each brightness level. In an average scene, a well-exposed image shows tonal distribution and weight distributed fairly evenly, like a flattened bell-shaped curve across the entire histogram.

How to Identify Problem Pictures

When examining a photo's histogram on the LCD of your camera, you are looking to see if the pixels drop off sharply at either end of the histogram. A steep drop-off is called *clipping*, and it indicates that some of the pixels in the image are either overexposed (right side) or underexposed (left side). When pixels are clipped, they are either pushed to pure white or black and lose all detail.

Use a Histogram as You Take Pictures

Even under the best conditions it may be difficult to evaluate a photo on the camera's LCD screen, but it is especially difficult under harsh sunlight. On digital cameras that display a histogram, you can judge whether or not a picture is properly exposed by checking the histogram immediately after you take the picture.

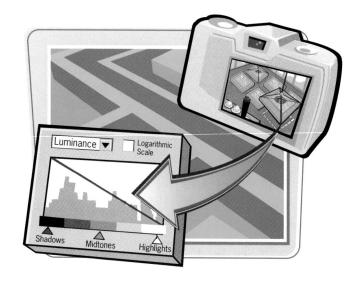

Turn On the Histogram Display

To see if your camera offers a histogram display, check the playback display options, or check the camera manual. Sometimes you may need to scroll through the image information menu to get to the histogram in playback mode. In some cameras you can even select histograms that show the red, green, and blue color distribution along with the exposure tones.

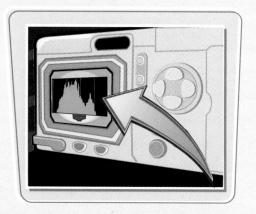

Use Overexposure Warning

Some cameras offer an LCD display mode that flashes the overexposed parts of the image. Some areas of an image, such as a bright, overcast sky or a white fence, can be overexposed without affecting the quality of the photo. If your camera offers a histogram display, areas of the photo that are too light appear bunched up on the right side of the display.

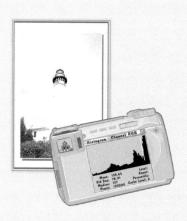

Avoiding Digital Photography Pitfalls

Does the Overexposure Warning Flash?

If the overexposure display flashes in certain areas, note the exposure settings shown. You can then move the subject to a less bright area, or choose an exposure compensation setting, such as –1.0 EV, that lets half as much light into the camera. Take the picture again and check the histogram.

Non-Average Scene Histograms

When scenes are predominately dark or light, the histogram reflects the predominate tones. For example, if you take a picture of a bright or backlit scene, the pixels fall on the right side of the histogram. In a darker situation, the pixels fall on the left side of the histogram.

High-Key Histograms

In high-key scenes, with mostly light tones, most of the brightness pixels fall to the right of the histogram, even with an accurate exposure, as shown here. Highkey photos are popular in advertising these days, but you need to ensure that areas in which the details are to be preserved are not so bright that the camera records no detail in the picture.

Low-Key Histograms

In *low-key* scenes, with mostly dark tones, most of the brightness pixels fall to the left of the histogram, even with an accurate exposure, as shown here. In low-key scenes, try to ensure that darker shadow areas retain detail by checking that the scene is not overexposed. You can also regain some shadow detail using the midtone adjustment in the Levels dialog box.

Compensate for Shutter Lag

Unlike film cameras that instantly take a picture when you press the shutter release button, many digital cameras delay before taking the picture. With each new model of digital camera, the amount of delay (shutter lag) gets smaller, and with most modern dSLRs, this lag is nearly imperceptible. The fact is almost all compact digital cameras have some degree of shutter lag. Regardless of how much shutter lag your camera has, you can learn how to work around the delay to avoid missing the action.

What Is Shutter Lag?

The delay between the time you press the shutter release button and the time when the camera takes the picture is called *shutter lag*. Shutter lag happens because of the time that it takes for things to happen, like charging the image sensor, focusing, or metering. Because of this delay, you can miss capturing the action, such as the moment a family member blows out candles on a birthday cake, or when a basketball player moves a ball down the court.

Avoid Missing Critical Moments

To work around shutter lag, you can anticipate the action. Focus on where the action will happen and press the shutter release button halfway down, wait for the action, and then take the picture. Pressing the shutter release halfway down to set the focus and meter cuts the lag time a lot. Making sure that the flash is charged, ready with the red eye mode Off, helps speed things up if you are taking flash photos. Also, if your camera has the capability, switch to burst mode to capture a rapid sequence of pictures with no shutter lag.

You can fix many problems in image-editing programs, but you cannot fix areas of the image where the camera records no details. You can learn how to avoid blowing out the highlight details.

What Are Blowouts?

When you take pictures in a scene with very bright and very dark areas, the brightness differences may exceed the camera's *dynamic range*, or its ability to record both very bright and very dark areas. As a result, very bright areas often lack detail and appear as solid white.

How to Avoid Blowouts

It is particularly important to avoid blowouts in the main subject area. One very problematic subject is a wedding dress on a bright, sunny day. To avoid blown highlights, switch to a semiautomatic or manual mode, and then select spot or center-weighted metering. The camera meter weighs exposure primarily for light falling on the subject instead of averaging the entire scene, ensuring accurate subject exposure, as shown here. If the dress is not properly metered, it blows out and the details of the dress are lost.

Pay Attention to Your Light

The best way to avoid having blown-out areas on your photos is to pay attention to your light. Any time you have hard sunlight and shadow, the contrast is too much to capture in a photograph. Taking a moment to evaluate what the light is doing in your photograph and turning or moving your subject into some open shade helps with blown-out areas on your subject.

Keep Your Camera Steady

Small, lightweight cameras invite a lot of everyday, impromptu snapshots. But the camera's light weight can also mean blurry pictures. You can learn how to get sharp pictures with small cameras.

What Is Camera Shake?

Newer pocket- and palm-size digital cameras make everyday snaps inviting and easy. Because of their low weight and holding the camera out away from you to see the LCD, avoiding camera shake — blur from hand movement during shooting — can be challenging, especially if the light level gets low. Whenever you have the zoom lens extended to telephoto, the camera is more susceptible to shake.

How to Avoid Camera Shake

In all but very bright scenes, you need to steady the camera by leaning against a solid surface such as a wall, or by setting the camera on a solid surface when taking the picture. Alternatively, you can buy a tabletop tripod that ensures sharp images. By keeping your camera close to your face and keeping your elbows tight to your body, you can create a more stable platform for your camera. When you press the shutter release, be sure you press it down firmly and smoothly; do not jab it down quickly.

Avoid Undesirable Colorcasts

Avoiding Digital Photography Pitfalls chapter 10

With digital cameras, you can easily avoid taking pictures that have an unwanted colorcast. Setting the camera to get accurate color also saves time when you edit images on the computer.

What Causes Undesirable Colorcasts?

Modern digital cameras produce accurate color in photos automatically without using additional settings. Colorcasts occur when you take pictures in one type of light, such as shade, but the camera either cannot determine the color temperature of the light source, or the camera is set to a type of light,

such as bright sun. In the photos shown here, one was shot with AWB in the shade, which gives it a cool, blue cast. The second photo was taken with the WB set to shade, giving it the correct tone. To produce accurate colors. the camera must be set for the light in the scene. See Chapter 4 for more information about light.

Set White Balance to Get Accurate Color

When shooting outdoors, you can usually use the automatic settings with confidence. However, you may want to experiment with different white balance, or WB, settings, to become familiar with the effect that each setting produces and to help you avoid taking pictures with unnatural colorcasts. To set the white balance, press the WB button and check the menu to find a setting that matches the scene light, such as daylight, fluorescent, flash, or tungsten (common household light). Be careful when you use manual settings: It is easy to forget that by selecting a white balance setting, you have turned off the automatic white balance.

Never Use Digital Zoom

Although all digital cameras often advertise amazing telephoto zoom capability, digital zoom produces a lower-quality picture than just using the lens's optical zoom.

How Digital Zoom Works

With digital zoom, the camera crops into the center of the image, getting rid of the edges, and then expands the center section to full-image size. Some cameras interpolate, or add pixels into the image, to bring the image to full-resolution size. Because interpolation guesses where to add pixels to the image, the results are never as good as using optical zoom.

How to Avoid Using Digital Zoom

On all digital cameras that have digital zoom, you can turn off digital zoom by selecting an option on the camera's menus. Most cameras with digital zoom include an LCD indicator or an audible signal to tell you when to move from optical to digital zoom. Use the indicators to avoid activating the digital zoom feature.

Reduce Digital Noise

Avoiding Digital Photography Pitfalls chapter 10

Digital noise is multicolor flecks or pixels in dark areas of a low-light picture or areas of solid color, such as a bright blue sky. The noise can make your digital images look like a grainy film image. You can reduce the chances of getting digital noise by following a few simple guidelines.

Recognize Digital Noise

When you take digital pictures in low-light scenes, or if the ISO is set to a higher number, you often see brighter, colored pixels scattered throughout the dark and shadow areas of the image. Although you may not see noise on the LCD without zooming in, you will see it on the computer at 100-percent or 200-percent magnification, and in larger prints, especially in large expanses of solid color.

How to Avoid Digital Noise

Both high ISO settings and long exposures contribute to digital noise. To prevent digital noise, select settings such as ISO 400 or lower. dSLR cameras have lower noise in the images than compact digitals. If you have to take photos of moving subjects under low-light conditions, you can turn on digital noise reduction, if it is available on your camera. Digital noise reduction does not eliminate the noise, but it does reduce it; however, it may produce a "smeary" look.

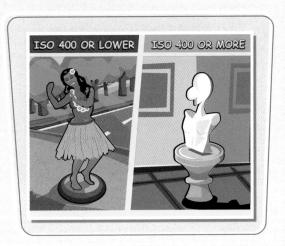

CHAPTER

Capturing Unique Photo Opportunities

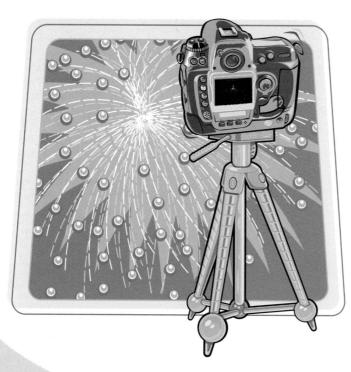

Some photographic situations are not ordinary and require extra effort to get a satisfactory result. Whether you are taking photographs of items to sell on eBay or for insurance purposes, capturing the grandeur of a fireworks display in the evening, or shooting and creating a panorama, you can use your digital camera to get the most out of each event.

Photograph Products to Sell on eBay

Millions of people sell products on eBay every day. While using an existing product photo is a timesaver, products that sell best are those that include photos of the actual items. Taking your own photo, you can more accurately show exactly what you are selling, and if there is an interesting detail or flaw, you can point that out in a detail shot. In this section you learn the basics about how to photograph your priceless objects to get the best price for them.

Keep It Simple

Do not take a photo of an object that has a cluttered background or a background the same color as the subject you are photographing. You want the eyes of the potential buyer to focus on the object that you want to sell and not to be lost in the background.

Fill the Screen

Fill the screen with the subject you want to sell. If the object you are photographing is small, hard to see, and potential buyers have a difficult time examining it, they will move on to similar objects for sale. Move in as close as possible and use the macro setting if necessary.

Capturing Unique Photo Opportunities

Use Props to Hold Objects Up

If the object is a book or something that typically lies flat, prop it up by putting it in a stand or by putting something behind it; this makes things look more dynamic. For flat items like books, magazines, or art, make sure that you are square to the item, so that the perspective is correct.

Using a tripod is very beneficial in this situation, and will help you to get your camera square to the subject. Additionally, with flat items, you can use tools such as the ALZO Horizontal Mount, which lets you position your camera so that it looks straight down at a subject on a table or floor.

Focus, Focus, Focus

The autofocus (AF) system of a digital camera typically has a difficult time focusing under low light or when the subject is really close. Make sure your photos are in focus by viewing them on your computer or using the zoom function on the LCD screen on the back of your camera. Use the macro setting when appropriate, and make sure there is enough light so you do not have to worry about camera shake or depth of field.

Look At Your Light

Take a few minutes to think about your lighting when shooting for eBay. You can place your subject near a window, outside in the shade, or in some other place that has plenty of light. Use a flash if necessary, and if you can, try bouncing the flash against a neutral wall or ceiling to get a softer light. Many eBay sellers invest a little in getting a small "light tent," which sheds even lighting on any subject.

Take Great Close-Up Photos

Close-up photography (called macro photography) opens up a whole new world of detail. Most digital cameras do not require any special equipment because they have a macro mode built in. This section covers some very simple and basic rules for taking macro photographs.

Switch the Camera to Macro Mode

Most digital cameras' macro mode is enabled by selecting the focus mode with a button or from a menu on the LCD screen. When the camera is in macro mode, it can focus on subjects that are as close as one inch from the camera lens.

Get Close to Your Subject

Often the subjects of macro photography are at or near ground level. The best way to create a great photo is to get down on the ground with the subject. This allows you to steady the camera with your elbows on something solid, such as the ground.

Capturing Unique Photo Opportunities

Use a Focus Light

When photographing natural subjects under low lighting conditions, the autofocus, or AF, system of the camera often has a difficult time finding the sharpest focus. Many digital cameras have AF assist lights built in, and shooting in macro is just the place to use this. Other times, the light on your subject may be what draws you to the subject, and some photographers even use a pocket flashlight in the field to help with focus.

Depth of Field

When a camera is in macro mode, depth of field (DOF) is greatly reduced. This means that something only a few inches behind the subject may be completely out of focus. Reducing the aperture (increasing the f-stop number) can help increase the amount of area in focus, but it will rarely be more than a few inches in macro mode. In most cases it produces a soft background that enhances the photo.

Take Photos at Night without a Flash

Taking photos at night without the use of flash can produce dramatic pictures; the camera changes the way areas of light and dark appear. The necessity to leave the shutter open for long periods of time to get a proper exposure produces streaks of lights as moving cars go past the camera lens. The light produced by high-pressure street lamps changes the colors of ordinary scenes into something surreal. A tripod might be helpful in this sort of photography, or making sure that you have set your camera to a high enough ISO.

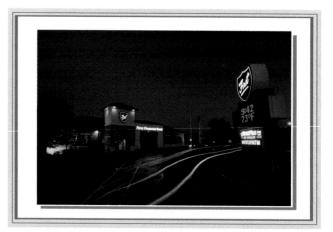

Use Night Mode

If your camera has a night mode setting, you should use it. Usually selected through a dial setting, the night mode usually increases the ISO (sensitivity) settings of the camera to a high level. This higher setting allows you to take photos without a flash, but it also increases the amount of noise in the photo.

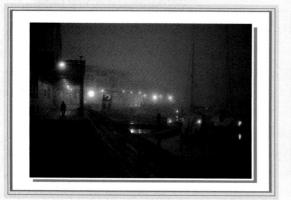

Keep Your Camera Steady

If your subject is stationary, you can take a photo under low-lighting conditions by stabilizing your camera. In most cases this means using a tripod, but a camera placed on a bean bag or something solid works just as well. The only problem with this approach is if the subject moves — your steady camera is of no use then.

Capture Firework Displays

Capturing Unique Photo Opportunities

Firework displays dazzle viewers but can be a real challenge for the digital photographer to capture. Although the lights in the sky are beautiful to the human eye, they are dim to the digital camera and confuse many of the mechanisms in the camera such as autofocus and light metering. Some digital cameras actually have a fireworks shooting mode, but most do not. Here are some basic things to know about photographing fireworks.

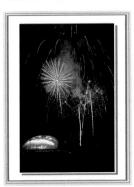

Capture Firework Displays

Set Up Your Camera

- Set up your camera on a tripod.
- Turn off your camera's flash.
- 3 Set the focus mode to landscape.

Note: This turns off the automatic focus, or AF, and sets the focus to infinity.

4 Set the shutter speed to bulb.

Note: If your camera does not have a bulb setting, use a 1-second setting.

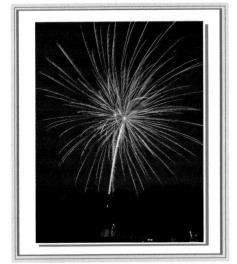

Capture a Burst of Fireworks

- 6 Aim the camera at the area you expect the fireworks to explode.
- **6** Wait until you hear the sound of a firework being launched (a dull thump).
- If you use bulb setting, push your shutter release button down, and hold it.

Note: If your camera has a remote shutter control, you can use it to prevent any jiggling caused by the pressure from your finger on the shutter release button.

8 When the burst has completely finished, release the shutter.

Note: For cameras without a bulb setting, press the shutter release button after the explosion has started.

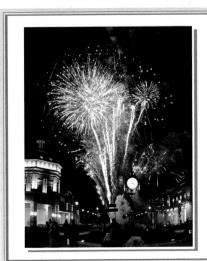

CHAPTER

12

Organizing Your Photos

One of the many benefits of owning and using a digital camera is the ability to take an almost unlimited number of photos without incurring additional costs, such as film and processing fees. You can take and download so many photos to your computer that sorting and organizing them is often challenging. In this chapter, we discover how to start organizing your images so that it is quick and easy to view and find a particular photo.

Why Use Image Editing Programs?130
What Is a Digital Editing Workflow?132
Photo Editing Options134
Understanding Metadata in Your Photos136
What Are RAW Digital Photos?137
Import Photos to Your Browser138
Review, Sort, and Tag Your Photos140
Tag Photos142
Find Images Using Tags146
Use Tags to Sort148

Why Use Image Editing Programs?

Image editing programs allow you to view and modify photographic images. You are able to open your digital photos, as well as crop, color-correct, and enhance them. With some image editing applications, you can even create special effects, modify elements of the image, add text, and convert images to different formats for various uses.

Image Editing Programs

You can choose from a variety of image editing programs. In fact, many digital cameras and photo printers include a simple image editing program. Such bundled programs are usually more limited in scope than those that are purchased separately. Most new home computers also have powerful image software built in that may allow you to do all the photo editing you need. These are easy to use and intuitive to learn and work with in conjunction with other programs on your computer.

Photoshop elements

Use a Complete Image Editing Program

For a more advanced user, Photoshop Elements is considered a standalone image editing program. Based on the most widely used professional image editor — Photoshop — Photoshop Elements is very powerful and versatile, and therefore one of the most popular programs available. Photoshop Elements not only allows you to download images to your computer, correct photo problems, and apply special effects; it also includes a photo organizer that simplifies the task of viewing and organizing your digital images.

Change Ordinary Photos into Digital Creations

Using your image editing software you can make extensive changes to your photographs, adding or subtracting color or even subject matter. You may be able to add text to a picture and turn any photo into a greeting card. You can use your favorite photos to create a personalized calendar or create a slide show from any group of photos and save it with music and transitions.

Greentzed

Why Use an Organizing System for Digital Photos?

When you start taking photos with a digital camera, the number of photos you take will increase dramatically. It is not unusual to take more than 100 photos at a birthday party or other event. With so many photos, you need a way to sort, group, and save them in specific locations on your hard drive or external media to keep things from getting lost and forgotten.

Stay Organized

You can import photos from your camera or memory card directly into your image editor's photo browser and categorize or tag them for easy reference. You can then use this photo browser to find and view specific photos while keeping them easily accessible and smartly organized.

What Is a Digital Editing Workflow?

A digital editing workflow is a sequence of steps for importing, organizing, editing, and sharing your digital images. Following a workflow that fits your particular needs ensures that all your photos are imported, reviewed, organized, corrected, or enhanced, and prepared for sharing in a simple, straightforward manner. Setting up your workflow early helps to make sure that your images are easy to locate and work with now and in the future, saving yourself time and frustration.

Import and Organize Your Photos

The first steps of the digital workflow include moving the photos from your camera or another folder to your computer, reviewing the photos, assigning tags and keywords that can be used to identify them, and grouping them into collections — which are similar to traditional photo albums with photos grouped by themes.

The Editing Process

Evaluating your photos to find the best ones is very important. Use your photo browser to select your favorite photos with flags, or rate them with stars. This also gives you a chance to delete unusable images from your hard drive and to focus on your best photos.

Tuning Up Your Photos

The next steps include making changes to the photos to correct image rotation, removing defects such as red eye, and making adjustments to color and lighting. At this stage you can also make other enhancements such as removing objects or people from a picture, creating a composite of several pictures, and adding text or special effects.

Photos Daddy-O!

Make Digital Photo Creations

Optionally, you can use any photo to create special greeting cards or postcards, design photo calendars, and put together slide shows and photo albums. Many people create standard prints of these images for things like scrapbooks and traditional photo albums.

Output Photos for Print, CD, DVD, the Web, and E-mail

The final steps of the digital workflow is to print your images or creations or share them by burning a CD or DVD, making a Web photo gallery, or sending photos as e-mail attachments.

Photo Editing Options

There are many photo editing options, from the software that comes with your camera to expensive professional software. Some easyto-use, easy-to-learn, and still powerful software is probably already located on your computer.

As you begin to go farther in your photography, the software that comes with your camera and the software built into your computer may not be powerful enough to harness your creative vision. Several software developers have come up with very powerful image editing software. Do some research before you spend your money on these, and make sure they do what you want and they work intuitively for you. Most of these allow for a free trial period so you can try them and see how they work for you.

Basic Photo Editing Options

Windows Live Photo Gallery

If you are using a PC with the Windows operating system, you can begin using Windows Live Photo Gallery, which is part of the free Windows Live downloadable software suite. Windows Live Photo Gallery is a photo browser which also allows you to go through and look at your photos, select and edit, and help output your images easily on your PC.

iPhoto

For Mac users, you can take advantage of iPhoto, which is part of the iLife software suite. iPhoto gives you the ability to review, organize, edit, share, and output your images. iPhoto is also designed to be integrated with your Mac and all of the iLife applications such as iMovie, Mail, and so on. iPhoto helps you easily work with your photos in any Mac application.

Advanced Photo Editing Options

Photoshop Elements

Photoshop Elements is the most popular computer image editing program available, and because it is based on the most widely used professional image editor — Photoshop — Photoshop Elements is also a powerful and versatile program. Photoshop Elements not only allows you to download images to your computer, correct photo problems, and apply special effects; it also includes a photo organizer that simplifies the task of viewing and organizing your digital images. Photoshop Elements can be purchased for either Windows or Mac.

Photoshop Lightroom

Photoshop Lightroom is also based on, and can integrate with, Photoshop, but it is a more powerful image catalog system, browser, and RAW converter. Photoshop Lightroom uses a system of *sidecar* files to make changes to your photos without actually affecting the image files until you output your photos. The catalog system with Photoshop Lightroom is also excellent, allowing both easy access to your folders and the ability to make collections of favorites and events. Photoshop Lightroom is available for both Windows and Mac.

Photo Mechanic

Photo Mechanic is a very powerful photo browser that can be used on both Windows and Mac. It allows for very fast scrolling through images at high resolution. Photo Mechanic is an excellent program for those dealing with batch changes to EXIF data and image resolution. Photo Mechanic is the image editing software choice for photojournalists.

ACDSee

ACDSee is a bundle of image processing software that can be purchased together or separately. It has options that allow for creative framing and card making, help with high quality printing, and image organizing. ACDSee Pro offers many of these options as well as professional-level color and contrast controls and pixel-level editing. ACDSee is available for computers using Windows.

Corel Paint Shop Pro

Ease of use is the hallmark of Paint Shop Pro. This image editing program adds features that allow for 1-click solutions to correct many of your photos' problems, such as red eye, sharpness, and contrast. Paint Shop Pro also lets you add special effects and print and share your photos using its easy-to-learn interface. Paint Shop Pro is available for computers using Windows.

Understanding Metadata in Your Photos

One of the unique features of photos taken with digital cameras is that a lot of information about the camera and its settings is stored with each image. When you release the shutter, a digital camera records more than just the scene you captured. The camera attaches descriptive data known as *metadata* to each image file on the digital media card. Many different types of data can be attached to an image. Some cameras even provide a Global Positioning System (GPS) receiver connection, thereby precisely pinpointing the location where the photograph was taken.

What Is EXIF?

EXIF stands for Exchangeable Image File Format. It is the most commonly used metadata. It was developed to standardize the exchange of data between imaging devices such as a camera and software. EXIF is the information that the camera stores with each photo and includes the date and time, the make and model of the camera, the white balance settings, whether the flash was used, and other details about the image capture.

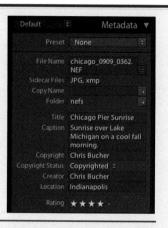

chicagoBDay_0909_A-312.jpg Camera Data 1 Make: NIKON CORPORATION Model: NIKON D90 Date Time: 2009-09-19T19:56:22.00-04:00 Shutter Speed: 1/400 sec Exposure Program: Aperture priority F-Stop: f/4.5 Aperture Value: f/4.5 Max Aperture Value: f/4.4

How You Can See the Metadata

Photographers and photo students used to have to write down all their exposure information in a log to remember what they did later when they looked at the developed photos. Now you have all that information at your fingertips as you are learning what effect changing your camera has on your photos — and the camera saves the information automatically.

Personalize Metadata

You can add your own information to the file's metadata to help identify and organize your images. When you add titles, tags, and descriptions in your photo editing software, it stores that data with the photo file. In fact, when you edit photos in Photoshop Elements, the edit history is also added to the metadata.

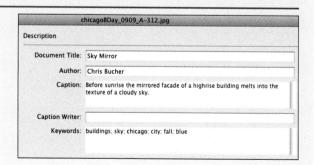

dSLRs and most high-end compact digital cameras can save photos in a format called *RAW*. The term RAW is not an acronym. It means that the image data coming off the camera sensor is not processed or compressed before being saved to the memory card. Although RAW format files are larger than JPEG files, they give the photographer more control over exposure, color, and tonal correction of the photo when it is processed on the computer.

Processing RAW Format Digital Photos

Before you can use a RAW format file on your computer, you must first convert it into a standard graphics format. There are several ways to process RAW digital photos in your computer. You can use conversion software provided by the camera manufacturer, a third-party conversion program, or the RAW file conversion software now included in many popular image editors. Regardless of the process you choose, the end result is an image in a format that can be used with your image editor, such as a JPEG or TIFF.

RANK PART OF THE P

Advantages of RAW Format

When you take a photo using a JPEG format, the image sensor data is processed using the camera's current white balance, exposure, contrast, and saturation settings and these settings cannot be changed. When an image is saved as a RAW file, the actual data produced by the photo sensor is stored on the memory card. As the photographer, you can then visually control the color and tonal corrections as you process the image on the computer. This allows you to maximize your control of virtually every aspect of the image, not to mention get the best possible image quality because you are working with the original image file with the most information.

Import Photos to Your Browser

When you bring photos or any other media files into your photo browser or image editor, you have the opportunity to rename your images; add keywords, events, and dates; and create or build your catalog. Each photo editor does this slightly differently; here are some basics for both Mac and Windows.

Import Photos into iPhoto

If you already have photos on your computer, it is easy to just drag the folder of photos onto the iPhoto icon in the dock. The photos are automatically imported and sorted by date, and are then called *events*.

Import Photos from a Camera or Card to iPhoto

When you plug your camera or memory card into your Mac, the photos automatically upload into iPhoto. This is a nearly seamless operation, and by default, iPhoto opens when you first plug in the disc or camera. As above, the photos are sorted initially by date.

Import Photos from a Camera or Card to Windows Live Photo Gallery

 Connect your card or camera to the computer by plugging it into the USB slot.

The Import Pictures and Videos dialog box opens.

- 2 Type a word, phrase, or event that describes the photos.
- Click Import.
- Leave the Erase After Opening box unchecked.

Note: Remember to format the card in the camera after you are certain you have saved all images.

The Windows Live Photo Gallery opens and displays your photos.

How do I view newly imported photos?

When you are ready to go back to look at the photos, remember that Windows stores the imported digital photos in the Pictures library. Windows Live creates a new subfolder, which is named with the date of the import and whatever word, phrase, or event that you typed into the Tags box before importing. So if you downloaded the photos on November 29, 2010 and you typed **Colorado** in the Tags box, the subfolder will be named 2010-11-29 Colorado.

Review, Sort, and Tag Your Photos

After the photos are in your computer and have been added to the catalog, the next step is to carefully review them, compare similar images, and decide which ones should be kept and which should not. Why not keep all of them? Photos take up space on your hard drive, so keeping photos that you do not need wastes your time — when looking through the catalog — and occupies space on your hard drive.

Review and Tag Your Images

With all the new technology available to us we are now able to access our images and the people in them like never before. In both Windows and Mac, you can "tag" your photos, assigning them keywords, descriptions, and people's names so that they may be found, and so that they may be grouped together. These new technologies also allow you to use facial recognition software so that you can easily find photos of family and friends among the many photos stored on your computer.

Rate Your Images

Many photo browsing software programs have ways to rate your photos, usually by giving the photo a star rating. Rating your photos is a great way to help refine your editing choices. Giving your favorite two or three photos from a shoot five stars lets you know that those are probably ones that might go on the wall, four-star photos might go in the photo album, three-star photos might go into the long form slide show, and, well, you get the picture.

Flag in iPhoto

Besides using star ratings, iPhoto also uses flags to denote favorite photos.

In the large view of a photo, simply click on the flag to mark that photo as flagged. In the browser view, a small flag () appears at the upper left corner of the photo. The flag is easily seen, but unobtrusive, so that you can find your favorite photos quickly.

Arrange

How the photos get arranged on your screen is entirely up to you. Some people set their photo browser to show images via date or name, whereas others are constantly changing their viewing options. Typically you can arrange by Date, Name, Filename, Rating, Type, Flag, or Tag, and generally you can set them to ascending or descending order, depending on what you are looking for.

Reviewing in Windows

In Windows Live Photo Gallery, you can quickly scroll through your photos to see which photos you like or dislike. Positioning your cursor over the image (), but without clicking, creates a larger thumbnail, which allows you to make sure the photo is in focus without leaving the browser.

Tag Photos

Tagging your photos is a quick and easy way to find and recognize the people in your photos. This is the digital equivalent of writing the names of the people in the photo onto the back of photo prints. It is fast and easy and fun!

Clicking the photo takes you to a larger version of the photo. Click Info for the Tags Window to pop out.

Tag Photos

Tag Photos in Windows Live Photo Gallery

Click Tag someone.

- 2 Click that person so that his or her face is highlighted.
- 3 Type that person's name.

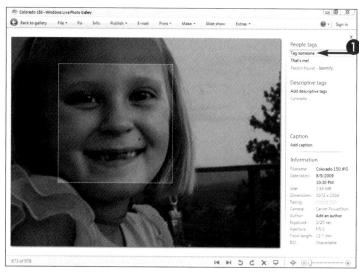

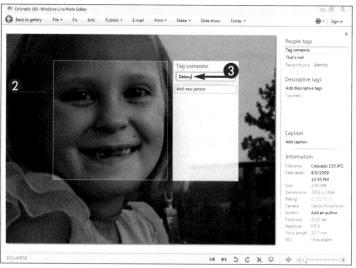

Organizing Your Photos

- Click Descriptive tags.
- Type any words, names, or descriptions of the photo that would help you remember them or group the photo with others.

- **6** Click **Caption**.
- **7** Type a caption of what is going on in the photograph.
- 8 Click a star rating for the photo for reference and grouping later.

TP

What if I want to tag something else besides a person?

In some cases you may want to tag a building, mountain, tree, or other inanimate object so that you can find it in a search later. Go ahead and click the **Tag Someone** button and then just use the cross-hair tool to tag your object and then name it as needed. You now have a tag for that object, but obviously any facial recognition will not work on a building or tree.

Tag Photos (continued)

In iPhoto, you can tag photos using the Faces tool, which is essentially the same as in Windows, but the interface is slightly different. iPhoto can locate people using built-in facial recognition type software, so tagging someone helps you find all the people with that face.

Tag Photos (continued)

Tag Photos in iPhoto

- Click once on a photo of a face to select it.
- 2 Click the Name button (1).

- Click **unnamed** in the text box.
- 4 Type the name of the person.

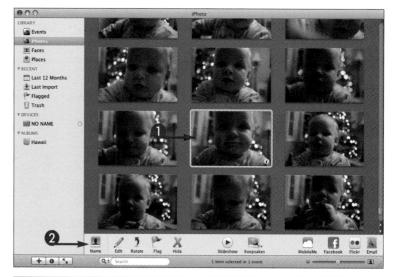

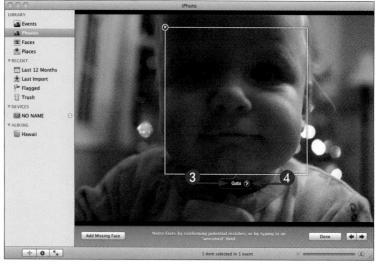

- 6 Click the arrow next to the name.
- 6 If a face is unrecognized, click **Add Missing Face** to put a selection box on the face.

iPhoto searches for other faces that might be the same as the one you just named.

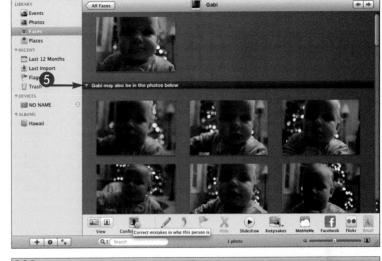

Click each face to confirm that this is the right name for the face.

You can ignore any faces that do not match the name.

8 Click **Done** to finish tagging that face.

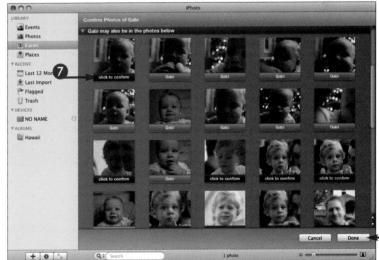

TP

What if iPhoto does not recognize a particular face in one of my photos?

000

iPhoto may not have scanned through the photos yet for the face that you are looking for, or there may be some obscuring of the face which would make it unrecognizable to Faces. You can easily click the **Add Missing**Face button to make the positioning box appear so you can continue with the Faces process.

8

Find Images Using Tags

As you begin to scroll through your photos, the facial recognition software in your computer starts to pick up faces in your photos. With every new face that you tag, it becomes easier to identify the person and then just put that name with the photo.

Finding the photos of the people you are looking for is very easy, especially after you have begun the process and tagged people right from the start.

Find Images Using Tags

Using Tags to Find Images in Windows Live Photo Gallery

- Click Identify.
- Click the tagging square on that person's face.

The Tag Someone menu opens.

- 3 Click the name of someone on the list if you have already put his or her name in.
- If it is a new face, type the name and then click Add new person.
- 4 Click the Arrange by drop-down menu and click person.
- All the people that you have tagged are shown under a headline with their name.

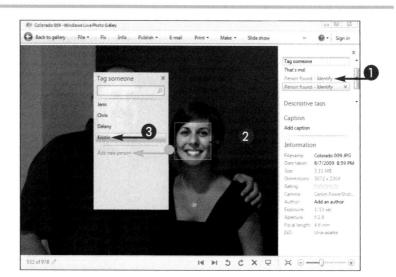

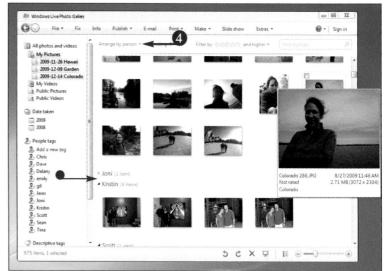

Using Faces to Find Images in iPhoto

Click Faces.

Find the person that you are looking for on the corkboard.

Click a face to get to the photos of that person.

TP

Are there other ways to add information in the Tags field?

You can enlarge the Details pane with a right-click on an empty section of the pane; click **Size** and then **Large**. At that point you can see many fields where you can add or edit data for each photo, such as Title, Subject, Rating, Comments, and Authors.

Use Tags to Sort

After you have done any tagging and starring of your photos, sorting through and arranging your favorite photos in any particular folder is easy. This keeps your favorite photos right at the top, or allows you to find what you are looking for easily.

If you are looking for someone, but there are still too many photos of that person, use your tags and sorting tools to find your dates.

Use Tags to Sort

Use Tags to Sort in Windows Live Photo Gallery

- Click a person's name.
- Click the Arrange by drop-down menu and click date.
- This opens all the photos of the person you selected arranged by month.

- 3 Click the triangle next to each month to collapse unused months.
- Position your mouse over the photo that you think you are looking for to make a larger thumbnail.

Use Tags to Sort in iPhoto

- Click Events.
- iPhoto initially sorts your photos by the date they were uploaded. Click the date below the photo.
- Rename that event to a more descriptive title.

- Click your event.
- You can see the date and how many photos are in the event.
- Position your mouse over the Key photo for that event.
- By simply dragging your mouse over that Key photo you can quickly see all the images in that event's album.
- You can choose another photo as vour Key photo. Click and drag vour mouse on the event. When you see the photo that you want for that event, Control +click it and click Make Key Photo from the menu that appears.

This all seems like so much sorting and tagging and starring. Why should I do this?

It really does not take long before you will have many, many photos on your computer - and hence many folders. Taking a few minutes when you import your images will save you countless hours when you are looking for things later. The more you do now, the easier it will be in the future.

By going to Places, iPhoto allows you to use a GPS-enabled camera to locate where you have taken photos. Places is a very easy, menu-driven way to log all your travels and sort your photos by location.

CHAPTER 5

Enhance Your Photos with Basic Photo Editing

Now that you have selected your favorite photos, you can start making them look better. You can improve the color and contrast, crop to fit a frame, and start adding digital photo effects to your images. This chapter introduces the basics of digital photo editing.

Learn About Local and Global Changes152
Zoom In with the Zoom Tool154
Rotate an Image156
Straighten an Image160
Crop an Image164
Adjust the Exposure166
Adjust the Color Temperature170
Adjust the Tint174
Adjust the Saturation178
Adjust Noise and Sharpness182
Remove Red Eye186
Retouch Spots on Your Photos190
Retouch Spots on Your Subjects192
Apply Photo Effects194
Use the Auto Enhance Button198

Learn about Global and Local Changes

When you are making changes to your photos, you are changing what the pixels in your photos look like. Each of those tiny pixels helps to create the photograph. Sometimes you want to make changes to the whole photo, affecting all the pixels at once, whereas other situations lend themselves to just changing a few pixels in a small part of the photograph.

What Are Global Changes?

When you change your entire photograph all at once, you are making global changes to it. Changes to color, contrast, and exposure are all global changes. Global changes can be small or large adjustments, but are done over the entire photograph.

What Do Global Changes Do?

As you make global changes, each and every pixel in your photo is affected. So if you are using an exposure or brightness tool to make your photo darker, you make everything in your photo darker — all the pixels get darker.

What Are Local Changes?

When you change smaller selected parts of your image, you are making local changes. Local changes can be broad strokes such as lightening a foreground when the scene is backlit, or can be as tiny as changing one or two individual pixels.

at of titles or

Why Use Local Changes?

Often the changes that you will want to make to your photos involve only part of the images, things like getting rid of red eye or a dust spot on your sensor, or even adding or subtracting whole people from the photo. Local changes are often considered retouching because they can include fixing blemishes or cleaning up distracting elements from the photo.

Why Are These Changes Different?

Getting all your adjustments right, so that the photo is exactly the way you want it — all those global changes are the first steps in the image-editing process. Zoom the image out to see the whole photograph to make sure that it all looks great. Then you use the local changes to retouch and fine-tune the individual pixels on your photo to create your final image. In most image-editing programs, the different tools are arranged in that order, with global tools at the left or top, and more local tools over to the right or down to the bottom.

Zoom In with the Zoom Tool

When editing images, you can zoom in on certain areas to see them better and then zoom back out to view the whole image. You can change views quickly and efficiently using the Zoom tool along with certain keyboard keys and other available options.

It is easy to enlarge or reduce the size of photos, whether you want to see just small details or you want to examine your photographs more closely for retouching or for cropping small areas of the image.

Zoom In with the Zoom Tool

Using Zoom in iPhoto

- Click Photos.
- Click the photo that you want to view.
- **③** Click the **Edit** button (**≥**).

The photo opens in edit view.

Orag the zoom slider to the right to zoom into the center of the image.

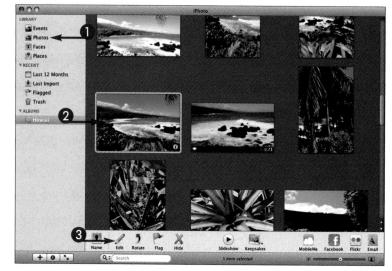

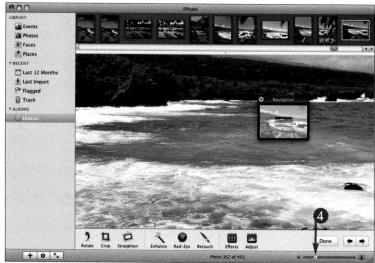

Using Zoom in Windows Live Photo Gallery

- Click My Pictures.
- Double-click the photo that you want to view.

The Windows Live Photo Gallery opens and your photo is displayed here.

hand corner to zoom in on the image. Move the slider to the right to magnify the photograph, and to the left to return it to full image view.

> When you have zoomed in on the image, \ changes to ₹7. You can use ny to move the image around in the Windows Live Photo Gallery.

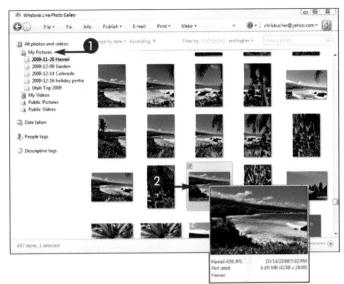

Can I zoom in without using the zoom slider tool?

In iPhoto, pressing zooms you into the photo 100%, and pressing zooms into the photo 200% from the mouse pointer's current location. If the mouse pointer is off the image, pressing those keys zooms into the center of the image.

Can I zoom in to see detail in any of the viewing options?

In most photo browsing and editing software, every different module and viewing option almost always has a zoom function. Look for the slider on the bottom tool area in Windows Live and iPhoto even in the book template. When you are using a tool in Photoshop Elements, you can press the spacebar to use the cursor as a zoom tool.

Rotate an Image

When you are going through your photos, sometimes you may find that you have an image that has a horizontal orientation when you shot it as a vertical, or vice versa. Even despite their technological advances, today's cameras still cannot always determine this automatically, especially when the photos are shot looking straight up or down.

Rotate an Image

Rotate an Image in iPhoto

- 1 Click the photo or photos you want to rotate.
 - You can select multiple photos by pressing and clicking the photos.
- elicking the
- ② Click the **Rotate** button (5).
- iPhoto rotates the photos 90 degrees counterclockwise.

If the photo needs to be rotated 90 degrees clockwise, you can click the **Rotate** button (5) twice more.

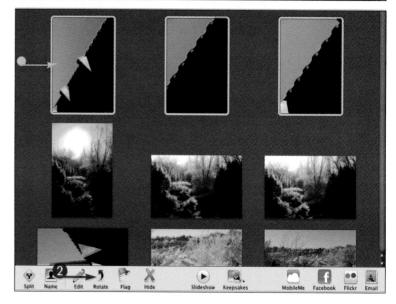

chapter 13

There are additional ways to rotate an image in iPhoto after you have selected your photo or photos.

- You can Control +click or rightclick the selected image to open the options menu. Select Rotate Clockwise or Rotate Counter Clockwise as needed.
- You can also select your photo and then click **Rotate** in the Edit menu.
- The photo is rotated 90 degrees counterclockwise.

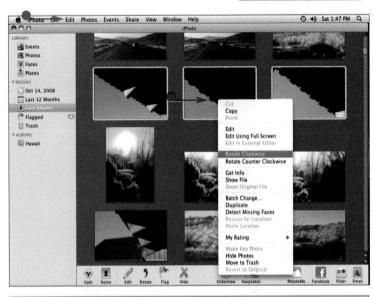

TIP

Do I always have to rotate an image counterclockwise?

Occasionally, the photo that you want to rotate would be best turned 90 degrees clockwise. You can press and hold Option on the keyboard and the Rotate button turns from counterclockwise to clockwise (). If you tend to use clockwise more often, you can change this option in the iPhoto General Preferences pane.

Rotate an Image *(continued)*

When you are going through your photos, sometimes you may find that you have an image that has a horizontal orientation when you shot it as a vertical, or vice versa. Windows Live Photo Gallery can rotate your photos in much the same manner as iPhoto.

Rotate an Image (continued)

Rotate an Image in Windows Live Photo Gallery

- Click the photo or photos that you want to rotate.
- Click the rotate arrow that will work for your image, clockwiseor counterclockwise.

- The photos are rotated 90 degrees counterclockwise.
- You can also rotate your image in the Gallery Fix window. To open the Gallery Fix window, you can either double-click the selected photo or you can click Fix from the gallery view, which takes you to the Gallery Fix window.

chapter 13

 Click a rotate arrow, clockwise or counterclockwise as needed.

The photo is rotated 90 degrees clockwise.

TP

What if I have a lot of images that need to be rotated?

When you have several different images that need to be rotated, just highlight one that needs to be rotated from the gallery view in either iPhoto or Windows Live, and then highlight additional images to rotate by Ctrl +clicking (Windows Live) or Option +clicking (iPhoto) each image and then rotate them all at once.

Straighten an Image

Matching the grid to the horizon is an easy way to straighten your photo. Use iPhoto's Straighten tool to nudge the photo clockwise or counterclockwise for a level photo.

Straighten an Image

Straighten an Image in iPhoto

- Select the photo you want to straighten.
- ② Click the **Edit** button (②).

The photo opens in edit view.

3 Click the Straighten button ().

chapter 13

A grid appears over the photo, allowing you to match the horizon to the nearest line on the grid.

4 Move the slider left or right to shift the angle of the photo.

The photo is straightened.

5 Click **Done** to return to the previous view.

TP

What if the horizon line is not quite straight?

Sometimes distortion in a camera's lens makes straight lines bow slightly. There are advanced software solutions to this, such as Photoshop, and even some camera manufacturers' software helps with that distortion. Without going to those lengths, just make sure that either side of the horizon line is the same distance to the nearest line in the grid.

Straighten an Image (continued)

Try as you might, sometimes getting a photo perfectly straight is difficult. Having a crooked horizon is visually distracting in most photos. Both Windows Live Photo Gallery and iPhoto have easy and precise ways to quickly get your photos back on the straight and narrow.

Straighten an Image (continued)

Straighten an Image in Windows Live Photo Gallery

- Select the photo you want to straighten.
- Click Fix to open it in the Gallery Fix window.

The photo opens in the Gallery Fix window.

Click the Straighten photo tab.

A grid appears over the photo, allowing you to match the horizon to the nearest line on the grid.

4 Move the slider left or right to shift the angle of the photo.

The photo is straightened.

- **(** Click the check mark (**(** ✓ **)** to apply the changes.
- Click Back to gallery to save your changes.

TIP

How do I make sure the photo is level?

By matching the lines of the grid with the horizon line, or some other straight line in the photo, it should be readily apparent, when the lines match up, that the photo is level. You can use this same grid and slider on a vertical line, like the edge of a building, to make sure that the photo is level.

Crop an Image

Although good composition is important when you take your photos, cropping is equally important. Cropping can help you make your images more exciting and dramatic or eliminate something distracting in your photo. Cropping can also be used simply to fit a favorite frame or a layout for the office newsletter.

Crop an Image

Crop an Image in iPhoto

- Select the photo you want to crop.
- ② Click the **Edit** button (☑).
 The photo opens in edit view.
- (3) Click the **Crop** button (12).
- A crop marquee appears as a box around the area of the photo to keep. The areas outside the crop are darkened.
- 4 Click and drag a corner handle of the marquee to adjust it.
- 6 Click Apply.

The photo is cropped.

Click **Done** to return to the previous view.

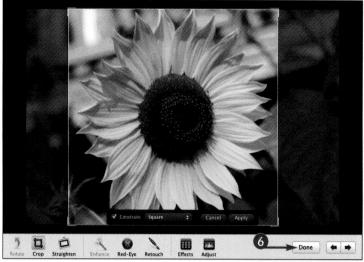

Crop an Image in Windows Live Photo Gallery

- Select the photo you want to crop.
- Click Fix to open it in the Gallery Fix window.

- (3) Click the **Crop photo** tab.
- 4 Click here and choose a dimension.

Note: Click **Original** to keep the same relative height and width; click **Custom** to crop to any height and width.

- 5 Click and drag the handles to set the new size.
- **6** Click **Apply**.
- Click Back to gallery to save your changes.

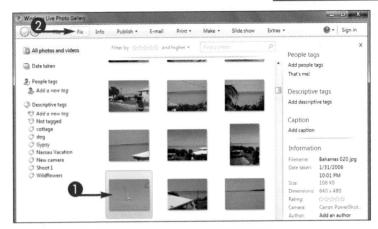

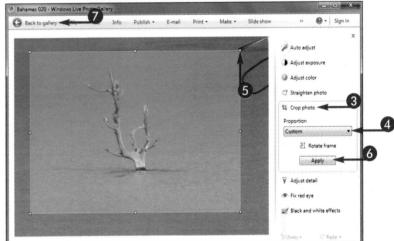

What is the Constrain option in iPhoto?

Constraining your crop simply means that you are holding the ratio proportion of the sides the same. For example, most digital cameras create an image with proportions of 4×6. So when you want to make an 8×10 image, you constrain your crop to that 8×10 proportion () so that you get exactly the crop you want. You can constrain your crop for nearly any possible proportion.

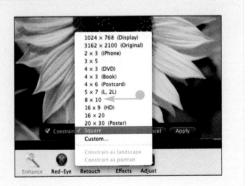

Adjust the Exposure

Adjusting your exposure in iPhoto allows some real control over your photograph. You can make broad adjustments to the whole photo, or you can select certain tones to brighten or darken.

Adjust the Exposure

Adjust the Exposure in iPhoto

- 1 Select the photo you want to apply an exposure adjustment to.
- 2 Click the **Edit** button (2).

The photo opens in edit view.

3 Click the **Adjust** button (■). The Adjust panel opens.

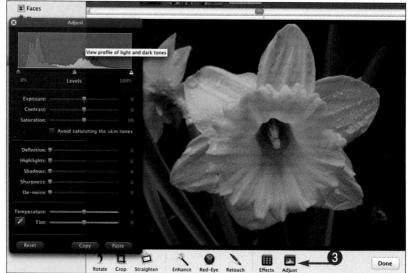

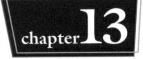

- Move the Exposure slider to the right to make the photo brighter or left to make the photo darker.
- Move the **Highlights** slider to the right to make the tones of the highlights darker.
- Move the Shadows slider to the right to make the tones of the shadows lighter.

In this example the overall exposure was lightened slightly and also the contrast increased so that the yellow of the flower would pop out from the background.

Moving the sliders too far to the right causes your photos to look very unrealistic and strange, but do not be afraid to experiment.

The photo's exposure is changed.

- Click the Close button (☑) to apply the changes and close the Adjust panel.
- 8 Click **Done** to return to the previous view.

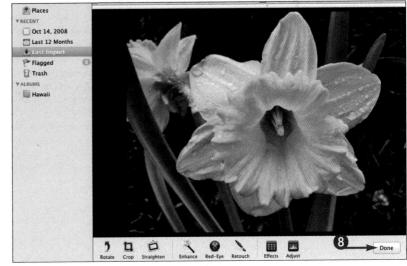

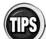

What do the Levels do?

You can select a white, middle, or gray point in your photo by moving those points on the histogram. Moving any of those three settings changes your apparent brightness, darkness, and contrast.

What do I do if I do not like my exposure changes?

Simply click the **Reset** button on the Adjust panel to return the photo to its original form.

Why are Copy and Paste buttons here?

You can save your settings for the next photo by clicking the **Copy** button, and then when you get to the next photo click **Paste** to apply those settings.

Adjust the Exposure (continued)

One of the things that many people want to do for their photos is to make them lighter or darker. This adjustment in exposure can be accomplished in several ways, affecting shadows, highlights, and overall brightness differently.

Adjust the Exposure (continued)

Adjust the Exposure in Windows Live Photo Gallery

- Select the photo you want to apply an exposure adjustment to.
- Click Fix to open it in the Gallery Fix window.

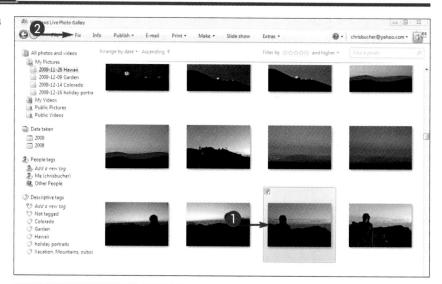

The photo opens in Gallery Fix window.

3 Click the **Adjust exposure** tab.

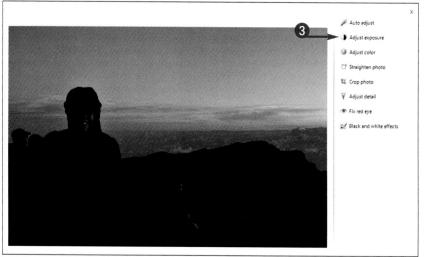

- Move the Brightness slider to the right to make the photo brighter or left to make the photo darker.
- Move the Shadows slider to the right to lighten the shadows or left to darken the shadows.
- Move the Highlights slider to the right to lighten the highlights or left to darken the highlights.

In this example the overall exposure and the dark areas were lightened slightly, but the highlights and sky were darkened, making them appear richer.

The photo's exposure is changed.

- Click the check mark (☑) to apply the changes.
- Click Back to gallery to save the changes.

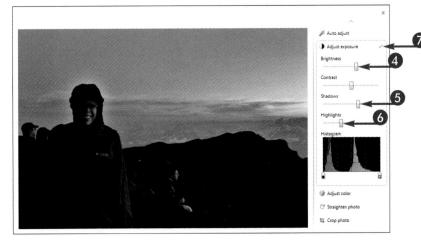

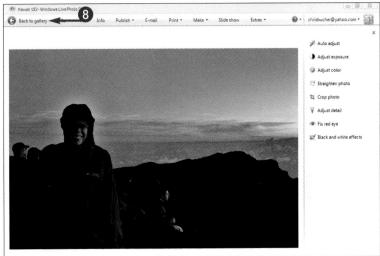

Can I overdo exposure changes?

Yes, the exposure changes in the computer are there to get a better exposure, but making the changes too extreme lessens the overall quality of the image, making dark areas noisy and highlights appear banded.

What do I do if I do not like my exposure changes?

Simply click the **Revert** button (), or Ctrl + R, at the bottom of the Gallery Fix window to return the photo to its original form.

Adjust the Color Temperature

When adjusting for color temperature, you can use the sliders to adjust for the white balance of a photo, and in iPhoto you also have an Eyedropper tool to help get it correct for your photo.

Adjust the Color Temperature

Adjust the Color Temperature with the Sliders in iPhoto

Select the photo you want to change the color temperature of and click the Edit button (⋈).

The photo opens in edit view.

Click the Adjust button (
The Adjust panel opens. You can place the Adjust panel wherever you need it to best see your photo.

3 Move the **Temperature** slider to the right to make the image more warm, or amber, and to the left to make it more cool, or blue.

The photo is now much warmer and brighter than the original.

- 4 Click the Close button (☑) to apply the changes and close the Adjust panel.
- 6 Click **Done** to return to the previous view.

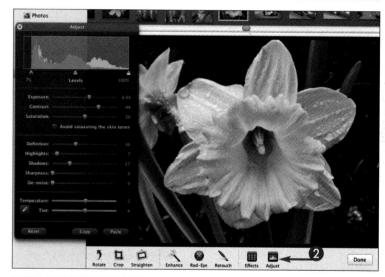

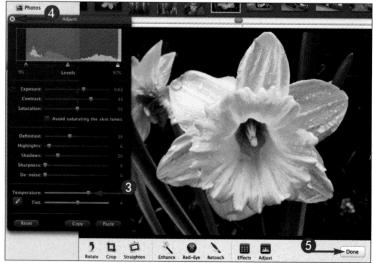

Adjust the Color Temperature with the Eyedropper Tool in iPhoto

- 1 Repeat Steps 1 and 2 from the previous page to open the Adjust panel.
- 2 Click the **Eyedropper** tool (2).

In this example, pick a neutral gray or white point in the photo to remove the colorcast.

This photo contains several places to select good gray or white points.

In this example, an easy white point was the white paint on the front of the bike.

3 Click the cursor on the white point.

The photo now has the correct color temperature.

- 4 Click the Close button (☑) to apply the changes and close the Adjust panel.
- **5** Click **Done** to return to the previous view.

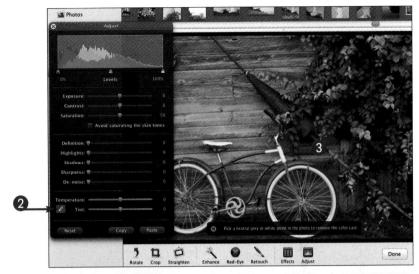

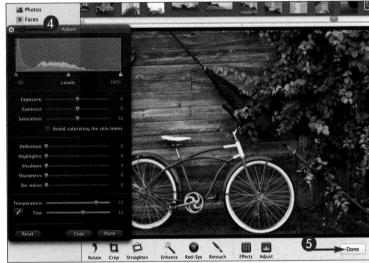

What if I still do not like how the photo looks?

If after using the Eyedropper tool () to adjust color temperature, you still do not care for the results, you can still manually slide to

still manually slide the **Temperature** and **Tint** sliders to get to your desired result.

What does the Avoid Saturating the Skin Tones check box do?

When you are working with some tools, especially the levels and other exposure settings, sometimes the skin tones on photos tend to get overrich and ruddy. Checking that box tells iPhoto to increase the color and contrast of the image

without making the people look too much like cartoon characters.

Adjust the Color Temperature *(continued)*

As discussed in Chapter 4, you can change your color temperature with the white balance settings in the camera. This section shows how to make changes to the photo if you selected an incorrect white balance or your auto setting made a mistake.

Adjust the Color Temperature (continued)

Adjust the Color Temperature in Windows Live Photo Gallery

- Select the photo you want to change the color temperature of.
- Click Fix to open it in the Gallery Fix window.

The photo opens in the Gallery Fix window.

Click the Adjust color tab.

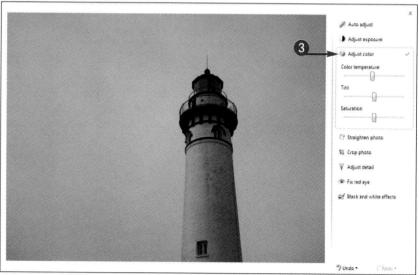

chapter 13

In this example the entire photo had a cool tone to it, rendering the white of the lighthouse a little too blue.

Move the Color Temperature slider to the right to make the image more warm, or amber, and to the left to make it more cool, or blue. Adjust color
Color temperature

Tent

Saturation

Straighten photo

Ti Crop photo

▼ Adjust detail

● Fix rest eye

Eff black and white effects

The photo's color temperature is changed.

- 5 Click the check mark (☑) to apply the changes.
- Click Back to gallery to save the changes.

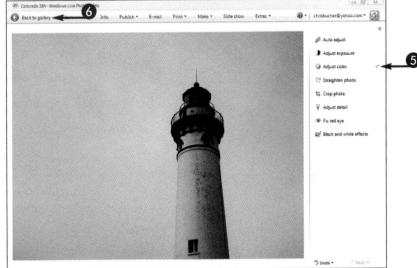

TIP

How do you know when to change the color temperature?

Look at any white areas in the photograph and ask yourself what color that area looks like. Does that white really look white, or does it look more bluish or more yellow? If the photo has no white area, look at any sort of skin tone and ask the same question. This is somewhat subjective and sometimes you may not want your color temperature to look exactly correct; for example, on a cloudy day you may want people to look a little warmer than the blue light makes them.

Adjust the Tint

The Eyedropper tool in iPhoto usually adds in at least a small amount of tint adjustment when you use it adjust the color temperature. Use the tool and the sliders to adjust the tint so that your photos look great.

Adjust the Tint

Adjust the Tint in iPhoto

- 1 Select the photo you want to change the tint of.
- ② Click the **Edit** button (☑).

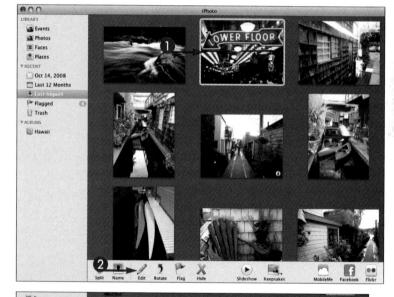

The photo opens in edit view.

3 Click the Adjust button (
The Adjust panel opens.

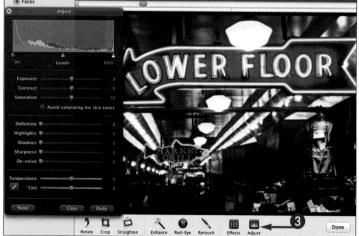

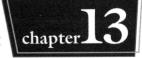

In this example the entire photo had a very yellow/green tone to it. This is largely due to the mix of different kinds of light in the scene.

- Move the **Tint** slider to the left.
 This adds magenta to the scene, removing much of the green from the fluorescents.
- Click the Close button (☑) to apply the changes and close the Adjust panel.

The photo's tint is changed.

6 Click **Done** to return to the previous view.

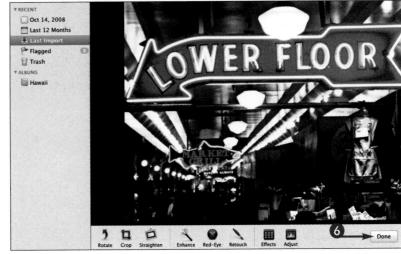

Is it better to make changes to tint in the camera?

You can make finer adjustments to your photos through the editing software on your computer than you can with your camera. Your camera, though, is what records the color in the first place, so make sure it is set correctly. Learn to look at the source of the light illuminating your photos and use that to set your white balance. If there is a question, use the Auto WB setting and if possible, capture your image as a RAW file to maximize your options once you get to the computer.

Adjust the Tint (continued)

Much in the way color temperature is the adjustment between yellow and blue, tint is the adjustment of green and magenta. Making changes to the tint is usually done in small amounts, fine-tuning the photograph, and often comes from mixed lighting situations.

Adjust the Tint (continued)

Adjust the Tint in Windows Live Photo Gallery

- Select the photo you want to change the tint of.
- Click Fix to open it in the Gallery Fix window.

The photo opens in the Gallery Fix window.

Click the Adjust color tab.

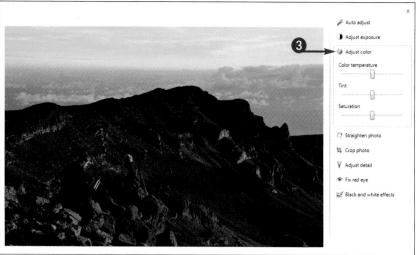

In this example the entire photo had a very green tone to it. This may have been a problem with the auto white balance or an improperly set white balance.

Move the **Tint** slider to the right to make the image more warm, or amber, and to the left to make it more cool, or blue.

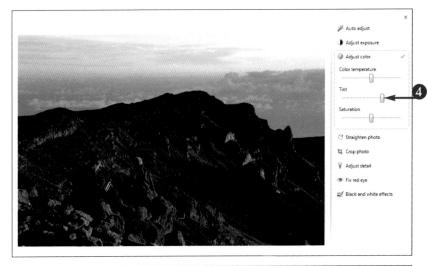

The photo's tint is changed.

- **5** Click the check mark (✓) to apply the changes.
- 6 Click **Back to gallery** to save the changes.

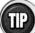

Should I change the tint when I make color temperature adjustments?

Most color temperature changes do entail at least a little bit of tint change. Unless you are working with a lot of fluorescent light, CFL-type bulbs or commercial lighting, which emit some very unnaturally colored light, changes to tint with color temperature adjustments will be slight. If you are trying to make your photos slightly warmer, you should move the Tint slider toward the magenta side just a bit, making your image look a little more like a natural warm tone, as opposed to just yellow.

Adjust the Saturation

Saturation is the intensity of the colors in your photograph. Using the Saturation tool in iPhoto allows you to add some richness to the colors in your photos. You can also use it to desaturate a photo, turning it into classic black and white.

Adjust the Saturation

Adjust the Saturation in iPhoto

- Select the photo you want to change the saturation of.
- ② Click the **Edit** button (☑).

3 Click the Adjust button (
The Adjust panel opens.

chapter 13

In this example, a hazy day makes for a washed-out looking photo.

4 Move the **Saturation** slider to the right.

This adds richness and makes the image more vivid.

- Click the Close button (☑) to apply the changes and close the Adjust panel.
- Click **Done** to return to the previous view and select a new photo.

The photo's saturation is changed.

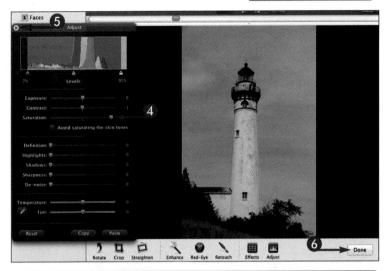

TIP

Even though I adjusted the saturation, when I print the image the colors are still not as rich as what I see. Why?

The monitor on your computer has a broader range of colors that it works with than does a print. As you move the slider more and more, the results will be less apparent on paper — the limit of what can be printed is much lower. Higher-end photo printers do have better color characteristics, and different ink and paper combinations give different results. Talk to your imaging professionals where you purchase your photo equipment to discuss some of the choices available, and professional photo printing services may also help with critical color issues.

Adjust the Saturation (continued)

Saturation is the intensity of the colors in your photograph. Many photos are greatly improved with some judicious use of the Saturation slider, making dull photos pop to life, but too much can easily make a photo look artificial and unreal.

Adjust the Saturation (continued)

Adjust the Saturation in Windows Live Photo Gallery

- Select the photo you want to change the saturation of.
- 2 Click **Fix** to open it in the Gallery Fix window.

The photo opens in the Gallery Fix window.

Click the Adjust color tab.

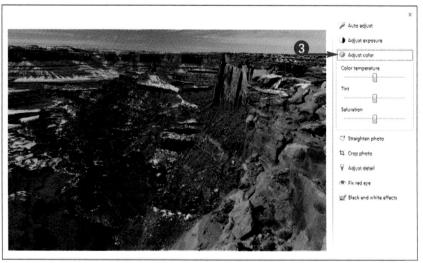

In this example the photo is a little dull.

Move the Saturation slider to the right to make the image richer.

You can move the Saturation slider to the left to make the photo look more black and white.

The photo's saturation is changed.

- 6 Click the check mark (☑) to apply the changes.
- Click Back to gallery to save the changes.

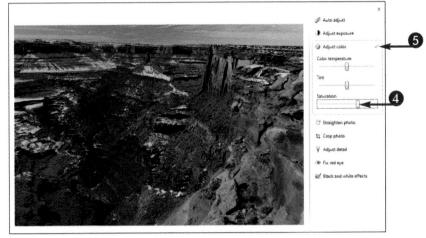

TIP

When should you make changes to the saturation?

Images often need more saturation when the lighting situation is more soft or dull. Overcast or hazy skies, and photos taken in the shade or with backlight, often make for images that have a lack of rich color, and those are good opportunities to add saturation, bringing some extra life to your photos. Photos with brightly sunlit subjects generally have rich color, especially when the sun is low in the sky. Saturation adjustments can be done in Photoshop Elements, Windows Live Photo Gallery, iPhoto, or in your camera, but can be best controlled with the slider in your computer's image-editing software.

Adjust Noise and Sharpness

Virtually all digital photographs have some inherent softness and noise. This is produced at the pixel level of the actual image sensor. Noise and sharpness are thus related, and careful adjustments can really help improve the look of your photos.

Adjust Noise and Sharpness

Adjust Noise and Sharpness in iPhoto

- Select the photo you want to change the noise and sharpness of.
- Click Edit.
 The photo opens in edit view.

- 3 Move the zoom slider to the right.
- Move the Navigation window to an important part of the photo to better see the noise and sharpness detail.
- 6 Click the **Adjust** button (■).

 The Adjust panel opens.
- **6** Move the **Sharpness** slider to the right.

chapter 13

- Move the **De-noise** slider to the right to increase the sharpness.
 - Look in the shadow areas of your photo to determine the noise reduction.
- 8 Click the Close button (☑) to apply the changes and close the Adjust window.
- Olick Done to return to the previous view.

The photo's noise and sharpness are changed.

Note: The general rule is to make sharpness the last adjustment to your photo. If you make further adjustments, you may have to resharpen, which may degrade the quality of the image.

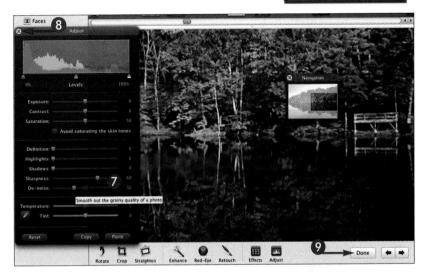

What if my photo is out of focus?

If your photo is really out of focus, not a lot can be done to get it in focus. Increasing sharpness and contrast and even lowering the noise reduction will show the sharpness at the pixel level, which may help somewhat.

Both Windows Live and iPhoto increase contrast at the pixel level to add to the apparent sharpness of your photo. Noise reduction works against that by smoothing that contrast out. Use these tools carefully.

Adjust Noise and Sharpness (continued)

Virtually all digital photographs have some inherent softness and noise. This is produced at the pixel level of the actual image sensor. Noise and sharpness are thus related and careful adjustments can really help out the look of your photos.

Adjust Noise and Sharpness (continued)

Adjust Noise and Sharpness in Windows Live Photo Gallery

Select the photo you want to change the noise and sharpness of, and click Fix to open it in the Gallery Fix window.

The photo opens in the Gallery Fix window.

Click the Adjust detail tab.

Adjust exposure

Adjust color

Straighten photo

Crop photo

Adjust detail

Fix red eye

Black and white effects

This automatically zooms in close on the image. Use the cursor to move the view to a place where you can get a good look at the photo's detail.

- **3** Move the **Sharpen** slider to the right to increase the sharpness.
- Click Analyze.

This takes a moment, but an auto noise reduction is made.

Move the Reduce Noise slider to increase or decrease the effect to your photo.

Look in the shadow areas of your photo to determine the noise reduction.

6 Click the check mark (✓) to apply the changes.

The photo's noise and sharpness are changed.

The view goes back to full image view.

Click **Back to gallery** to save the changes.

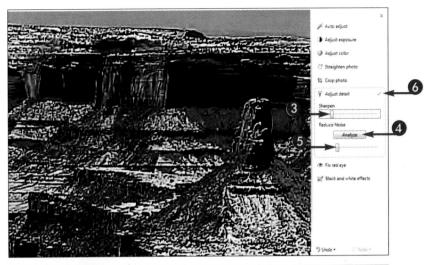

Are there any tips on how much to change the noise and sharpness in a photo?

You might think that a photo should just be as sharp as it can be and as noise free as possible, so use those sliders liberally, but that will not work. As with so many of the tools in your image software, noise and sharpness changes should be performed cautiously. Moving those sliders all the way to the right will obviously make your photos look terrible. As you bring a slider back to the left, when the photo looks pretty good again you are probably in the right neighborhood for the correct amount of noise and sharpness.

Remove Red Eye

Red eye is caused by the reflection of the camera flash from the back of a person's eye. It is unnatural and unattractive but very easy to remove from your photos. iPhoto has both a manual and an automatic way to get the job done.

Remove Red Eye

Remove Red Eye Automatically in iPhoto

- Select the photo you want to remove the red eye from.
- ② Click the Edit button (≥).

- 3 Click the **Red-Eye** button (). The Red-Eye Removal window opens at the bottom of the screen.
- 4 Click Auto.
 In many cases, this is all you need to do to remove the red eye.

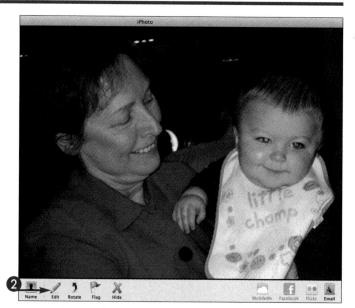

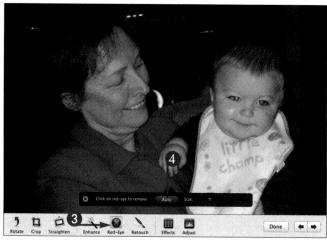

Remove Red Eye Manually in iPhoto

- 6 Move the red-eye slider to adjust the tool to match the size of the red in the eyes.
- **6** Use the zoom slider to get close to the eyes for a good match.
- Position the Red-Eye tool over the top of the red parts of the eye.
- 8 Click each eye.
- Olick Done to return to the previous view.

The photo returns to standard view.

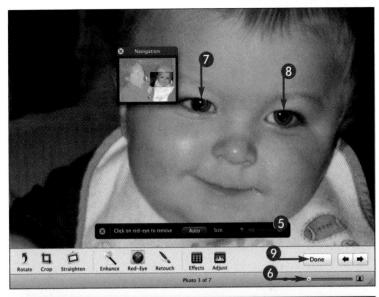

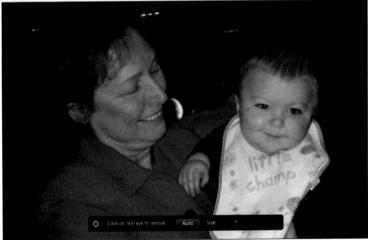

How else can you eliminate red eye?

The reflection of the flash into the back of the eye is a direct result of distance between the flash and the lens. That is why you see red eye from compact cameras more than from dSLRs. Even some of the larger compacts have flashes that pop up, and that small distance makes for a huge difference in the lack of red eye that occurs. Red-eye reduction in a camera usually entails either a series of preflashes or other bright light before the photo is taken. This has the effect of slightly closing the iris before the photo is taken, lessening the red-eye effect.

Remove Red Eye *(continued)*

Red eye happens when the flash from the camera reflects off the back of your subjects' eyes. It happens mostly on compact cameras, and it happens more often to light-complected people and babies in very dark situations. It is a nuisance, but there are many ways to get rid of it.

Remove Red Eye (continued)

Remove Red Eye in Windows Live Photo Gallery

- Select the photo you want to remove the red eye from.
- Click Fix to open it in the Gallery Fix window.

The photo opens in the Gallery Fix window.

3 Click the Fix red eye tab.

It may be good to zoom in at this point using the zoom slider.

To move the photo around while you are zoomed in, press Alt and drag.

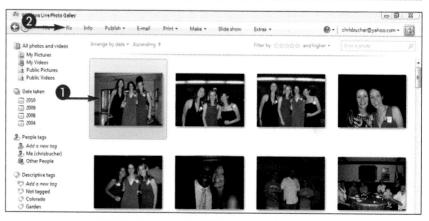

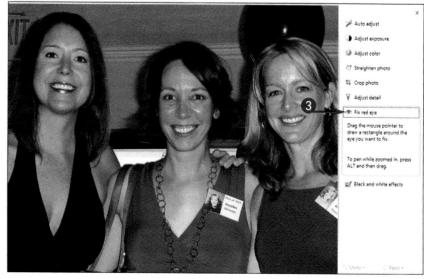

chapter 13

- Drag the mouse pointer to draw a box around the eye that you want to fix.
- **(5)** Click and drag over each eye that needs red-eye removal.

After you make the box around each eye, Windows Live Photo Gallery automatically removes the red eye.

- 6 Click the check mark (☑) to apply the changes.
- Click Back to gallery to save the changes.

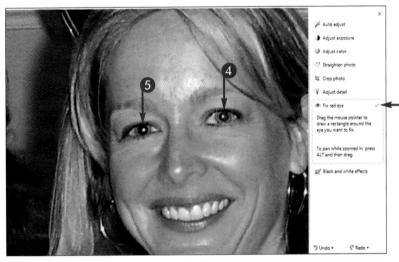

Are there other ways to get rid of red eye?

Virtually every piece of photo-editing software, do-it-yourself photo kiosk, and even online photo print service now provides for red-eye removal in your photos. It is in no way difficult to do, but if you have a lot of photos it may take a while. Some software does it virtually automatically, whereas with others you need to select the red eye to be removed.

Retouch Spots on Your Photos

With iPhoto you have a Retouch tool, which is very powerful for removing small distracting spots on your photos. You can use this for a few different types of things, but the results are the same.

Retouch Spots on Your Photos

- Select the photo you want to remove the spots from.
- **2** Click the **Edit** button (\mathbb{Z}).

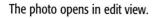

- 3 Use the zoom slider to get closer in on the offending spots.
- 4 Use the cursor to navigate to the spots.

Dust spots like this are a hazard any time you change the lens on your dSLR.

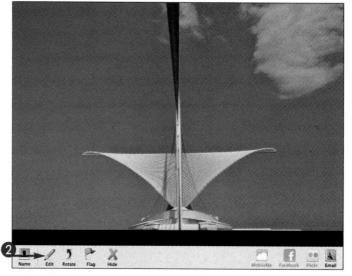

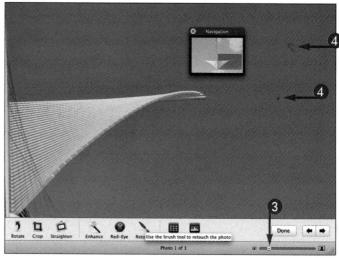

- **⑤** Click the **Retouch** button (**N**).
 - A circle-shaped tool appears over the photo.
- 6 Adjust the size of the tool so that it covers the offending spot.
- Click the spot.

The Retouch tool averages the color and tones on the spot and effectively removes the mark from the photo.

- 8 Navigate around the photo to make sure no additional dust spots appear.
- Olick Done to return to the previous view.

The photo returns to standard view.

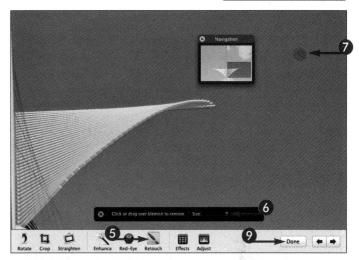

TIP

How do you keep those dust spots off your photos?

Those black spots on your photos are really a nuisance. The spots are actually shadows from the dust on your camera's sensor, blocking the light from the lens onto the sensor. To keep your sensor clean, try to change lenses only when necessary. When you do change your lens, make sure your camera is turned off. When the camera is on, static charge in the sensor attracts dust. Try to keep the lens opening facing downward so that dust does not drop into the camera, and be particularly cautious if you are changing lenses in a dusty or dirty environment.

Retouch Spots on Your Subjects

With iPhoto you have a Retouch tool which is very powerful for removing small distracting spots on your photos. The Retouch tool also works on distracting marks on the skin of people in your photos.

Retouch Spots on Your Subjects

- Select the photo you want to retouch.
- ② Click the **Edit** button (②).

The photo opens in edit view.

- 3 Use the zoom tool to get closer in on the blemishes.
- 4 Use the cursor to navigate to the blemishes.

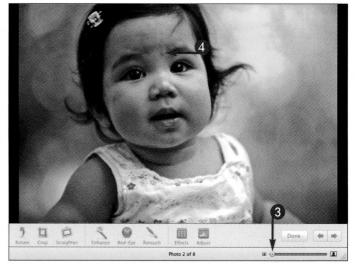

- 6 Click the **Retouch** button (N). A circle-shaped tool appears over the photo.
- **6** Adjust the size of the tool so that it covers the offending spot.
- Click the spot.

The Retouch tool averages the color and tones on the spot and effectively removes the mark from the photo.

- Navigate around the photo to make sure no additional blemishes appear.
- Olick Done to return to the previous view.

The photo returns to standard view.

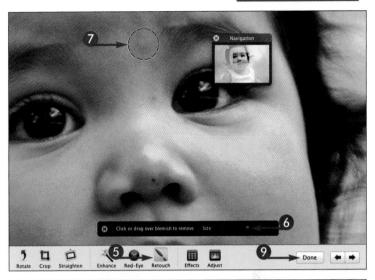

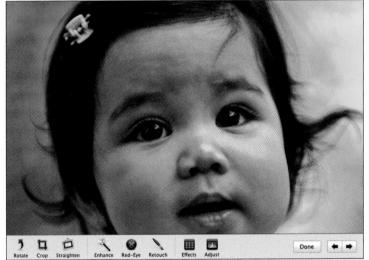

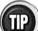

Can you use different techniques to do the retouching?

With smaller areas, keep the brush small and make several small clicks to better blend the blemish into the skin, and continue to click the area as opposed to dragging the brush. With larger areas, use a larger brush and drag it more to blend it into the whole area better. Try to make sure the area that you are blending is of the same color and tone. If you get too close to an area such as an eye or nostril, the smear will be very dark and unattractive.

Apply Photo Effects

Doing some creative enhancing of photos is easy in iPhoto. You can easily apply an effects filter to your photo, change its strength, and even stack multiple filters. When you are done, if you do not like your creation, just click the middle image and return to the original.

Apply Photo Effects

Apply Photo Effects in iPhoto

- Select the photo you want to apply an effect to.
- Click Edit.
 The photo opens in edit view.
- 3 Click the **Effects** button (**IIII**).

The Effects panel opens.

- 4 Click the effect you want to apply. iPhoto applies the effect.
- Some effects have a numerical value; click the arrows to adjust the level of the effect.

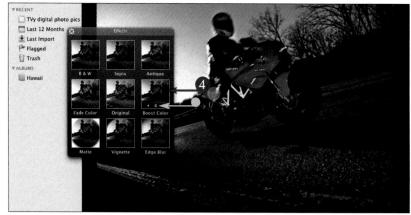

chapter 13

Repeat Step 4 to add more effects to the photo.

Note: You can see previews of what the effects are going to be and how they will change the photo in the Effects panel.

Click Done.

The photo returns to standard view.

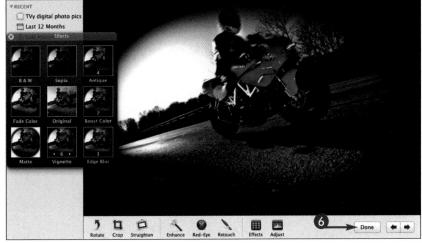

TIP

How do all these effects make your photo better?

This is a very subjective thing. Many people never apply any sort of effect to their photos and are always happy with them, whereas others always want to add something. These effects can add mood and tone to a photograph. iPhoto is a very powerful tool and all these filters, effects, and adjustments are there to give you more options. Even with digital technology, you cannot always take the photo that you have in your mind, but these tools can help create it once you get back to the computer.

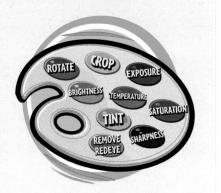

Apply Photo Effects (continued)

Windows Live Photo Gallery has a black and white effect which allows you some great creative options for your photos. There are several different effect options with different tones and contrast levels for your photographs just like using colored filters on black and white film.

Apply Photo Effects (continued)

Apply Photo Effects in Windows Live Photo Gallery

- Select the photo you want to apply the black and white effect to.
- 2 Click **Fix** to open it in the Gallery Fix window.

The photo opens in the Gallery Fix window.

- 3 Click the Black and white effects tab.
 - Positioning your mouse pointer over the different icons tells you what filter the software will emulate.

chapter 13

Click the red filter icon.

The image is converted to a very high-contrast black and white photo.

You can make additional adjustments to further polish the look of your black and white image.

- Click the Adjust exposure tab and move Contrast and Highlights sliders to further increase the contrast in your photos.
- **6** Click the check mark (✓) to apply the changes.
- Click Back to gallery to save the changes.

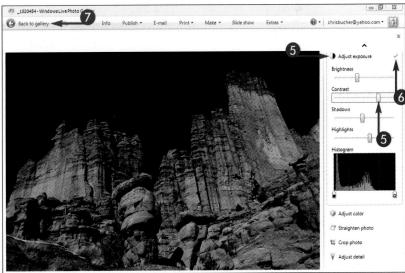

Why are the black and white effects filters called Red, Yellow, and Orange?

In the days of black and white film, people used to put colored filters in front of the lens to affect the contrast. A red filter allows red light in, but blocks blue and green. This makes the red colored rock in the example look brighter, while making the blue sky look darker. The yellow and orange filters have slightly different effects. Orange can make skin look soft and glowy, whereas yellow adds contrast, but not as extreme as the other two.

Use the Auto Enhance Button

The Enhance button in iPhoto is a great way to instantly improve the appearance of a photo with the simple click of a button. iPhoto takes the color and brightness already there, makes some calculations, and attempts to make a great photo out of an ordinary one.

Use the Auto Enhance Button

Use the Auto Enhance Button in iPhoto

- Select the photo you want to enhance.
- ② Click the **Edit** button (②).

iPhoto opens the photo in edit view.

3 Click the **Enhance** button (N).

chapter 13

iPhoto makes the Enhance changes.

- You can click the Adjust or Effects buttons (☐ or ☐) at this point if you would like to make additional changes to the photo.
- 6 Click Done.

TIP

How does the software know what to do?

iPhoto uses complex calculations and algorithms to make a guess as to how to make the photo better when you click the Enhance tool. There is always room to make additional changes, but if you want to get a great start, the Enhance button is the way to go. The changes that Enhance makes are in the Adjust panel, so at the very least, you can start to see what the computer is trying to do. Remember that you can always revert to the original, so never hesitate to make changes that you might not like. Trying new things is always fun.

Use the Auto Enhance Button (continued)

Windows Live Photo Gallery has a great button that may save you a lot of time and effort, called the Auto Adjust button. Even when you know how all the adjustments work, and how to apply all the different things that Windows Live does, sometimes it is great to be able to just push one button and get a great result.

vs Live Photo Gallen

All photos and videos

2009-12-09 Garden 2009-12-14 Colorado

My Pictures 2009-11-26 Havyaii

chrisbucher@yahoo.com*

Use the Auto Enhance Button (continued)

Use the Auto Enhance Button in Windows Live Photo Gallery

- Select the photo you want to auto adjust.
- Click Fix to open it in the Gallery Fix window.

ppen it in the indow.

| 209-12-16 holiday portraits | Utah Ting 2009 | My Videot | Public Vid

The photo opens in the Gallery Fix window.

Click the Auto adjust button.

 The Adjustment panes all open to their new auto settings.

The photo reflects those new settings.

You can make additional adjustments to further polish your photo if necessary.

4 Click Back to gallery to save the changes.

The photo is saved and goes to full screen to display its largest view.

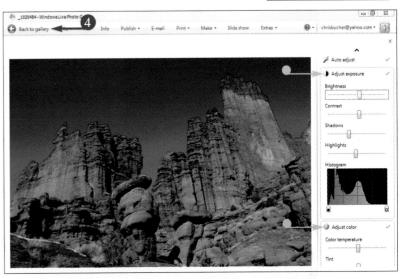

Why not just auto adjust every photo?

You can always just click the Auto button at the beginning and see what you get, and even make some changes from there or revert if you do not like the auto changes. As you get more experienced you will begin to recognize what Auto adjust does regularly and know whether the effect matches what you want to do with your photos. Sometimes the Auto Adjust button will create exactly the effect you want, and other times it may be exactly what you do not want due to some color shift or exaggerated contrast.

CHAPTER

1

Advanced Photo Editing with Photoshop Elements

You can make all your photos look better with Photoshop Elements. Start by adjusting your monitor to better display your photos. Then you can crop, improve the color and contrast, remove red eye, and tint or change color images to black and white for a special effect. This chapter introduces more advanced digital image editing.

Why Calibrate and Profile Your Monitor?204
Open the Photoshop Elements Quick Fix Workspace206
Get Familiar with the Quick Fix Workspace207
Open a Photo to Fix in the Quick Fix Workspace208
Open a RAW Photo File210
Zoom In and Out212
Move Around the Image213
Rotate an Image214
Select a Comparative View215
Improve Composition by Cropping216
Use the Quick Fix Auto Buttons218
Try an Auto Fix for a Quick Improvement219
Remove Red Eye with One Click220
Undo Changes221
Convert a Color Photo to Black and White222
Add a Colored Filter Effect to Any Photo223

Why Calibrate and Profile Your Monitor?

Your monitor is used for viewing your photos. If your monitor is dull or changes the colors in the image, you cannot accurately edit your photos for color or tone. You can calibrate and profile your monitor for more accurate color. This section and the section that follows explain why and how to get better color from your monitor.

What Are Calibration and Profiling?

When you calibrate your monitor, you check and compare the color values it displays to a known standard. You then create a profile or a description of how your monitor displays color at that particular moment.

Why Should I Calibrate and Profile My Monitor?

You need the monitor to show consistent and predictable color so you can more accurately view and color-correct your images. Making sure the monitor is as accurate as possible also helps ensure that the print reflects the colors you see on-screen.

Different Kinds of Monitors

CRTs and LCDs are the two basic types of computer monitors. A CRT uses a cathode ray tube and is more like a traditional TV. An LCD is a flat panel display, which uses liquid crystals in the viewing area. Both can be calibrated and profiled with hardware and software methods. Most new computers come with LCD monitors.

Calibration and Profiling Methods

You can use either a software-only method or a hardware-software combination to calibrate and profile. With the software-only methods, your eyes are the determining factor in judging the accuracy of the color as displayed on the monitor screen. Using a hardware device called a colorimeter along with its corresponding software is far more accurate. The colorimeter measures the actual output of color. The software with both methods produces the profile, a data file describing how your particular monitor shows colors as compared to a known ICC, or International Color Consortium, standard. The video card inside your computer uses the new profile to compensate for your monitor and to display the color according to the standard.

The Software "Eyeball" Method

You can use the Adobe Gamma software automatically installed with Photoshop Elements to calibrate and create a monitor profile. Because your eyes are the measuring tool with this method, you should dim the lights to avoid reflections on-screen. You should also wear neutral colors such as gray or black so that no colors reflect from the screen and change your color vision.

Hardware Methods

Using a hardware colorimeter to calibrate and profile your monitor is easier and results in more consistent color. The device is small, attaches to the monitor while you calibrate and profile, and reads color patches that its software produces on-screen. Colorimeters are not cheap, but they do not have to be terribly expensive. Companies like X-Rite, Pantone, and LaCie have excellent colorimeters. X-Rite and Pantone both have consumer-level products like the Eye-One and the hueyPRO which cost between \$100-\$200, as well as more expensive professional products like the ColorMunki.

Open the Photoshop Elements Quick Fix Workspace

Photoshop Elements includes two Editor workspaces that you can open easily from the top line of the toolbar. The two workspaces are the Quick Fix workspace and the Standard Edit workspace. You can use either one, or start with the Quick Fix to make changes to an image, and then move on to the Standard Edit to make further enhancements.

Open the Photoshop Elements Quick Fix Workspace

Use the Buttons

- Launch Photoshop Elements.
- Click the Quick Fix tab to open the Quick Fix workspace.

- If you know which photo you are looking for, click File and then Open to select a photo through the file directory.
- To browse through folders of photos, click File and then Browse with Bridge to open the Adobe Bridge photo browser.
- You can then either click the photo that you want to edit, or you can drag that photo to the Photoshop Elements icon to open the photo.

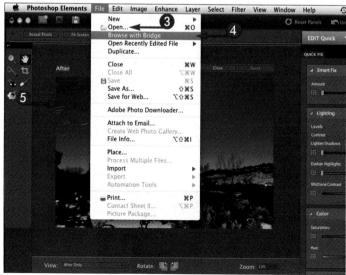

Get Familiar with the Quick Fix Workspace

Advanced Photo Editing with Photoshop Elements

chapter 14

The Quick Fix workspace offers simple and easy-to-use tools for making basic photo edits and comparing the changes you make side by side with the original photo. You can view and move around the image at various sizes, correct red eye, make a variety of color and tonal enhancements, crop, and sharpen, all from this workspace.

Access the Tools

Using the tools on the left side of the image window, you can zoom in and out of the photo, move around a zoomed-in image, select a specific area to change, crop the image for composition, and fix red eye quickly.

Change Your View

In the area below the main image window, you can select a before and after view, rotate the image, and change the zoom percentage.

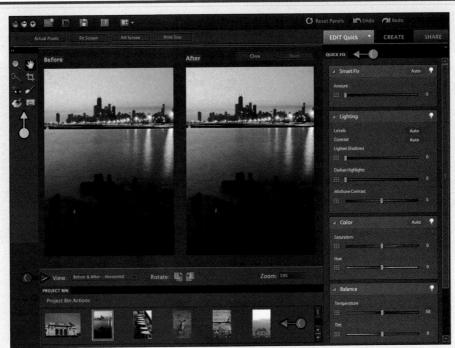

View All Open Photos

The Project Bin shows thumbnails of all the open images. You can easily switch between images in the main window by clicking another image in the Project Bin to navigate among your open photos. You can click the **Project Bin** tab to hide the Project Bin.

Make Quick Fixes

Try the Auto fixes on the right side of the screen. Starting at the top, apply one Auto control by clicking on the grid next to the slider so you can see all the different changes available. You can click the **Reset** button and try the next Auto fix for a different effect. Be careful not to overdo some of the effects, which may make the photos look unreal.

Open a Photo to Fix in the Quick Fix Workspace

You can open almost any image on your hard drive with Photoshop Elements. You can also open several photos at once, or open a recently viewed photo without navigating to the location where the photo is stored.

Open a Photo to Fix in the Quick Fix Workspace

Open One or More Images

- Click File.
- Click Open.

The Open dialog box appears.

- 3 Click here to display additional folders.
- 4 Click the file you want to open.
- 6 Click Open.

Note: Shift +click files in a series or # +click (Ctrl +click) multiple separate files and click Open to open them all at once.

Note: Be careful how many photos that you open at once. Depending on your computer, more than a few could lock up or crash your computer.

Photoshop Elements opens the image. The image also appears in the Project Bin.

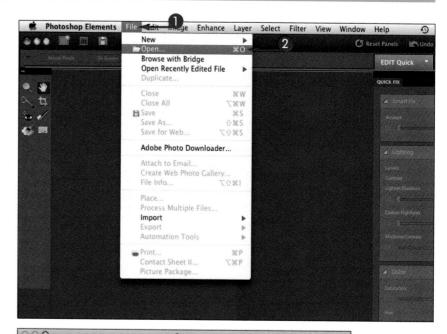

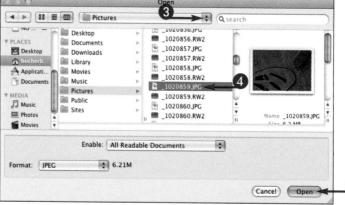

6

Advanced Photo Editing with Photoshop Elements

Open a Recently Edited Photo

- Click File.
- Click Open Recently Edited File.
- 3 Click the name of the photo from the list.
- Photoshop Elements opens the image.
- The image also appears in the Project Bin.

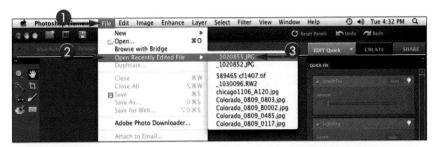

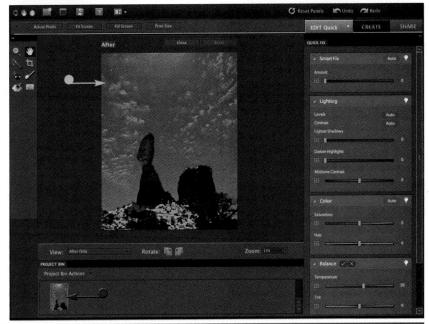

TP

What types of files can Photoshop Elements open?

Photoshop Elements can open most of the common image file formats in use today. The almost universal image format is JPEG, which is a compressed file type and can be used for Web, e-mail, or print. JPEG files can be both high resolution for printing or Web resolution for display on the monitor.

File Type	Description
JPEG (Joint Photographic Experts Group)	The standard format for digital photos.
TIFF (Tagged Image Format File)	The industry standard graphics file format.
PSD (Photoshop Document)	Native file format for Photoshop and Photoshop Elements.
BMP (Bitmap)	A Windows image format.
GIF (Graphics Interchange Format)	An older-style format for Web images.
RAW (unprocessed camera sensor data)	Unique format that must be converted to a standard graphics format before the image can be used.
PNG (Portable Network Graphics)	A compressed file format mostly used for screenshots.

Open a RAW Photo File

RAW images are different from other images a digital camera produces. The Camera Raw file format includes all the original digital data as the camera's sensor captures it. Because a RAW file has not been processed or compressed, you can use Photoshop Elements to set the white balance, tonal range, contrast, saturation, and sharpening to your requirements.

all it.

Photoshop Elements saves a sidecar file labeled .xmp with each RAW photo you open. The original file is not overwritten. When you click Save in the Raw dialog box, you can save the file with another name and format. When you click Open, you open the file to continue editing it in Photoshop Elements.

Open a RAW Photo File

- Click File.
- Click Open.
 The Open dialog box appears.
- 3 Click the photo file.
- 4 Click Open.

The dialog box for the RAW file from your camera opens. This window is the Adobe Camera Raw converter window.

- You can use these tools to change the view for adjusting the image.
- 6 In this example, click the Color Sampler tool () to sample for the white balance.

Note: The Auto fixes, which are checked by default, are not always the best for your photo. You can move the sliders to adjust your specific image.

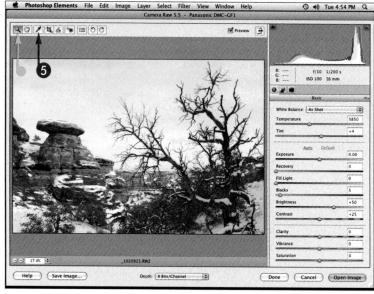

Advanced Photo Editing with Photoshop Elements

- 6 In this example, click here and select a different white balance.
- Use the sliders on the side to work with highlights, shadows, exposure, and saturation.
- 8 Click Open Image to take the image back to Photoshop Elements.

The file opens in Photoshop Elements with the Raw settings applied.

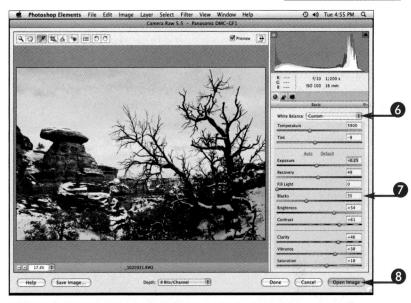

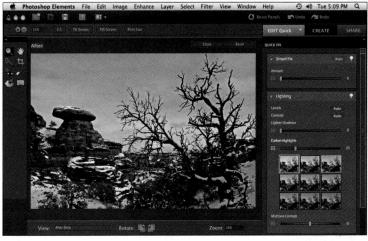

Can I change my mind and reprocess the file after it is converted?

Yes. When you select **Open** in the Raw dialog box, Photoshop Elements saves your changes and creates a new image as it opens the RAW photo. You can

reprocess the original RAW file in different ways as many times as you want and get multiple versions from the same original image capture.

Can all digital cameras produce RAW files?

No. Only some point-andshoot digital cameras have a Raw setting. However, most prosumer cameras and all professional digital cameras or digital SLR — single lens reflex — cameras allow you

to capture and save RAW files. You must set this option in the camera's shooting preferences.

Zoom In and Out

When editing images, you can zoom in on certain areas to see them better and then zoom back out to view the whole image. You can change views quickly and efficiently using the Zoom tool along with certain keyboard keys and the options in the Options bar.

Zoom In and Out

- Open a photo in the Quick Fix workspace.
- 3 Click and drag ⊕ to create a zoom marquee over a specific area.

If you press and hold the spacebar after you start to click and drag, the zoom marguee moves to another area.

You can also click anywhere in the image to zoom in to the spot where you place the Zoom tool.

Press and hold Option (Alt) to temporarily change \oplus to \bigcirc .

Photoshop Elements zooms in on the area you selected in Step 3.

- Click Fit Screen to make the entire image fit in the screen.
- Click Actual Pixels to view the image at 100 percent.
- Double-click the **Zoom** tool () to automatically zoom the image to 100 percent.
- Print Size shows an approximate printed size depending on the actual document size and the size and resolution of your monitor.

Move Around the Image

Advanced Photo Editing with Photoshop Elements

When you zoom in to work on an area, you may need to move around in the image using the zoomed-in state. You can use the Hand tool to move around easily. You can also use the keyboard keys to switch between the Hand tool and the Zoom tool to make moving around the image much quicker.

Move Around the Image

- Open a photo in the Quick Fix workspace.
- Click and drag in the zoomed-in image.

You can press and hold Option (Ait) to temporarily change $\langle ^n \rangle$ to \bigcirc .

You can also press the spacebar to temporarily access the Hand tool () when the Zoom tool () is selected.

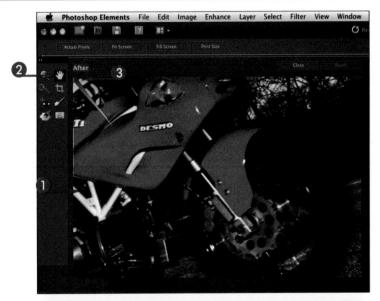

Rotate an Image

Your digital photo files likely include images shot both horizontally and vertically. You can easily rotate any image in Photoshop Elements using either a menu selection or a shortcut button. You can even use the Rotate menu command to flip an image either horizontally or vertically.

Rotate an Image

- Open a photo in the Quick Fix workspace.
- Click Image.
- Click Rotate.
- Click a degree of rotation.
- You can click Flip Horizontal or Flip Vertical to reverse the image.

- Photoshop Elements rotates the photo.
- You can also click the left or right Rotate Shortcut button
 (■ and ■).

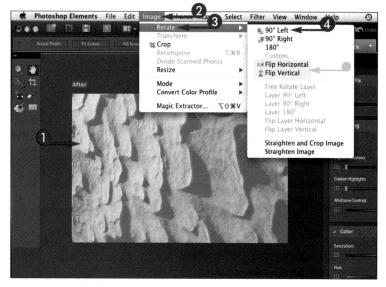

Select a Comparative View

Advanced Photo Editing with Photoshop Elements

chapter 14

Being able to compare the original photo with your edited version makes your work more efficient and effective. You can easily set the Quick Fix workspace to display two versions of the photo at once, and dynamically update the after version as you make changes.

Select a Comparative View

- Open a photo in the Quick Fix workspace.
- Click here and select Before & After (Horizontal).
- You can select Before & After (Vertical) depending on the photo.

The photos appear above and below when you choose Vertical.

Note: When you close Photoshop Elements, the view that is in use becomes the default view when you open Photoshop Elements again.

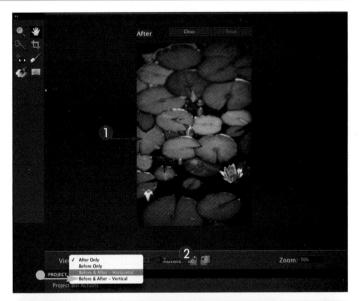

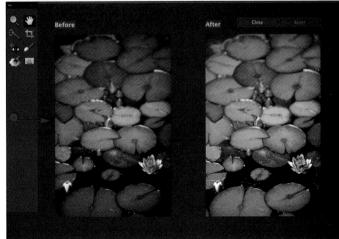

Improve Composition by Cropping

You can remove parts of an image, such as parts of a distracting background, to help focus your image and improve your composition. Using the Crop tool in Photoshop Elements, you can crop to arbitrary dimensions or you can specify the width, height, and resolution.

Improve Composition by Cropping

- Open a photo in the Quick Fix workspace.
- Click here and select Before & After (Horizontal).
- 4 Click the Aspect Ratio and select No Restriction. You can also select proportional cropping if you are making a photo of a particular size.
- **(5)** Click and drag in the After image and then release the mouse.
- A crop marquee appears as a box around the area of the photo to keep.
 The areas outside the crop are darkened.
- You can click and drag a corner handle of the marquee to adjust it.
- You can type a specific width and height in the data fields in the Options bar above the image.
- You can click inside the marquee and drag to move it to another position.

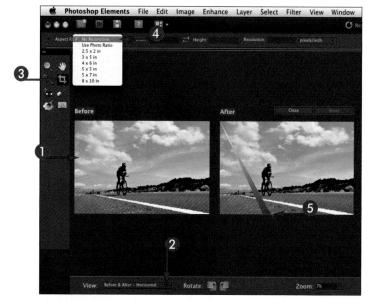

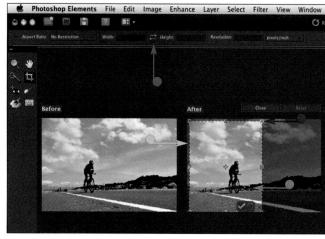

Advanced Photo Editing with Photoshop Elements

chapter 14

- 6 Click the Commit button (☑) to apply the crop.
- You can click the Cancel button
 (a) to cancel the crop.

Photoshop Elements crops the image.

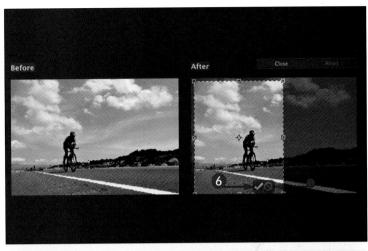

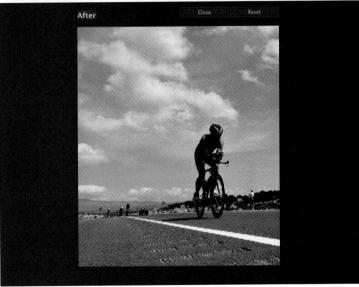

TIPS

Is there a quick way to crop to traditional photo sizes?

Yes. Click the **Aspect Ratio**, and you can select any of the options — such as 4×6 inches or 5×7 inches. You can invert the preset aspect ratio by clicking the **Swap** icon () to get a 6-×-4-inch crop or a 7-×-5-inch crop, for example.

Do I have to enter a number in the Resolution data field in the Options bar?

Not necessarily. When you use the **Crop** tool (on a photo, the resolution remains the same as that of the original photo. For example, if your photo is 5×7 at 300ppi, and you crop the photo to 5×4 inches, the resolution of the new 5×4-inch photo remains set at 300ppi. If you click the **Aspect Ratio** and choose a preset aspect ratio, the resolution automatically changes to match that of the preset.

Use the Quick Fix Auto Buttons

Photoshop Elements includes many easy-to-use editing tools in the Quick Fix workspace. Depending on the image, the Quick Fix Auto buttons may be all you need to improve a photo. You can select a before and after view; it is easy to see the results of each Auto button by comparing with the original photo. Even easier is the grid view for many of the tools allowing you to see several different options for each tool by mousing over the photos in the grid.

Auto Buttons Overview

The Smart Fix makes changes to the overall color balance in the photo, including adjusting the highlights and shadows. It applies a more general correction. The Red Eye Fix automatically finds and removes red eye in the photo. Auto Levels adjusts the contrast and the colors using the lightest and darkest pixels in the image, whereas Auto Contrast only changes the contrast. Auto Color fixes the contrast and color according to the highlights, midtones, and shadows. Auto Sharpen sharpens the edges in the image using a default setting.

Use Multiple Auto Buttons

You can apply one Auto fix and then another. Although you can compound the effects of clicking the Auto buttons multiple times, you rarely need more than two or three to improve most photos. You can apply these in any order, with the exception of the Auto Sharpen button, which should always be applied last.

Click and Drag to Adjust Photos

Clicking an Auto button makes the correction according to the software presets. You can make further edits or reduce the amount of the correction by using the sliders in each section. To apply the correction, click the **Commit** button (), or click the **Cancel** button () to cancel the changes.

Use the Quick Fix Preview Grid

By clicking the Quick Fix Preview grid button (), a grid of options opens. This shows nine different auto settings available from that adjustment slider. Positioning your mouse over each of these options temporarily changes the view of the photo in the main window. When you like what you see, you simply click the preview image and Photoshop Elements applies the change.

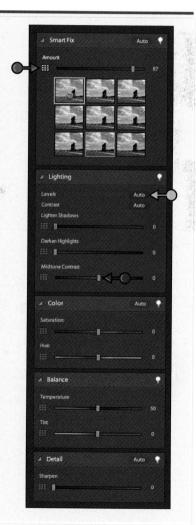

Try an Auto Fix for a Quick Improvement

Advanced Photo Editing with Photoshop Elements

Clicking any one or a combination of Quick Fix Auto buttons is a fast way to make general improvements to an image. If an Auto fix does not improve the photo, you can step backward by clicking Edit from the menu bar and selecting Undo. You can also start the editing all over again by clicking the Reset button above the After image.

Try an Auto Fix for a Quick Improvement

- Open a photo in the Quick Fix workspace.
- Click here and select Before & After (Horizontal).
- Click a Quick Fix Auto button Smart in this example.

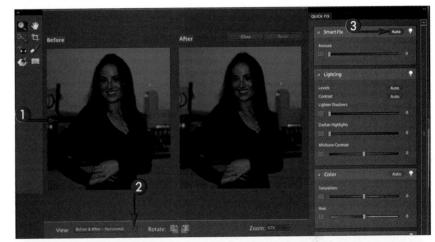

- The color and contrast of the After view change.
- You can click **Reset** if the change does not improve the photo.
 - You can repeat Step **3** using a different Auto button to find the appropriate correction.

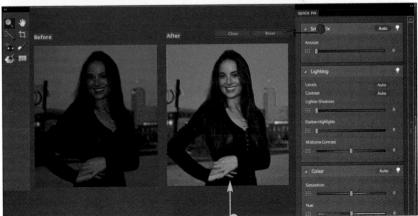

Remove Red Eye with One Click

Using a flash in a darkened room when the subject's pupils are enlarged often creates a red eye effect. Although many newer digital cameras can automatically remove red eye, Photoshop Elements includes a simple fix for this phenomenon.

Remove Red Eye with One Click

- Open a photo in the Quick Fix workspace.
- Click here and select Before & After (Horizontal).

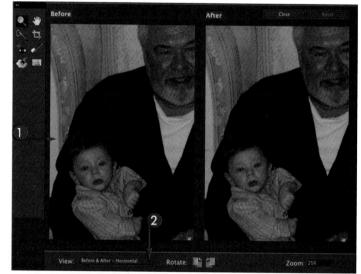

- 3 Click the **Zoom** tool (■) to zoom into the image to better see the red eye.
- Click the **Red Eye** button (on each red eye to be fixed.
- The red in the subject's eye is automatically removed.

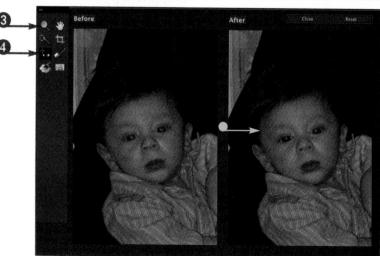

Undo Changes

Advanced Photo Editing with Photoshop Elements

In the Quick Fix workspace, Photoshop Elements allows you to undo changes one step at a time using the Undo arrow in the menu bar. You can also use the opposite arrow, or Redo arrow, to step forward again through your steps. The Reset button in the main image window erases all the steps at once, returning your image to its original state.

Undo Changes

- Open a photo in the Quick Fix workspace.
- Click here and select Before & After (Horizontal).
- Click an Auto button.
- 4 Click a second Auto button.
- Click and drag the sliders until you improve the photo to your liking.
- 6 Click Undo (□) to undo a previous action.
- Click **Redo** () to redo a previous action.
- 8 Click Reset Panels () to restore the original image.

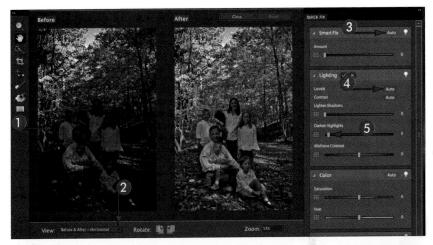

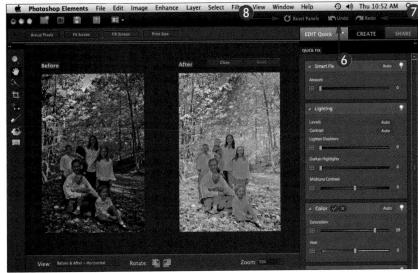

Convert a Color Photo to Black and White

You can easily change any color photograph to a black-and-white image, also called a grayscale image, using Photoshop Elements. Here is one quick way of making this conversion in the Quick Fix workspace.

Convert a Color Photo to Black and White

- Open a photo in the Quick Fix workspace.
- Click here and select Before & After (Vertical).
- 3 Click and drag the Saturation slider completely to the left.

A Smartin Route

| A Smartin Route
| A Smartin Route
| A Lighting | Auroute
| A Lighting | Auroute
| A Control Route
| Auroute

The photo changes to black and white.

- 4 Click the Commit button (☑) to apply the change.
- If the photo appears flat, you can click the **Auto Levels** button.

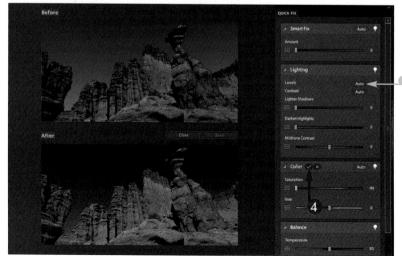

Add a Colored Filter Effect to Any Photo

Advanced Photo Editing with Photoshop Elements

chapter 14

You can visually change the time of day or alter the entire mood of a photo by changing its overall color. By applying the digital equivalent of a colored lens filter in Photoshop Elements, you can repurpose any image, even a bland one, quickly and easily.

Add a Colored Filter Effect to Any Photo

- Open a photo in the Quick Fix workspace.
- Click here and select Before & After (Vertical).
- 3 Click and drag the Saturation slider completely to the left.
- Click and drag the Temperature slider to the left to add a blue tone.
- **(5)** Click and drag the **Tint** slider to the right to add magenta for a purple tone.

The image appears to have a purple filter applied.

(Click the **Commit** button (**▶**) to apply the change.

Note: You can click and drag the **Temperature** slider to the right to add a red tone. You can click and drag the **Tint** slider to the left to add a green tone.

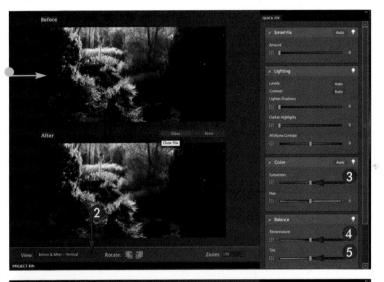

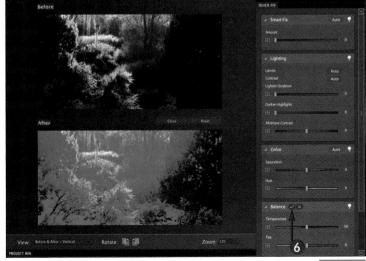

CHAPTER 5

Printing Photosand Other Projects

Digital photography is not only a new way to take photos. The way you store and share those photos also differs from traditional film photography. In addition to the benefits of editing and enhancing your photographs, you have more printing options and more ways to share or show off digital images. This chapter covers the basic concepts and introduces you to many digital archiving and printing possibilities.

Archive Your Photos to CD or DVD Media226
Create a Contact Sheet228
Understanding Resolution230
Digital Photo Printing Options232
Get the Best Prints234
Choose a Photo Printer236
Match Prints to Monitor Display238
Optimize Printer Settings and Print a Photo240
Print One Photo as a Traditional Picture Package244
Use the Create Tab for Fun Photo Options246
Create a Greeting Card248
Print to an Online Photo Service250

Archive Your Photos to CD or DVD Media

With digital photos, your original photo files are your digital negatives. You should always work on a copy of the original file and never alter the original. Photoshop Elements, along with Bridge, can help you store the original photo files on CD or DVD media to keep them safe. After you edit the copies and make photo creations, you can burn a CD or DVD of those images as well.

Archive Your Photos to CD or DVD Media

- Launch Photoshop Elements.
- 2 Launch Bridge.
- 3 Select the individual files to archive.

Note: If you are archiving the entire catalog to CD/DVD, do not select any photos.

- 4 Click File.
- 6 Click Burn CD/DVD.

The Burn Disc dialog box appears and another dialog box asks you to insert a blank disc.

- 6 Insert a blank CD or DVD depending what type of burner you have.
- Click OK.
- 8 Click here and select a write speed for your burner.
- Olick Burn.

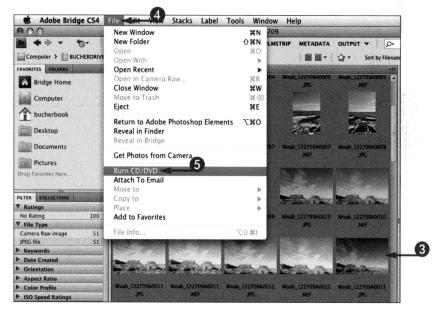

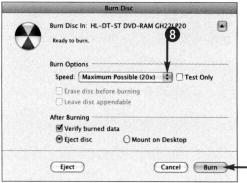

Archiving Alternatives

Although burning a disc through Photoshop Elements and Bridge is fast and easy, many people use their own computers' Burn Disc utility as well as third-party applications such as Toast. Alternatives to burning to CD or DVD media include saving to external hard drives or uploading to off-site servers. Many options are available, and no one thing is better than another; many people make multiple backups. The most important thing is that you do back up your photos regularly, whether to disc, hard drive, or online.

Label Your CD

You can write directly on the top side of CD/DVD media with a marking pen. Use only a marker made for writing on CD/DVD media because the ink from a regular marker can eventually damage the media or the data on the media. Write the name of the disc and the date you burned the disc. You can also print the information directly on special inkiet-printable CD/DVD media with some inkiet printers.

Verify the Disc

A dialog box may appear asking if you want to verify the disc. Click **Yes**. Verifying a disc adds time to the burn cycle. Although verifying does not ensure a correct burn, it does warn you of incorrect burns so that you can try again.

Create a Contact Sheet

You can print a traditional contact sheet from the Bridge browser. When you print a contact sheet using the photos you select and burn to CD/DVD media, you have a visual record of the images on the media.

Create a Contact Sheet

- Open a photo folder in the Bridge browser and select the photos to print.
- Click Output.
 The Output pane appears.
- 3 Select PDF to make a traditional contact sheet that can be printed or viewed online.
- 4 Click Refresh Preview to see a preview of the contact sheet.
- Under Document, select a paper type. If you are printing to a standard printer, click U.S. Paper.
- 6 Click on **Letter** for standard 8.5×11 paper.
- Under Layout, select the number of columns.
- 8 Select the number of rows.
- Olick Use Auto-Spacing to keep photos uniform (☐ changes to ☑).

Printing Photos and Other Projects

chapter 15

The Overlays options allow you to put the filename and extension below the photo to identify it later.

- (changes to).
- **①** Click **Extension** (changes to **☑**).
- Select font, size, and color for your filename overlay.
- (3) Click View PDF After Save (changes to ✓).
- Click Save.

The Save As dialog box appears.

- 13 Name your contact sheet.
- 16 Select a place for it to be saved.
- Click Save.

The PDF document of your contact sheet is then automatically built, saved, and shown for you to review. At this point you can use your regular printer setup to print the PDF contact sheet of your photos.

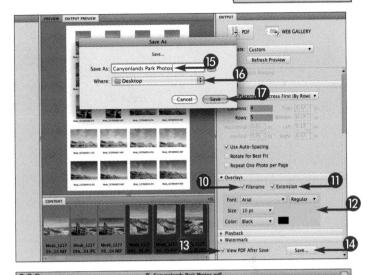

(III)

How do I print a contact sheet that fits in a CD jewel case?

In the Page Setup dialog box, click **Printer**. In the next Page Setup dialog box, click **Properties** and then click **Layout**. If your printer has a CD page size, select it, or click **Custom**. Set the **Width** and **Height** fields to **4.75** inches each. Click **OK** to close each dialog box, and then click **Print** in the Print Selected Photos dialog box. If you cannot set a custom print size, select a small page size from the list. You can print the small page on letter-size paper and trim it to fit a jewel case.

Understanding Resolution

When you take digital photos, view photos on-screen, or print digital photos, the size and quality of the image you view depends on the resolution of the image. The camera, monitor, and printer use different but related types of resolution. Understanding the basic concept is the first step to achieving good quality output from your digital images.

A Basic Definition of Resolution

Resolution refers to the amount of detail you can see in a digital image. On monitors and in images, resolution is described as pixels per inch, or ppi, and as dots per inch, or dpi, for inkjet printers.

Monitor Resolution

The monitor's resolution refers to the number of pixels that fit into the screen. You can set the monitor resolution, such as 1024×768, 800×600, or even 1980×1200, for some of the big 24-inch monitors in the Displays System Preferences pane. The size of a digital image displayed on-screen depends not only on the pixel dimensions of the image itself and the physical size of the monitor, but also the monitor resolution settings. An image 800 pixels wide by 600 pixels high appears smaller but smoother on-screen when the monitor is set to the higher resolution, because a 1-inch square on a monitor set to 1024×768 can contain more image pixels than a 1-inch square on the same monitor set to 800×600.

Image Resolution

Unlike film cameras, digital cameras record details as pixels. The larger the resolution capabilities of the camera — as in a 15-megapixel camera versus a 12-megapixel camera — the greater the number of pixels in the resulting image. To an extent, more pixels in the image means a higher image resolution, and the higher the image resolution, the larger you can print the photo and maintain sharp details. You can also crop more and still have a high-resolution image to print.

Printer Resolution

Printer resolution refers to the fineness of details that the printer can reproduce on paper. Printer resolution is measured in dots per inch, or dpi. The greater the number of dots per inch, the finer the detail in the finished print. An inkjet dot can be made up of many droplets, and inkjet printers have different droplet sizes as well as dpi capabilities depending on the model.

PPI Does Not Equal DPI

It is important to understand that the pixels per inch in an image do not numerically equal the printed dots per inch. In other words, the printer does not print a 300-pixels-per-inch image with 300 dots per inch. Inkjet printers may print a 300-ppi image at 360 dpi on bond paper, 720 dpi on photo paper, or 1440 or 2880 or higher dpi on the highest grade photo papers.

Calculate Desired Print Size by Image Resolution

You can determine the number of megapixels you need to print the best quality photo by multiplying the desired height and width in inches by the 300-pixel-per-inch resolution. For an 8-x-10-inch photo, you multiply 8 times 300 to get 2400 pixels, and 10 times 300 to get 3000 pixels. Your camera needs to capture 2400×3000 pixels, which is 7,200,000 pixels, or just more than 7 megapixels.

Best Image Resolution for Inkjet Printing

When preparing an image for inkjet printing, an image resolution of 240 to 300 ppi at the desired width and 240 to 300 ppi at the desired height of the final print is generally considered the standard for the best resulting print.

Let Photoshop Elements Figure Out the Size for You

You do not have to break out a calculator. Photoshop Elements can help you determine the largest images you can print without altering the image data. Click Image, Resize, and then Image Size. In the Image Size dialog box, deselect Resample Image (changes to). Make sure Constrain Proportions is selected). Set the Resolution to 300 ppi. The width and height change accordingly, showing the largest print you can make with the best detail from the existing photo.

Digital Photo Printing Options

Digital photography offers many different options for getting good prints. You can print photos yourself on a photo printer, take your files to a photo store or kiosk, or use online services. The choice depends on your time and the number of prints you want to make.

Key Considerations

Whichever option you choose, some of the key factors to consider include print quality, print longevity, turnaround time, cost per print, and convenience, and do not forget your time and effort creating the print, sending the file to be printed, or taking the file somewhere and picking it up.

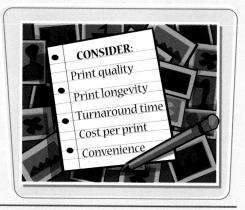

Print on a Home Photo Printer

If you are printing photographs on your home printer, your printer should be designated as a photo printer. Photo printers generally have more ink colors and can produce prints of various traditional photo sizes. Some use dye-based inks, others specialty dye inks, and still others pigment-based inks. They can vary in cost from \$100 to \$800 and up. The cost per print varies from printer to printer and from photo to photo depending on the image itself. In terms of paper and ink, a 4×6 photo generally costs approximately 29 cents, and an 8×10 photo around \$3.

Advantages and Disadvantages

Today's inkjet photo printers offer the instant gratification of seeing your photos printed in front of you, and they produce quality prints that can last years depending on the type of ink and paper used, and the way you store or display the photos. Matching the ink and the paper is essential to the longevity and quality of the print. Most of today's standard photo printers use pigment-based ink, although some use dye-based ink. These printers maximize both color fidelity as well as print longevity. Your average cost per print depends not only on the photo but also on your abilities and the printer's consistency, because mistakes can waste expensive ink and paper.

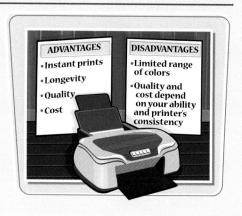

Print at a Kiosk or a Photo Lab

You can print pictures at photo kiosks, located in photo stores and shopping centers, or at traditional photo labs. Print sizes generally range from 3×5 inches to 8×10 inches, with varying prices. A 4-x-6-inch photo generally costs around 20 cents, with larger print sizes often costing significantly more.

Print at an Online Commercial Photo Lab

You can upload pictures to Web sites, such as Kodakgallery.com, Photoworks.com, or even your favorite retailers like Costco.com, which offer commercial photo printing. You simply create an account and upload your digital files. The service stores your photos in online albums. Some of these services allow you to select the photos to print and the specific numbers and sizes of each image at any time, and the service mails you your finished prints. Prices can be as low as 10 to 15 cents for 4-x-6-inch prints.

Advantages and Disadvantages

You can take your memory card or a disc to a kiosk or lab to have prints made. Many kiosks offer basic image-editing features such as cropping and red-eye removal, giving you the opportunity to enhance your photos before paying for a print. The longevity of the kiosk or photo lab prints vary with the type of equipment the kiosk or photo lab uses to print the photos, although most photo lab prints offer the same print life as traditional photographs.

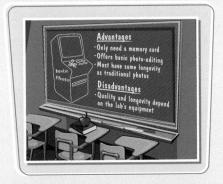

Advantages and Disadvantages

Most online photo labs allow you to share pictures with family and friends for free. Some even send an e-mail to your designated friends when you add photos you want them to see, offering a new way to share your photos. You and your family and friends can all order prints and even novelty items, such as t-shirts, books, mugs, calendars, and cards, with your photos printed on them. Many Web site photo printers use high-quality traditional photo-printing techniques so your traditionally sized photo prints last as long as film prints.

Get the Best Prints

Regardless of where or how you print your pictures, you can save yourself time and money by taking certain steps both in selecting the printing service or printer and in preparing your photos for print.

Evaluate and Test

Print prices and print quality can vary widely with kiosk printers as well as photo labs and online printers. Ask the store or service if they produce traditional photographic prints or if they use inkjet or another type of printer. It also pays to obtain sample prints using the same photo from several services and compare the costs and the quality of the prints. Sometimes interacting with real people during the print process for questions and evaluation is priceless.

Image Resolution Setting

You get the best results by starting with a high-resolution image file. Set your camera to the highest resolution, which may be called Large, Fine, Superfine, and so on, and to the best compression setting. This ensures that the image file size is large enough and has enough resolution to print high-quality photos and enlargements anywhere you decide to print them.

Edit and Enhance Your Photos on a Computer First

Although some kiosks and printing services can crop and make other enhancements to your photos, you can best control the changes and make better decisions yourself using photo-editing software, such as Photoshop Elements. You can be more selective and print only the best photos enhanced the way you want them.

Choose Pictures for Enlargements

Whether you print enlargements on a home printer or use an online or other commercial service, make sure the photos you enlarge have sufficient resolution to be enlarged. Photos with great color, strong composition, and good contrast also make better enlargements. Spend the extra time editing the image carefully and consider making test prints using small areas of the photo to check the results before printing the enlargement.

Crop with Restraint

Because cropping reduces the overall file size, use restraint when cropping photos. The more you crop, the smaller the file becomes, and the smaller the print you can make from the file. Be sure to check the file size in Photoshop Elements before cropping.

When and How to Resample an Image

You may sometimes need to resample images for print — for example, to make the photo larger than the original dimensions. For the Web, you almost always need to resample down, or downsample, the image to make it smaller so it loads more quickly. Downsampling throws away pixels. When you resample up, Photoshop Elements adds new pixels by interpolation — blending the data from the existing surrounding pixels to create new ones. The final image loses some detail and sharpness.

Change the File Size

If you leave **Resample Image** selected () in the Image Size dialog box when you change the width and height, you also change the original file size or the original pixel dimensions. When you resample an image, you add or delete image pixels from the image. Changing the pixel dimensions by resampling affects the image quality both on-screen and in print, often negatively.

Select Interpolation Methods for Resampling

To maintain the most detail when you need a smaller file size, such as preparing a photo for the Web, leave **Resample Image** selected () in the Image Size dialog box and click to select **Bicubic Sharper** for the interpolation method. If you must enlarge the file size, use **Bicubic Smoother**. Remember that Photoshop Elements is inventing pixels to fill in the added space, so you should avoid overly enlarging the file.

Choose a Photo Printer

Choosing a photo printer can be educational and fun or downright confusing. Before you begin a search for your personal photo printer, take some time to learn what to look for in a printer so that you can print high-quality photos at home.

Shop for a Photo Printer

Printer manufacturers include so many numbers in the specifications that figuring out what is important or how it compares with another brand of printer can be difficult. First, make sure that you are purchasing a photo printer and not just a color printer. Next, ask yourself what is the largest photo you want to print. The larger the print capabilities, the more expensive the printer. Finally, realize that photo printer technology changes radically every few years. Buy the printer that meets your needs today. You will most likely change printers as the technology improves.

bye Sublimination © Inkjet

Types of Photo Printers

You can choose from two types of photo printers — inkjet and dye sublimation. Most photo printers today are inkjet printers. Because they are designed to print high-quality photos, they may print more slowly than a printer designed to print text documents. However, inkjet photo printers can be used to print both photos and text. Dye sublimation printers produce very high-quality prints, but the cost per print is much higher than that of inkjet photo printers and they do not print text well.

Inkjet Printers

Inkjet printers spray tiny droplets of ink through a series of nozzles on the print head. The inkjet printers from various manufacturers differ in the technology used to force the ink through the nozzle as well as the type of ink used. Some inkjets use a dye-based ink and others a pigment-based ink. Desktop inkjet printers can print various sizes from 4×6 inches all the way up to 13×19 inches and longer depending on the brand and the model. Many even print on roll paper, allowing you to make many prints quickly and easily.

Dye Sublimation Printers

Dye sublimation printers create high-quality, continuous-tone prints that resemble traditional photo prints. They use colored dyes on individual layers of plastic transfer film and use heat to transfer the images to special types of papers. The print sizes are limited with dye sublimation printers and the costs per print are often higher than for inkjet prints.

Printer Resolution

Printer resolution refers to the fineness of details that the printer can reproduce on paper as measured in dots per inch or dpi. Theoretically, the greater the number of dots per inch, the finer the tonal subtleties in the finished print. Select a photo inkjet printer that can print at least 1440 dpi. Higher resolutions might consume more ink, and require longer printing times, but produce finer detail and gradations. The human eye sometimes cannot see the difference between a photo printed at 1440 dpi and the same photo printer at 2880 dpi on the same paper. The printer

resolution needed to print the best quality photo also depends on the type of paper surface.

Printer Speed

Unless you expect to print a large number of photographs, speed is not usually a critical issue. The advertised speeds of the printer often are not necessarily standardized, so the numbers are difficult to interpret and compare. Take time to do some research and see what other photographers have to say and how different printers compare against each other on different photo Web sites.

Print Quality

The most important feature of a photo printer is the quality of the print. Try to collect print samples from the various printer models you are considering and on similar types of paper, such as glossy photo prints from one printer manufacturer and glossy photo prints from another manufacturer, always using the printer manufacturer's own papers. Compare the black areas in the photos. Look at the photos in different lighting conditions to see if the colors change. Pick the printer that produces the print you like best.

Match Prints to Monitor Display

Matching what you see on-screen to what you see in a photo print can be a challenge. Controlling the reproduction of color is called *color management* and is one of the most difficult parts of digital photography.

What to Expect

Prints can never appear exactly the same as what you see on the monitor because the way monitors produce color is different from the way printers produce color. The biggest difference is that you see the colors in a print because you see the light reflecting off the colors of the paper, whereas the image on a monitor has light glowing from behind it.

Monitor Color versus Printed Color

The screen and printer use different color systems — RGB on-screen and CMYK on the printer. The monitor produces colors by transmitting combined red, green, and blue light sources. We therefore see colors on the monitor as transmissive light. The printer reproduces colors by combining CMYK: cyan, magenta, yellow, and black inks. Many photo printers today print using up to nine colors of ink, with additional variations of CMYK, such as light cyan and light magenta to increase tonal variations. We see the printed colors as they are reflected off the paper, or as reflected light. When you print the image displayed on-screen, the RGB must be converted to CMYK — or variations of CMYK — and that process is not exact.

Basic Color Management

Professional photographers use a color management system to try to make colors more consistent from camera to monitor to printer. Color management involves special hardware and software that calculates the color each device produces. The software makes adjustments to match the color space or range of colors a device can produce with an established device-independent standard from the International Color Consortium, or ICC.

Printing Photos and Other Projects

Set the Monitor Colors

Good color management requires a hardware and software system. You can get close color matches by following certain steps, starting with monitor calibration and profiling as described in Chapter 14. At the very least, use the Adobe Gamma software that comes with Photoshop Elements, or Apple's Display calibration to set your monitor.

Choose the Editing Color Space in Photoshop Elements

Before changing any photos that will be printed, set the working color space. Click **Edit** and then **Color Settings** from either the Quick Fix or Standard Edit workspace. Select **Always Optimize for Printing** to set the Adobe RGB color space for editing and printing photos.

Match the Print Options

Printing on your printer involves two separate print dialog boxes, one for Photoshop Elements and one for your particular printer. When you are ready to print an image, set the print options in Photoshop Element's Print dialog box. When you click **Print**, your own printer's dialog box appears. Set the options for your printer and match the paper description to the type of paper you are actually using.

Keep Camera Settings Consistent

You can also get more consistent color by using the techniques provided in this book and by keeping your camera settings consistent. Avoid judging the colors and tones of the photo you just took using the small reviewing screen on the camera. It can display only a very limited number of pixels and colors. Avoid using the camera controls to add saturation or contrast. You can use the more powerful image-editing software, such as Photoshop Elements, on your computer.

Optimize Printer Settings and Print a Photo

When you print photos and other images on your personal printer, selecting the appropriate printer settings first can help you get the best results. Although you can print from the iPhoto or from Windows Live Photo Gallery, you have more options for better-quality prints when printing from Photoshop Elements.

Optimize Printer Settings and Print a Photo

- Open a photo file.
- Click File.
- Click Print.

Photoshop Elements File Enhance Layer Select Filter View Window Help Open... *0 Browse with Bridge Open Recently Edited File After Close *W ☐ Save #S Save As... **⊕**#S 6 19 Save for Web... 2897 Adobe Photo Downloader... Attach to Email... File Info 1第位7 Process Multiple Files Import ₩P

The Print dialog box appears.

Click Page Setup.

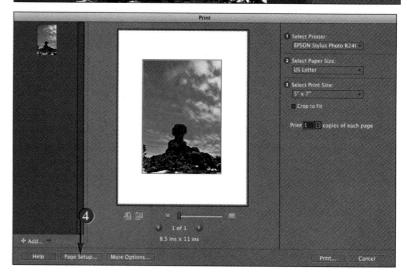

Printing Photos and Other Projects

The Page Setup dialog box appears.

- Select a printer.
- Select the paper size.
- Click an orientation depending on your photo.
- 8 Click OK.
- The settings in the Print dialog box reflect the paper size and orientation you choose.
- Click Print.

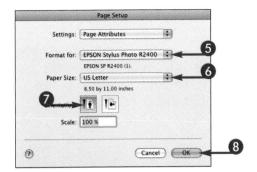

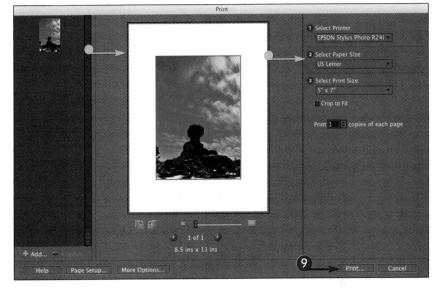

Why do I get so many warning dialog boxes when I want to print a borderless photo?

Some photo printers can print so-called borderless photos, images printed all the way to the edges of the paper. The warnings indicate that the amount of ink sprayed is reduced as the printer approaches the paper borders. Although this is technically accurate, the changes are generally imperceptible to the viewer. Click **OK** to close these boxes.

Why do I have bands or wide streaks across the print?

Banding lines and streaks on a print can come from using the wrong paper type or thickness, from misaligned printer heads, or from clogged inkjet nozzles. You can use the utility software provided with your printer driver to test and align the inkjet heads

and/or clean the inkjet nozzles. You may need to perform a number of cleaning cycles complete with test prints to clear a blocked nozzle.

Optimize Printer Settings and Print a Photo (continued)

You should always set the paper type to match the specific paper and print surface you are using. The printer driver can then determine the optimum amount of ink to spray as well as the correct spray patterns to produce the best results on that particular type of paper.

Optimize Printer Settings and Print a Photo (continued)

Note: You may get a Print Clipping Warning dialog box about the paper's printable area. Click OK if you are using the borderless feature of your photo printer. Otherwise, select Scale to Fit Media (■ changes to ✓) and then click OK.

The Print dialog box appears with the name of your printer in the Printer field.

- Select your printer.
- Select Print Settings.

Your printer's print settings appear.

Note: The Print dialog box and options vary depending on the printer model and your computer.

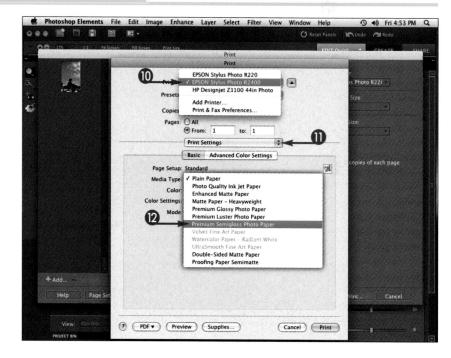

Printing Photos and Other Projects

Select Color or Black & White.

Note: If a Borderless warning dialog box appears, click **OK**.

Note: If the Printable Area -Maximum dialog box appears, click **OK**.

- Select Best Photo.
- If you are using ICC profiles to get the best color accuracy from monitor to print, in the Color Settings options, select Off (No Color Adjustment).
- (3) Click Print.

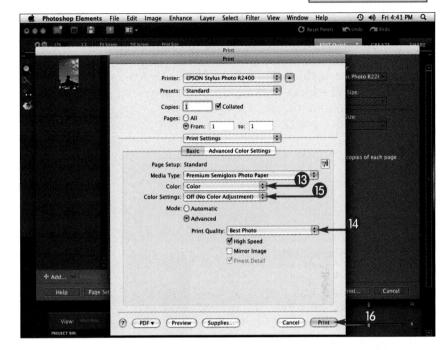

Why should I try different kinds of photo paper?

Different kinds of paper and the different surfaces of that paper give your photos a different look and feel. Many people use glossy paper for portraits, matte paper for landscapes, and watercolor-type paper for fine art black and white photos. Commercial printers have their own paper, plus there are many other manufacturers who make great papers, each with unique properties. Many people always print on the same glossy paper that came with the printer, whereas others try different paper with each photo. For optimal results, read the paper manufacturer's suggestions on print settings for each paper you use. Most paper manufacturers' Web sites also have information on each paper that they make, so you can get the best prints from each paper.

Print One Photo as a Traditional Picture Package

You can print various sizes of a photo like traditional portrait studios do, on a single page using your own printer and Photoshop Elements. You can even add frames or borders to customize your photos.

Print One Photo as a Traditional Picture Package

- Open the photo in Photoshop Elements.
- Click the Edit tab.
- Click File.
- Click Picture Package.

The Picture Package dialog box appears.

- Select a paper size.
 If you are using regular letter-size paper, select 8.0×10.0 in.
- Select a layout.
 - Many different options are here from a page full of wallets to two larger-size prints. The print package also changes depending on what page size you select.
- 300 pixels per inch is the default resolution. This should be great for most prints.

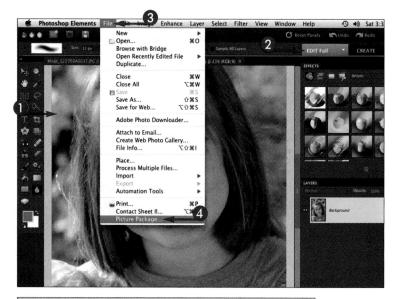

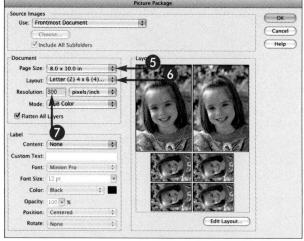

Printing Photos and Other Projects

- If you want to add a label to the photo, select **Custom Text** and then fill out the rest of the Label options.
- Click OK.

 Your picture package is built in a new window.

At this point you can go through the same steps as you do for a regular photo print.

If you want to save your picture package so that you can print it later, this is a good time to do so.

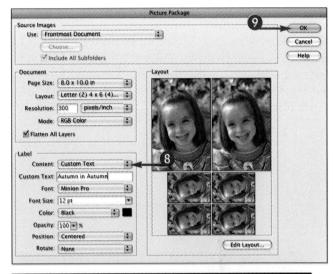

TP.

What if these package options are not the exact size and amount that I need?

Underneath the photos in the Picture Package dialog box is a button labeled Edit Layout. Clicking that button gets you to the Picture Package Edit Layout dialog box. This allows you to really customize your picture package by changing your paper size and adding and deleting specific photo zones. After you have built your new picture package, remember to click **Save** in the upper right corner and then name the package; it will be listed with the standard packages the next time you want to print a picture package.

Use the Create Tab for Fun Photo Options

Photoshop Elements 8 has a special tab with a lot of fun and creative new options that allow you to use your photographs to make professional-looking products. You edit the photos in the Edit tab, and then you can transform your photos into galleries, books, and greeting cards with just a few clicks.

What Are the Options?

Professional-quality photo projects are at your fingertips with the click of the Create tab in Photoshop Elements. Similar options are also available in iPhoto or in Windows Live Photo Gallery or other programs, but with Photoshop Elements the results are very professional and easy to create. It is nearly seamless to take a photo from the Bridge photo browser, edit it, and then easily produce a final product.

Create a Book

After you have edited a number of photos, such as from a vacation, party, or event, they are stored in your Project Bin. Many different themes are available for you to work with, or you can create your own, when you move into the Photo Book portion of the Create tab. Options for different print sizes and layouts range from classic to artsy to contemporary. This takes a number of steps, but the process is smooth as you move through each menu of the Photo Book building process.

Photo Collage

In some cases, it is nice to have a number of photos all on the same page. You might want to do this to show each class photo over the years for someone's graduation party, or even just so you can put several smaller photos on a large piece of paper for another project. Selecting a theme or creating your own is easy, as is laying out the photos on the page. Simply drag, turn, and resize the photos to your liking to create a collage masterpiece.

Slideshows and Galleries

The Create tab also allows you to output your photos. Clicking either the Web Photo Gallery or PDF Slide Show instantly takes you back to the Bridge browser and its Output menu. The menu gives you options for displaying the photos, and in what format. It simply takes the photos that you have already been working in and are already in your Project Bin and moves them into the slide show or gallery.

Create Photo Prints

Similar to the Slide Show and Gallery tabs, the Photo Prints tab takes you seamlessly back to the Print dialog box. You can do a lot from this printing module, like zoom the photo or flip it vertically or horizontally. In the Printing Choices tab of the More Options dialog box, you can place the filename on the print or even flip the photo to print it on material to make an iron-on, so you can put your favorite photo on a t-shirt.

More Options	
Printing Choices	
Photo Details Show Date Show Caption Show File Name	Iron-on Transfer ✓ Flip Image
Border Thickness: 1 Inches :	Trim Guidelines ■ Print Crop Marks
Help	Cancel Apply

Create a Greeting Card

Given all the options available in the Create tab, you can see just how easy some of these projects are. Using the predesigned templates in Photoshop Elements, you can quickly make greeting cards with your photos. You can also add text if you want to personalize the card. You can create your own thankyou notes, baby announcements, valentines, and more, and then share them easily by printing them, adding them as an attachment to e-mail, or using an online printing service.

Create a Greeting Card

- Open a photo in Photoshop Elements in the Standard Editor workspace.
- Click Create.
- Click Greeting Card.

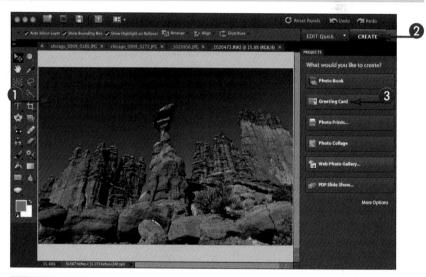

The Greeting Card panel appears to the right.

- 4 Select a card size.
- **5** Choose a theme, scrolling down to see the options.
- 6 Choose a layout.
- Click Done.

At this point Photoshop Elements builds your greeting card.

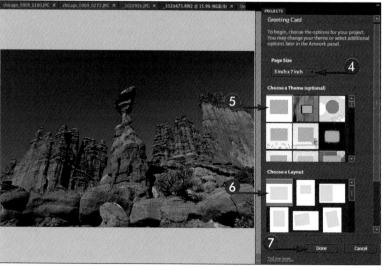

Printing Photos and Other Projects

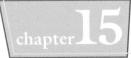

The Content panel appears.

- 8 Click the corner anchors to adjust the photo.
- Oouble-click here to open the Zoom toolbar to fit your photo to the layout.
- Click the Commit button (☑) to apply the settings.
- You can click and drag any additional backgrounds or icons from the Content panel.
- ① Click **Apply** to close the panel.
- Return to the Standard Edit workspace.
- (III) Click the **Text** tool (IIII).
- Select a font and size.
- **15** Type your text.
- Click the Move tool () and place the text exactly where you want it and resize if necessary.
- Save your greeting card by clicking **File** and then **Save**.
- 13 Type a name and click Save.

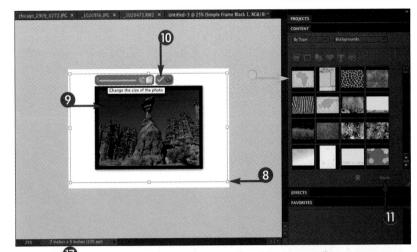

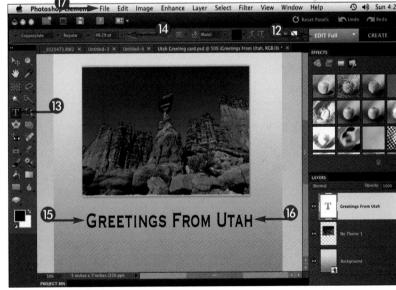

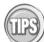

What can I do with a photo greeting card?

When you click **Save**, as in Step **18**, the Photo Greeting Card dialog box appears. You can **Create a PDF** of the card, click **Print** to print the card on your

printer, click **E-mail** to send the card directly as an e-mail attachment, or click **Order Online** to print the card using Adobe Photoshop Services through the Kodak EasyShare gallery.

Is there an easier way to add text to a greeting card?

In the Windows version, you simply double-click the background of the greeting card to create a text box to type in. You can do this right from the greeting card menu. Either way,

placing text onto your custom photo greeting card is easy and allows you to do a lot of creative things with it.

Print to an Online Photo Service

Although printing your digital photos on your own printer is convenient and immediate, it can also be costly and time consuming. Uploading your images to an online service has advantages, including being quick and providing the exact costs upfront.

Fix Your Photos First

Whether you print your own photos or send them out to be printed, you can get the best finished prints by cropping and enhancing the colors and tones of the photos yourself using Photoshop Elements or another photo-editing software.

Use any Online Photo Printing Service

You can save your edited photos in a separate folder to make them easy to find and print. Open your Web browser and log on to any Web-based photo service, such as Photoworks.com or Costco. com — your local photo shop might even have their own online option — and follow the steps on-screen to upload your photos. Each online service offers a guide and uploading software to help you save and upload your photos to fit their specifications. You can also burn a CD/DVD and mail it to an online service, where they upload all the photos for you. This is very useful if you have a slow Internet connection or numerous photos to upload.

Order Prints from within Photoshop Elements

You can order prints directly from within Photoshop Elements without launching a separate Web browser. Adobe Photoshop Services is linked to Kodakgallery.com.

Adobe Photoshop Services

Click to select the photos you want to upload from Bridge. Click **File** and then **Order Prints**, or click **Order Prints** in the shortcut menu bar. Photoshop Elements prepares the images and opens the Adobe Photoshop Services dialog box. The selected photos are listed along with a number of choices for print sizes, prices, and quantities.

Set Up an Account

You can open a free account on Photoworks.com, Kodakgallery.com, and many other online photo printing services. You can use your account to upload as many photos as you want to print or just share online. You can add e-mail addresses for your friends, and the online service can send a personal message to any of them to let them know you have photos ready for viewing and printing. You can create individual online albums for different events and let different friends and family members log on to specific albums.

Order Prints and More

Online photo services can print photos at various sizes on different paper surfaces. You can even use the service to help you create and print a variety of photo gifts, such as mugs, puzzles, calendars, cards, books, tote bags, and more. Your items are professionally produced and sent to the addresses you specify.

Online Photo Printing Advantages

When you use an online printing service, you know exactly how much each print costs. If you use a high-quality online service, the photographs are printed using equipment similar to silver halide film printing, so you can expect your photos to last as long as traditional film prints. The photo gift items are convenient, and being able to share the photos online and let others purchase their own favorites is an added benefit.

CHAPTER

Sharing Photos Electronically

Do you want to share your files on the Web or attach them to an e-mail? This chapter shows you how to prepare your photos for online viewing. It also shows you how to safeguard your photos with a personal copyright.

Add a Personal Copyright to Protect a Photo

If you upload your photos to a Web site for viewing but do not want others to use the files without your permission, you can add a personal copyright to the photo. You can make the personal copyright transparent to keep the photo visible but still protected.

Add a Personal Copyright to Protect a Photo

- Open Photoshop Elements in the Standard Edit workspace.
- ② Click the **Type** tool (图).
- Select the font family, style, size, and color you want in the Options bar.
- Click in the document to set an insertion point.
- 5 Press Option + G.

Note: On a PC, press All and type **0169** using the number pad on your keyboard.

- The copyright symbol appears.
- Type your name next to the copyright symbol.
- Click the **Move** tool () and place the text where you want it and resize if necessary.
- The copyright symbol and your name are on a type layer above the photo layer.
- 8 Click the Effects tab.
- O Click Layer Styles ().
- Double-click one of the bevels to make the type embossed.

Sharing Photos Electronically

- Click here and select Visibility.
- Click the middle button, Hide.
- The copyright and your name appear as a transparent, embossed copyright on the photo.

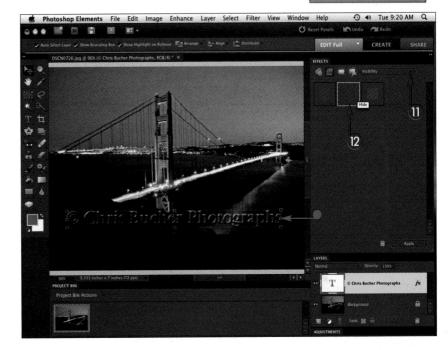

How can I move the copyright to a different location on the photo?

Because your copyright is on a separate layer, you can easily move it to another location

on the photo. Click the **Move** tool () and click and drag in the center of the copyright to move it where you want.

Can I change the size of the copyright?

Yes. Because your copyright is on a separate layer, you can easily change its size. You can cover as much or as little of the photo as you feel appropriate. Click the **Move** tool (and click)

and drag a corner of the bounding box around the copyright to stretch the copyright to the size you want.

Save a JPEG for the Web

Photo files intended for printing can be large. If you upload this same photo file to the Web, it downloads and appears very slowly on the viewer's screen. Much like iPhoto and Windows Live Photo Gallery, Photoshop Elements includes a Save For Web command to automatically save a duplicate of the file in another format optimized for Web viewing.

Save a JPEG for the Web

- Open Photoshop Elements in the Quick Edit or Standard Edit workspace.
- Click File.
- 3 Click Save for Web.
 The Save For Web dialog box appears.
- Click here and select JPEG.
- Click here and select a JPEG quality setting.
- Alternatively, you can select a numeric quality setting from 0, low quality, to 100, high quality. This determines how much the photo is compressed.
- 6 Check that the file quality and size are acceptable in the preview window.
- If you already have very highresolution images, you may need to resize the image. The easiest way is to just input a percentage for the downsampled photo.
- Click Apply to resize the new image.
- Olick OK.

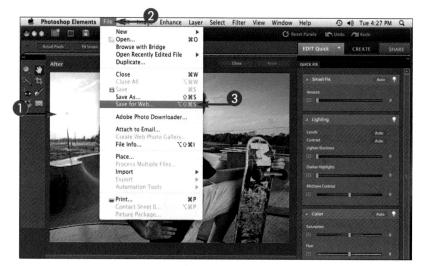

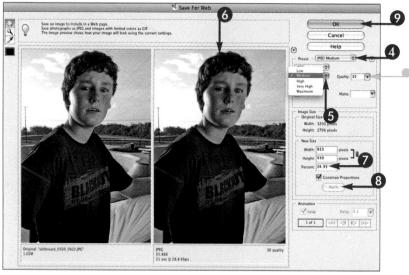

Sharing Photos Electronically

The Save Optimized As dialog box appears.

- Olick here and select a folder in which to save the file.
- Type a filename.
- Click Save.

Photoshop Elements saves the JPEG file in the specified folder. You can open the folder to access the file.

 The original image file remains open in Photoshop Elements.

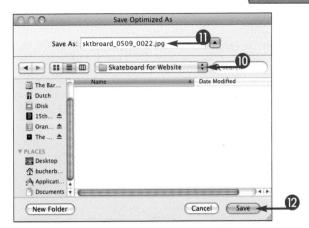

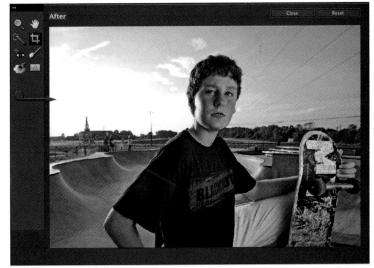

What is image compression?

Image compression applies a mathematical formula to reduce file size. JPEG, the compression method most often used with photos, retains all the color information but deletes some pixels to shrink the file size. You can select the amount of JPEG compression by choosing an image quality setting. Lower quality increases the amount of compression and creates a smaller file. Always edit the photo before you save it as a JPEG. Each time you open a JPEG file, edit it, and save it again as a JPEG, the loss of data compounds, further reducing the image quality.

Why not just use the Image menu to resize the photo file?

The Save For Web dialog box automatically saves the file as a duplicate so you do not risk overwriting your original. It also allows you to preview the different options for optimization specifically intended for Web files in a side-by-side view. The preview image window changes to reflect any changes you make to the settings, such as compression and color options, or the size of the image.

Preview an Image in a Web Browser

Photoshop Elements lets you preview the image in a Web browser so you can see how it will appear to your viewers. You can preview the image in any Web browser you have installed on your computer. This would be helpful when you want to know how a Web browser is going to interpret the color and contrast of your photos. Photoshop Elements, iPhoto, Windows Live Photo Gallery, and really all photo editors are designed just for images. Web browsers have so many jobs to do — tools, text, videos, and photos — that sometimes the photos do not appear properly.

Preview an Image in a Web Browser

- ① Open Photoshop Elements in the Quick Fix or Standard Edit workspace.
- Click File.
- Click Save for Web.

The Save For Web dialog box appears.

4 Click here and then click Edit List.

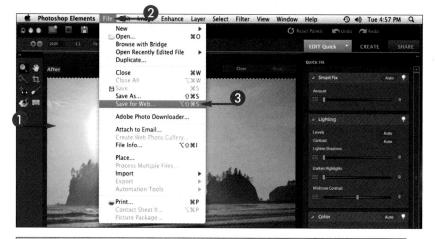

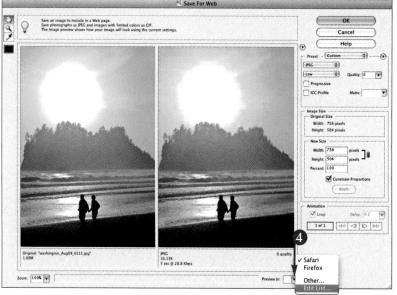

Sharing Photos Electronically

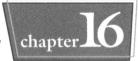

The Browsers dialog box appears.

- 6 Click Find All.
- Photoshop Elements populates the list with the browsers installed on your computer.
- **6** Click a browser name preferably the Web browser that you use most frequently.
- Click Set As Default.
- Click OK to close the Browsers dialog box.
- Click the Preview In arrow.

Photoshop Elements opens the default Web browser on your computer and displays the image in the browser window.

General information about the image appears below the preview.

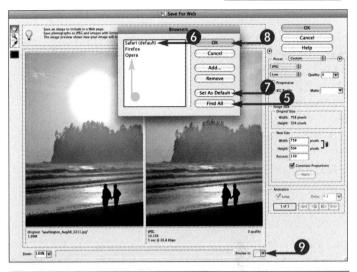

Why should I preview the image in various browsers?

Different browsers can make colors appear differently because the various browsers use different color spaces. To make sure your image appears the way you

want it to, test it in as many browsers as possible.

What is all the information below the preview image?

Photoshop Elements lists the image file format, the dimensions in pixels, the image size, and compression specifications. It also shows the coded HTML information

to build a Web page with the image.

ensions: 758w x 5041

Size: 10.13K

Create a Web Photo Gallery

You can have Photoshop Elements create a photo gallery Web site that showcases your images. Photoshop Elements not only sizes and optimizes your image files for the site, but also creates the Web pages that display the images and links those pages together.

Create a Web Photo Gallery

Open the Bridge browser, or from the Create tab click Web Photo Gallery.

- Click the Output tab.
- Click Web Gallery.

Select the photos that you want in your Web gallery from the filmstrip on the bottom. If you do not select any photos, Photoshop Elements displays all the images in your gallery.

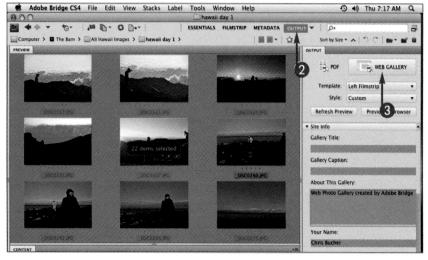

Sharing Photos Electronically

- 4 Click here and select the form of your Web gallery.
- Click Refresh Preview.

Bridge takes your photos and begins to build them into a preview of your Web gallery in the preview pane. This takes a few minutes depending on the quantity and resolution of your photos.

This is an active Web gallery so you can start to see how the gallery, main image, and filmstrip work.

- Alternatively you can click
 Preview in Browser to open your Web gallery in your default Web browser.
- **6** Type a title for the gallery banner.
- Type a caption.
- 8 Type any additional information about the gallery here.
- Type your name.
- You can also type an e-mail address and copyright info.
- Click Refresh Preview again to apply your changes.

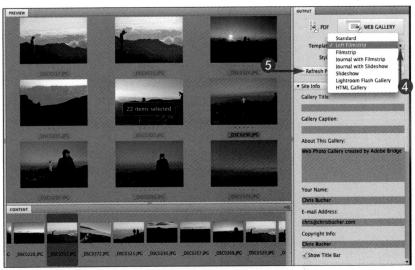

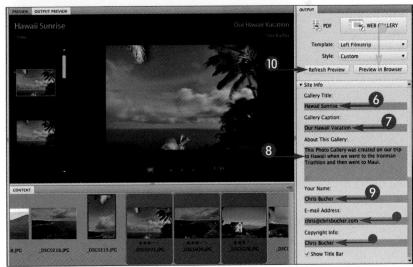

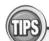

How do I determine the number of thumbnails that appear on each photo gallery page?

Photoshop Elements arranges the images on the pages based on the size of the thumbnails. To increase the number of images on each page, select a smaller thumbnail size. To decrease the number of photos on each page, select a larger thumbnail size.

How does the e-mail address appear in my gallery?

The photo gallery style you choose determines where the e-mail address appears on the page. It may appear below the gallery title, or it may appear below each large image. The e-mail address that appears is clickable; clicking it opens a new e-mail message on the viewer's computer.

Create a Web Photo Gallery (continued)

When you create a Web photo gallery, you specify the size and quality of the images that appear in the gallery. This phase of creating your Web gallery is where you can really customize the look and feel. Bridge makes it easy and intuitive.

Create a Web Photo Gallery (continued)

- Click any of the color boxes to activate the Color Picker. Main creates a frame around your gallery.
- Click the box for Thumbnail to select color for that area.
- Click the box for Slideshow to select color for that area.
- You can change every part of the gallery to give it all different colors or all the same color.
- With the Color Picker open, use the slider on the right to determine how bright the tone of your colors should be.
- Click your cursor somewhere on the color wheel to select the color you want to place in that zone on your web gallery.
- Click OK.
- Click **Refresh Preview** again to apply your changes.
- (B) If you want to see the names of your photos, click **Show File** Names (changes to).

Sharing Photos Electronically

- Select a size for the preview.
- 20 Select a size for the thumbnails.
- 2 Select the duration of the Web gallery's slide show. 3 to 5 seconds is a great place to start.
- 22 Select a transition effect.

The slide show is there when you have saved the entire Web gallery and opened them in a Web browser.

- Click **Refresh Preview** again to apply your changes.
- 24 Type a name for your gallery.
- Click Save to Disk (○ changes to ⊙).
- Click Browse.
- 27 Select where to save your gallery.
- **@** Click **Save**.

Bridge creates a folder containing your Web gallery. The window displays how the gallery looks in a Web browser. You can click a thumbnail to view a large version of the photo.

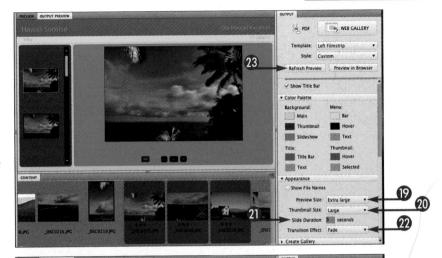

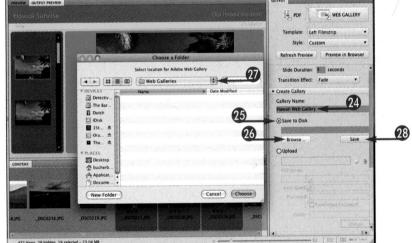

How can I view my Web photo gallery as it will appear in a regular Web browser?

You can launch your Web browser and then open the "index.html" file located in the folder you specified in Step 27. You can typically click **File** and then **Open** to open a file on you

and then **Open** to open a file on your computer using your browser. The "index.html" file represents the home page of your Web photo gallery.

Photoshop Elements creates a folder with all the parts required for a Web gallery page and includes the HTML code. You can upload this folder to your Internet service provider using a Web publishing application such as Adobe GoLive or Macromedia Dreamweaver, or you can use other file transfer protocol (FTP) software from your Internet service provider.

Send an Image with E-mail

Sharing your photos with your friends and family is easy. You can use Photoshop Elements to automatically attach an image to an outgoing message in your computer's e-mail program.

Because of the variety of different e-mail applications out there, each e-mail program has a slightly different process to attach photos, but the general process remains the same.

Photos Directly from Photoshop

Photoshop Elements, actually Bridge, as well as most photo-editing programs, have functions that bring your photos directly into your server-based e-mail program such as Outlook or Apple's Mail. This is usually as easy as clicking **File** and **Attach to Email**. This opens your e-mail program and attaches the photos directly to a new outgoing e-mail document. You can also use the Share tab in Photoshop Elements to direct you on saving the photos for e-mail.

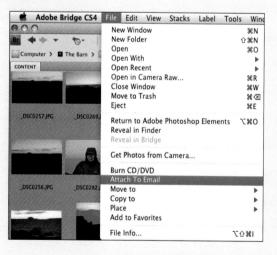

Drag and Drop

Some e-mail programs, such as Apple Mail, allow an even easier way to attach photos, and this is sometimes called *embedding* photos. In this case you just drag your photo file from wherever it is on your computer right into the text of the e-mail currently being composed.

Sharing Photos Electronically

Use the Attach Button

On Web-based e-mail programs such as Yahoo Mail, Hotmail, or Gmail, all you have to do is click the **Attach** button (). Sometimes, this is even shown as a photo icon. Clicking the **Attach** button opens a file browser that directs your Web browser to your photos folder. You then select the photo that you want to attach and click **Upload** or **Select**.

Many Photos All at Once

In some cases, you might need to send many photos all at once. Not all e-mail providers can handle that many photo files, so you need to compress them. Put all the photos that you want to send in a folder and then use Zip or Stufflt programs to compress your folder into one smaller file. On a Mac, you can do a Control +click of your folder (Ctrl +click in Windows) and select a compression method. Then you simply attach the whole compressed file of all the photos just like you would if you were attaching a single photo.

Web-Size Your Photos for E-mail

Saving photos for the Web was discussed earlier in the chapter. Most new cameras take very high-resolution photos and those files are quite large, really too large to e-mail. So do not forget to resize your full-size photos for the Web so that they will fit into an e-mail.

CHAPTER 7

Special Projects for Photoshop Elements

Although the Quick Fix workspace allows you to make quick and easy edits to your photos, the Standard **Edit workspace in Photoshop** Elements offers a full line of powerful image-editing tools. You can select the **Standard Edit workspace** from the Welcome screen or by clicking the orange Edit tab in the main Photoshop Elements window, You can use the layers in this flexible workspace to adjust areas, crop with creative shapes, colorize, and more, and never alter your original image.

Customize the Panel View268
What Are Layers and Why Use Them?272
Find Your Way Around the Layers Panel 274
Straighten a Crooked Photo276
Make a Creative Crop280
Select an Area of a Photo282
Whiten Teeth Digitally284
Duplicate the Background Layer286
What Are Photoshop Elements Filters?287
What Is the Filter Gallery?288
Understanding Styles and Effects290
Colorize a Black-and-White Photo292
Create a Sepia-Toned Photo294
Remove Blemishes with One Click296
Fix Skin Tone297
Adjust a Photo before Applying Filters298
Convert a Photo into a Sketch300
Convert a Photo into a Painting302
Create a Digital Photo Collage304
Create a Digital Panorama308
Understanding Type Layers310
Add and Edit Text312
Move and Resize Type to Fit a Photo313
Add Text and Match the Color
to the Photo314
Rotate Text316
Warp Text317
Stylize Text318

Customize the Panel View

In addition to the Layers panel, the Effects panel makes it easy to use all the image-editing power of Photoshop Elements. From this panel, you can not only apply the various layer styles and effects, but also access almost all the filters listed in the Filters menu. Customizing the Panel view can make you much more productive.

Customize the Panel View

Click the Edit tab.

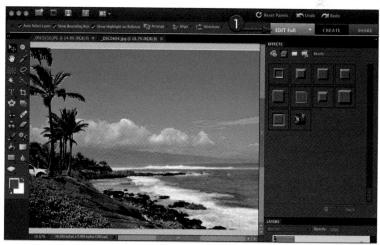

- The Effects panel is the first panel in the Panel Bin.
- ② Click the Layers panel's **More** icon (-■).
- Select Panel Options.

Special Projects for Photoshop Elements

The Layers Panel Options dialog box appears. You can change several Layers panel settings in this dialog box.

- 4 Click the smallest thumbnail size (changes to).
- Click OK.
- The Layers panel thumbnails become smaller, so more layers can fit in the panel.
- You can also click the Effects panel's More icon (☐) and select List View to see the choices as a list rather than as large thumbnails.

How can I see different items in the panel?

By clicking **Window** in the menu bar, a list of all the panels' options scrolls down. Just clicking any of these adds one of the panels to the Panel Bin. You can add all of the panels to the Panel Bin, but that gets confusing to work with. Try to keep open just the few panels that you need.

Are there other ways to arrange the panel?

You can also create a panel group. Once you have a few panels in the Panel Bin, you can click the tab of each panel and drag it next to another panel tab. The tabs are then lined up side by side for quick access by just clicking each one, and not scrolling up and down. You can close the grouping by clicking the **More** icon (--) and selecting **Close Tab Group**.

Customize the Panel View (continued)

The panels in the Panel Bin allow a substantial amount of change to your photos, as well as give you additional information and options. Use the panels to help you create the photos that you want, and learn how to manage them when you are not using them.

Customize the Panel View (continued)

6 Click the More icon (¬≡) on any panel.

- If you are not using a particular panel, you can close it by clicking **Close**.
- The panel has not gone anywhere; it simply is no longer in your Panel Bin. To open it back up, just click Window and reselect.

Special Projects for Photoshop Elements

While you are working on your photo, you may want to see it larger in the screen.

- **3** To free up space on the screen, click **Window**.
- Click Panel Bin.
- You can click **Tools** if you want to hide those as well.

The panels are hidden so that you can see your entire image in a larger view.

By clicking the arrows above the toolbar, the toolbar collapses to a single row of tools, making even more space.

How do I return to my regular view?

Click **Window** in the menu bar and then click **Panel Bin** or **Tools** again. The view comes right back. The procedure is the same with the different panels; from the Window menu, just click

Effects or **Layers**, for example, for the desired panel; the panel opens and closes with every click.

What is the correct way to view all the panels and toolbars?

There is no right or wrong way to arrange your photos and panels. It is generally thought that you should have the photo as big as you can on your screen, but still have the panels in the Panel Bin that you need. If you are not using the panels, why not hide them so you have more room to work on your photos? You can also activate and hide the menu bars at the top if you are not using those items.

What Are Layers and Why Use Them?

A layer is like a sheet of glass over the main image or photo. Photoshop Elements uses different types of layers to help you improve your photos or completely change them without altering the original image. You can change the way each layer interacts with the layers below it by changing the layer's blend mode and the layer's opacity. Using layers is the key to digitally altering photos and creating various effects, including changing color and adding frames.

Duplicate the Background Layer

When you first open a photo in the Standard Edit workspace, you have one layer named Background in the Layers panel. The layer is locked, meaning you cannot make certain types of changes to it. You can change the locked Background layer to an unlocked and editable layer by double-clicking the layer in the Layers panel and renaming the layer in the dialog box that appears. A preferable option is to create a duplicate layer of the original photo by clicking **Layer** and then **Duplicate Layer**. Photoshop Elements places a new identical but unlocked layer called Background copy above the Background in the Layers panel. You can then make changes to the duplicate, never risking damaging the original, and you can delete the copy if you do not like your changes.

HOW LINES.

Add Other Image Layers

You can click and drag other open photos onto the Background layer and Photoshop Elements adds these as regular image layers. You can resize the individual image layer and make changes to the way it blends into or hides the image below. You can also add a new blank layer above the other photo layers by clicking the **Layer** menu and then **New**, or by clicking the **Create a New Layer** icon () in the Layers panel.

Add an Adjustment Layer

An adjustment layer is a transparent overlay that allows you to make adjustments to the color and tones of the underlying layers. When you add an adjustment layer, Photoshop Elements places both a layer thumbnail and a layer mask thumbnail side by side in the Layers panel. You can add an adjustment layer from the Layer menu or by clicking the **Adjustment Layer** icon (2) in the Layers panel.

Special Projects for Photoshop Elements

About Layer Masks

Layer masks in Photoshop Elements are attached to adjustment or fill layers and are used to hide or reveal areas of the image below the adjustment layer. The mask starts out filled with white, making the adjustment cover the entire image below. You can remove parts of the mask and reveal portions of the underlying image by painting areas of the mask with black. Painting with darker or lighter shades of gray removes the mask in corresponding levels of transparency. Layer masks are often used to create composite images in which multiple photos blend into one another.

Other Types of Layers

You can add fill layers, which can contain a colored gradient, a solid color, or a pattern, and then blend the layer into the image using the layer blend mode or the layer opacity settings. You can also add shape layers that are similar to type layers and must be simplified so you can apply multiple colors or use filters on them.

Add a Type Layer

When you select the **Type** tool () to add text to your photo, Photoshop Elements places the text on a special kind of layer. You can edit the text, change the overall color, change the text direction, stylize, and warp the text on a type layer. However, to add different colors to the individual letters or to apply filters to the text, you need to convert the type layer into a normal image layer by clicking the **Layer** menu and selecting **Simplify Layer**. After the layer is simplified, you can no longer edit the text; however, the type can be blended into the photo in many ways.

Consolidate Multiple Layers

You can add as many layers as your computer's memory allows; however, layers increase the file size. You can *merge* some layers together to reduce the file size, and you can *flatten* all the layers when you are completely finished working on the image. Merging and flattening are permanent actions, and should be done only when you are finished editing the photo. You must flatten the layers to save the image as a JPEG for the Web or as an e-mail attachment.

Find Your Way Around the Layers Panel

The Layers panel is the key to working efficiently with layers in Photoshop Elements. The panel includes a thumbnail and the name of the layer. The icons and drop-down menus in the Layers panel allow you to make a variety of changes to the layers and to your overall image. You can access any of the commands that affect layers from the Photoshop Elements main menu; however, using the icons on the Layers panel is much quicker and easier.

Move the Layers Panel

All the layers for the open photo or image are listed in the Layers panel in the order in which they are added. You can move layers and change the order by clicking and dragging one layer above or below another layer in the Layers panel. Each time you add a layer, the list gets longer. You can extend the Layers panel by clicking and dragging the bottom-right corner of the panel. Because the Layers panel is so useful, you may want to drag the panel by its title tab out of the Panel Bin to make sure you can see all the layers on-screen. If you close the Layers panel, you can open it again from the main menu by clicking **Window** and then **Layers**.

LWDS NWMI CHATTY 101 Background 8 Lock

Active Layers and Visibility

The layer you are currently working on is called the active layer and is highlighted in blue. To make a change to the layer, such as applying a filter or erasing an area, you need to target and highlight the layer by clicking it. You cannot make certain types of changes to the original Background layer until you change it to a normal unlocked layer, as described in the previous section, "What Are Layers and Why Use Them?" You can hide or show a layer by clicking the Visibility icon (on and off. Hiding a layer is useful when you work on a duplicate and want to compare the before and after views with the original Background layer. Each time a new layer is added, you can use the default title for the layer or you can rename it to make it easier to identify. To rename a layer in the Layers panel, doubleclick its name and enter a new name in the highlighted title field.

Special Projects for Photoshop Elements

The Layers Panel Icons

You can use the icons at the top of the Layers panel to apply many changes to the image quickly. Click the Create a New Layer icon () to add a new blank layer, or click the Create Adjustment Layer icon (2) to add an adjustment or fill layer above the highlighted layer. If you click the **Delete Layer** icon (), or trash can, Photoshop Elements immediately deletes the highlighted layer. You can link two or more layers together by pressing Shift, clicking all the layers you want to link, then clicking the Link Layers icon (). The Link icon appears on each linked layer. You can also protect a layer so it cannot be changed, moved, or deleted by highlighting the layer and clicking the Lock All icon (). The Lock Transparent Pixels icon () is useful for protecting blank areas in a layer from being altered.

BLEND

What Are Blending Modes and Opacity?

The Layers panel includes a drop-down menu for selecting the blend mode as well as the master opacity for each layer. The blend mode determines how the pixels on that layer affect the pixels in the layer below. In Normal mode, whatever is on that layer acts as a completely new image and blocks the layer below. The other blend modes are grouped in the list by the way they interact with the layer below — for example, darkening or lightening the image. Click the **Opacity** arrow to use the slider to adjust the opacity of the layer or enter the numbers for the percentage directly in the data field. You can even click and drag directly on the word *Opacity* to activate the scrubby sliders, which change the layer opacity as you move the cursor.

There Is More!

You can click the **More** icon () at the top right of the Layers panel to access all the other commands for layers also found in the main Layer menu. From this drop-down menu you can add, delete, rename, and link layers. In addition, you can choose **Merge Down**, which merges the highlighted layer with the layer below; **Merge Visible**, which merges all the layers currently visible; and **Flatten Image**, which merges all the visible layers and deletes any hidden layers. You can also choose **Simplify a Type or Shape layer** and even change the thumbnail size when you choose **Panel Options**.

Straighten a Crooked Photo

You may have photos where the horizon is not quite level or a vertical building is leaning over. Photoshop Elements 8 includes a Straighten tool to help you align the horizon or adjust a vertical line. You can even have Photoshop Elements automatically remove the blank background areas created when straightening an image.

Straighten a Crooked Photo

Straighten a Horizon

- Open a photo in the Standard Edit workspace.
- ② Click the **Straighten** tool (**S**).
- 3 Select **Rotate All Layers** (■ changes to ☑).
- Click the Canvas Options arrow and select Crop to Remove Background.

5 Click and drag along the horizon line in the photo and then release the mouse.

chapter 17

The photo is straightened and cropped to remove any blank background.

If you click here and select Grow Canvas to Fit, Photoshop Elements enlarges the canvas to fit the rotated image. This selection shows the blank areas of the background where it was rotated but includes the entire original photo, which may be needed for some critical cropping.

Are there any other choices for the background?

Yes, when you click the **Canvas Options** arrow and select **Crop to Original Size**. In this case, the cropped photo appears straightened on a blank background exactly the same size as the original image, but the corners are cut off. With some creative cloning, in many cases, you can actually create new parts of the image, allowing more cropping options.

Straighten a Crooked Photo (continued)

Just the same as a horizontal photograph, a vertically oriented photo may be corrected with the Straighten tool. Working with buildings is slightly different because you are pointing the camera up at the building at an angle.

Straighten a Crooked Photo (continued)

Straighten a Vertical Building

- Open a photo in the Standard Edit workspace.
- ② Click the **Straighten** tool (**③**).
- ③ Select **Rotate All Layers** (■ changes to ☑).
- Click here and select Crop to Remove Background.
- Press and hold (Cirl) as you click and drag along a vertical line in the photo and then release the mouse.

The photo is straightened and cropped to remove any blank background.

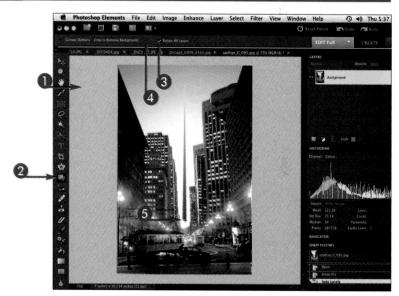

Straighten Another Vertical Building

- Repeat Steps 1 to 4 from the previous page.
- 2 Press and hold (Ctrl) as you click and drag along a vertical nearest the middle of the photograph line and then release the mouse.

In this example, the best placement for the Straighten tool is on the right edge of the tall building in the middle.

 If you use the Straighten tool with a building on the side of the image, you get a far more skewed image than you started with, as shown in this example.

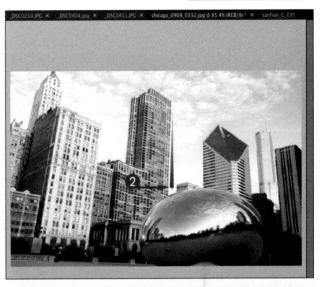

How do I make my photo open on a gray background as in some of the examples?

You can make the light gray background larger, giving yourself a little more screen space simply by minimizing the Project Bin. Additionally, you can drag the tab of the photo out of the Project Bin, creating that photo's own window. Then simply drag the corner of the window as large as you would like, making the gray background as large as the screen.

Make a Creative Crop

Photoshop Elements includes a Cookie Cutter tool to help you crop your photos into unique shapes. Although the default set of shapes is limited, the application includes more than 500 shapes, which you can load into the Custom Shape Picker. Turn your photos into various shapes or give them a custom brushed edge by cropping them with the Cookie Cutter.

Make a Creative Crop

Load Shapes into the Custom Shape Picker

- ① Open a photo in the Standard Edit workspace.
- Click the Cookie Cutter tool ().
- 3 Click the **Shape** arrow in the Options bar.
 The Custom Shape Picker opens.

You can choose a shape from what appears in the Picker.

- 4 Click the arrow to open the pop-up panel.
- 6 Click All Elements Shapes.
 Element loads additional shapes into the Custom Shape Picker.

Crop the Photo

- Scroll through the Custom Shape Picker and double-click a shape thumbnail.
- Click and drag in the image to create the shape.

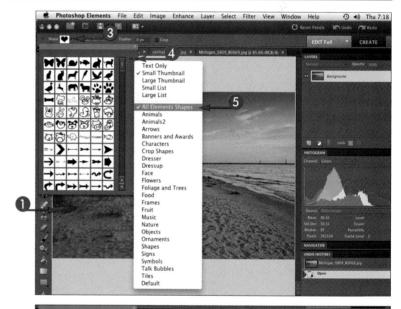

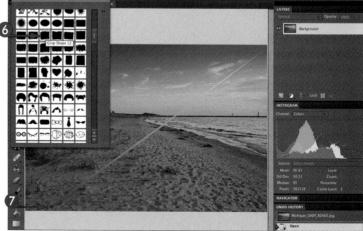

The photo is cut out to fit the shape on a transparent background.

- You can click and drag the handles to resize the shape to better fit the photo.
- 8 Click the **Commit** button (**2**).

The photo is cropped to the unique shape.

 The Background layer is automatically changed to Layer 0.

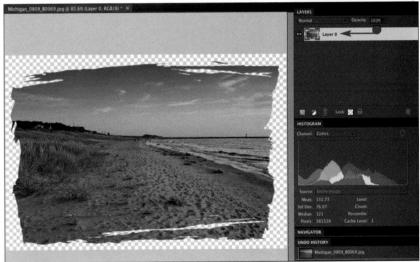

How can I change the checkerboard background?

The checkerboard indicates transparent areas on the layer. Create a new layer by clicking the **Create a New Layer** icon () in the Layers panel. Then, in the Layers panel, click the new layer and drag it below the photo layer. Click **Edit** and then **Fill Layer**. The Fill Layer dialog box appears. Click the **Use** arrow and select white, black, or a color. The background fills with white or the chosen color. To finish the creatively cropped photo, combine the two layers into one by clicking **Layer** and then **Flatten Image**.

Select an Area of a Photo

You can edit and adjust a specific area of a photo, such as a person's teeth or the petals of a flower, by making a selection. You can drag the Quick Selection tool across an area. Photoshop Elements then makes the selection based on the color and texture of the selected area. You can add to or remove areas from the selection using the Add to Selection and Subtract from Selection brushes in the Options bar.

Select an Area of a Photo

- Open a photo in the Standard Edit workspace.
- Click the Quick Selection tool ().

3 Click and drag over the area to select.

Note: A wavy dashed line immediately starts clinging to various different tones around the tool's cursor.

- A selection border appears around the area.
- Click the **Zoom** tool (■) and click and drag across the selection area to zoom in.
- 6 Click the Add to Selection tool (N) in the Options bar.
- Click and drag to push the line towards the foreground, adding to the selected area of the sky.
- Click the Subtract from Selection tool (S) in the Options bar.
- 8 Click and drag to push the line toward the background to be removed from the selection.
- Repeat Steps 5 to 8 if necessary.
- In this example, you can use the selection along with a levels adjustment layer to darken the background just a bit.

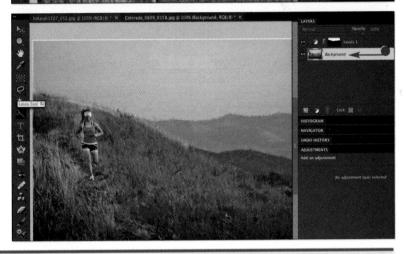

Are there other ways to make selections?

freely draw any shape, the

Yes. You can use the Rectangular Marquee tool () or the Elliptical Marquee tool () to select those shapes. You can use the Lasso tool () to

Polygonal Lasso tool () to draw a straight-edged shape, and the Magnetic Lasso tool () to select an area with strong contrast to the background. You can use the Magic Wand tool () to select pixels within the same color range.

Can I save a selection to make more changes?

Yes. After your selection has a selection border, click **Select** and then **Save Selection**. The Save Selection dialog box appears. Type a name for the new selection in the **Name** box, make sure that **New Selection** is checked (☑), and click **OK**. To edit the selected area, click **Select** and then **Load Selection**. Find the name of the selection and click **OK** to load the selection marquee on the photo.

Whiten Teeth Digitally

You can quickly improve any portrait photo by lightening the teeth of a smiling subject. This three-step technique involves making a selection, removing the yellow, and lightening the teeth. Be careful to not make the teeth too white and the enhancement unrealistic.

Whiten Teeth Digitally

- Repeat the steps from the previous section, "Select an Area of a Photo," to make a selection of the teeth.
- Click Select.
- Click Feather.

The Feather Selection dialog box appears.

- Type a value in pixels in the Feather Radius box; for example, type 1 to feather the selection by 1 pixel.
- Click OK.

Note: You can press ### (Ctrl +##) to hide the selection marquee. Hiding the marquee makes it easier to judge the color as you adjust it.

Note: This is a totally visual technique. You should feel free to zoom back and forth from tight view of the selection to a large area of the photo while you make adjustments.

- Click Enhance.
- Click Adjust Color.
- 8 Click Adjust Hue/Saturation.

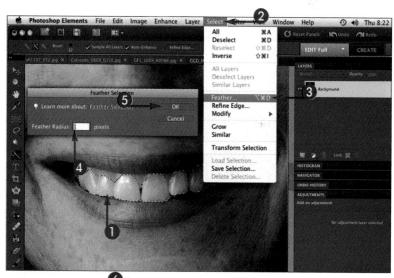

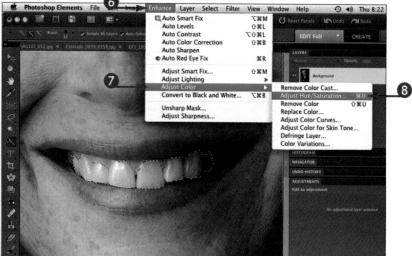

The Hue/Saturation dialog box appears.

Note: Move the dialog box, if necessary, to see the selected area

- O Click here and select Yellows.
- Click and drag the **Saturation** slider to the left until no visible yellow remains in the teeth.
- The teeth will have a slight gray tone.
- Click here and select Master.
- Click and drag the **Lightness** slider to the right until the teeth appear whitened but still natural.
- (B) Click OK.
- Press # + D (Ctrl + D) to deselect the teeth.

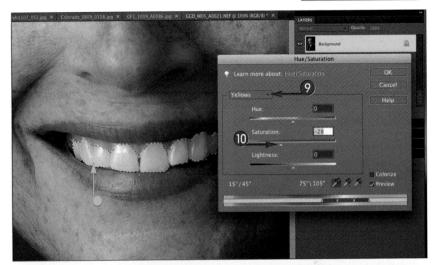

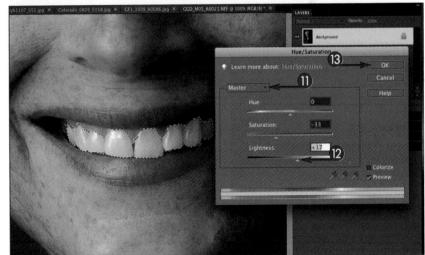

What does feathering the selection do?

Feathering a selection creates a soft transition between the selection and the surrounding area by blurring the edges. By softening the edges, the colors blend smoothly and the enhancement appears more

natural. To feather the selection of teeth in a portrait, a feather of 1 to 2 pixels is generally sufficient.

To what do hue, saturation, and lightness refer?

Hue is the actual color, such as red or green, and saturation is the intensity or purity of the color. The **Lightness** slider controls the lightness or tonal range of the color and works with the other two sliders. If you change the **Lightness** or the **Saturation** slider without making a selection, the tonal range of the entire photo is affected.

Duplicate the Background Layer

Duplicating the Background layer is a safety step in correcting digital photos. By applying filters or making other alterations to the Background copy layer, your original photo remains untouched. You can easily compare the before and after images by clicking the Visibility icon on and off next to the Background copy layer. You can also quickly delete the Background copy layer to revert to the original photo.

Duplicate the Background Layer

- Open a photo in the Standard Edit workspace.
- Click Layer.
- Click Duplicate Layer.
 The Duplicate Layer dialog box appears.
- You can accept the default duplicate layer name, Background copy, or you can type another name.
- Click OK.
- The Background copy layer is placed above the Background layer in the Layers panel.
- As an alternative to the steps above, you can click and drag the Background layer over the Create a New Layer icon () at the top of the Layers panel instead of using the Layer menu. When you release the mouse, the duplicate Background layer is automatically created and given a default name.

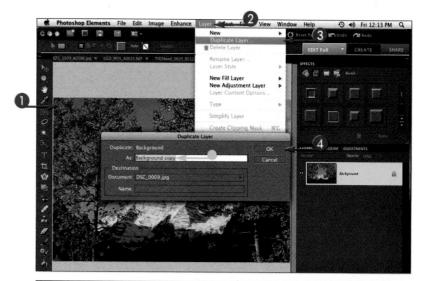

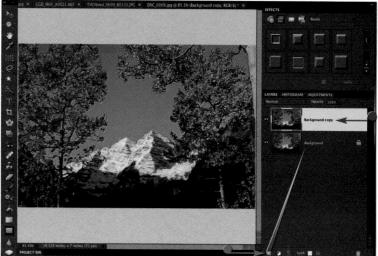

What Are Photoshop Elements Filters?

The numerous filters included in Photoshop Elements help you retouch or enhance your photos in different ways. Filters allow you to make specific improvements, such as reducing the noise in an image or changing the lighting, as well as making a totally new image out of the original photo. You can apply a filter to the entire photo or to a selection on a photo.

Use Photoshop Elements Filters on Separate Layers

By applying a filter to a duplicate of the original Background layer, or to a selection placed on a separate layer, you can alter your photo and never alter the original. You can use a duplicate layer to make it easy to compare the effect on the photo by clicking the **Visibility** icon () for the filtered layer on and off in the Layers panel. If you do not like the changes, you can quickly undo them by dragging the filtered layer to the Layers panel's trash can ().

Photomog Homan A

Types of Photoshop Elements Filters

Photoshop Elements includes a wide variety of filters grouped into various categories according to the effect created. Many software companies, such as OnOne and Nik, Inc., make filters that you can install in Photoshop Elements. After they are installed, the added filters appear at the bottom of the Filter menu. These third-party filters often make better improvements or help you make photo corrections more easily.

Adjustment Filters and Adjustment Layer Options

Some filters can be applied as an adjustment layer, a special layer that floats over the photo layer and alters the colors or tones of the image underneath. When you apply a filter as an adjustment layer, you select it from the Layer menu rather than the Filter menu. Unlike a filter from the Filter menu, which affects only one layer, a filter applied as an adjustment layer affects all the layers below it in the Layers panel.

What Is the Filter Gallery?

With Photoshop Elements you can apply a variety of filters to improve or change your images. The various filters included with the application can be applied from the Filter menu or the Effects panel. You can also use the Filter Gallery, which is a more flexible way to visually change your images.

Use the Filter Gallery

Selecting **Filter Gallery** from the Filter menu opens a new dialog box. The various filters are grouped into folders, and the thumbnails of each filter appear when you open a group folder. Clicking a filter allows you to see a large preview of the effect before you finalize the filter.

Preview

Advantages of Using the Filter Gallery

Using the Filter Gallery gives you more control over the effect on the image. Not only can you see a large preview of the effect, you can also apply more than one filter to a photo and see the effect each one has on the overall image. You can add as many filters as your computer's memory allows. You can also use the sliders to change the settings for each filter you apply, and click and drag the effects layers within the dialog box to change the order in which they are applied.

Disadvantages of Using the Filter Gallery

Not all the filters included in Photoshop Elements can be applied from the Filter Gallery. When you click **Filter** in the main menu, you see more filters than when you select **Filter** and then **Filter Gallery**. Using the Filter Gallery can also seem slower than just clicking a filter in the Effects panel because opening the Filter Gallery dialog box takes time.

Apply, View, Rearrange, and Delete Applied Filters

Adding multiple filters is one of the major benefits of using the Filter Gallery. Click the **New Effect Layer** icon (a) at the bottom right of the dialog box to add an additional filter layer. Click a different filter thumbnail to change the type of filter used on that layer. You can alternatively hide and show the effect by clicking the **Visibility** icon (b) by the layer. Rearrange the effects layers by clicking and dragging them to change the order, and the overall effect also changes. To delete a layer effect, you can click and drag the layer to the trash can icon (a).

Various Parts of the Filter Gallery

The Filter Gallery dialog box has four separate sections. The preview pane on the left opens the photo at 100% view. You can zoom in or out using \vdash and \vdash , click the percentage data field to select a different size, and click directly on the preview image to move it around in the window. The folders containing the thumbnail views of each filter are in the center of the dialog box. The top section on the right includes any adjustment sliders for the currently selected filter. The bottom right section shows a list of the applied filters as effects layers.

Image Size and the Filter Gallery Filters

On the monitor, a very large image file can appear almost unchanged by certain filters. To transform a photo into an artistic image, the filters in Photoshop Elements modify the pixels in the photo. They add texture, displace some pixels, and increase the contrast of others. Because the changes are applied to each pixel, the artistic changes to a large file can sometimes appear minimal on the screen. Always view the final image at 100 percent or full size to judge the effect of the filters on your photo.

Understanding Styles and Effects

Photoshop Elements includes not only numerous filters to help you alter or enhance your photos, but it also has many effects and layer styles. These special effects and preconfigured layer styles are found in the Effects panel so you can apply them with a click of the mouse.

What Are Layer Styles?

Layer styles apply a predesigned image style to the entire layer. The style is nondestructive, meaning it acts as an adjustment layer and does not permanently change the pixels in the original image. Styles affect the layer's content. If you change what is on the layer, the style is applied to the new content.

Different Types of Layer Styles

Layer styles include Bevels, Shadows, and Glows, which give borders to the content in the layer. Other layer styles, such as Glass Buttons, Patterns, and the Wow libraries, totally cover the entire layer.

Create Custom Styles

Layer styles are cumulative. You can continue to click the Style thumbnails in the Effects panel to add one style onto another, creating an original style. You can edit the attributes of certain styles by double-clicking the **Layer Styles** icon (A) on the layer. You can then move the sliders in the dialog box that appears to edit the style.

Remove Styles Quickly

You can remove all the layer styles applied to an individual layer by clicking the **Layer** menu and selecting **Layer Style** and then **Clear Layer Style**. However, you can also click and drag the **Layer Styles** icon (A) on the layer to the Layers panel's trash can (1) and release the mouse.

What Are Effects?

Effects are actually a series of steps programmed to give a specific look to the image. Although effects include filters, layer styles, and other functions, you only click the effect name and see the result. Some effects can be applied only to a selection on a layer or to type. Others require the layers to be flattened or combined because they can work only on the Background layer. Still other effects automatically create a duplicate layer and apply the effect to that layer. Effects include Frames, Image Effects, Text Effects, and Textures.

Apply and Remove Effects

Unlike layer styles, which are applied by clicking once on the thumbnail in the Styles and Effects panel, you can apply an effect by double-clicking its thumbnail. To remove an effect, click the **Undo** arrow () in the Options bar. If the effect is on a separate layer, you can click and drag that layer to the Layers panel's trash can ().

Effects and Memory

Effects, like filters, use a lot of your computer's memory (RAM) to create and apply changes to photos. The larger the photo file you are working on, the more memory is required to apply effects and filters. To free up as much memory as possible so Photoshop Elements can function efficiently, you should exit from other applications. You can also make more memory available by clicking **Edit**, **Clear**, and then **All** to clear the undo history and clipboard within Photoshop Elements.

Colorize a Black-and-White Photo

You can make any black-and-white photo appear hand-colored using a separate layer and the Soft Light layer blending mode. You can select the colors for different areas and hand-color the entire photo, or only color specific areas for effect.

Colorize a Black-and-White Photo

- Open a photo in the Standard Edit workspace and duplicate the Background layer as described in the section "Duplicate the Background Layer," earlier in this chapter.
- Click the Create a New Layer icon () to add a new blank layer above the Background copy layer.
- 3 Click here and click Soft Light from the menu that appears.
- ← Click the Brush tool (■).
- 6 Click the Foreground color box.

The Color Picker appears.

- 6 Click and drag the slider to select a color range.
- Click in the color field to select a color.
- 8 Click OK.

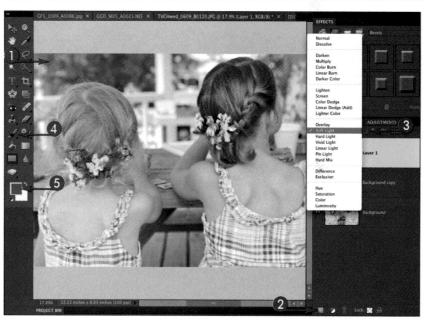

- Olick here to open the Brush presets.
- Click a small soft-edged brush to select it.

Click and drag over an area to paint the color.

Note: Press # + Spacebar (Ctrl + Spacebar) to temporarily use the **Zoom** in tool (\oplus) and drag across the area to zoom in, if necessary. Press Spacebar to temporarily use the **Hand** tool ($\$^n\gamma$) to move around in the enlarged photo.

Repeat Steps 4 to 11 for each area you want to color.

Note: Repeat Steps **9** and **10** to select a different brush size, if necessary.

Click the Opacity arrow and move the slider to the left to lower the strength of the colors.

What does the Soft Light blending mode do?

The layer blending modes determine how the pixels on the top layer blend with the pixels in the layer below. The Soft Light blending mode applies the new color to the gray tones in the black-and-white photo, without changing the lightness values of the pixels. The colors appear as a colored veil over the image.

Is there a faster way to change brush size?

Create a Sepia-Toned Photo

You can create an "old style" sepia-toned photo from any color or black-and-white image using Photoshop Elements. You can add an adjustment layer with a brown color as the foreground color and change the layer blending mode to blend the sepia with the image on the layer below. You can even change the color of the sepia at any time to suit your taste.

Create a Sepia-Toned Photo

- Open a photo in the Standard Edit workspace.
- Click the Foreground color box. The Color Picker appears.
- 3 Click and drag the slider to select the brown color range.
- 4 Click in the color field to select a sepia brown color.
- 6 Click OK.
- **6** Click Layer.
- Click New Adjustment Layer.
- 8 Click Gradient Map.

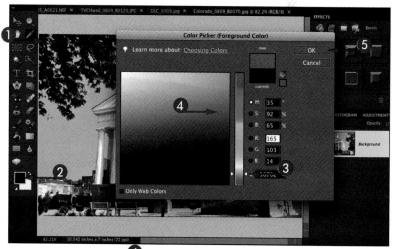

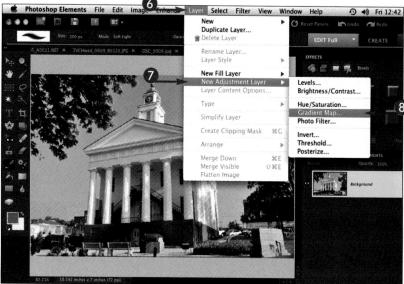

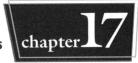

The New Layer dialog box opens.

- Q Click the Mode arrow.
- Select Color from the menu that appears.
- Click **OK** to close the New Layer dialog box.

A sepia tone gradient map adjustment layer is applied to the image.

 The gradient map thumbnail opens in the Adjustments panel in the Panel Bin.

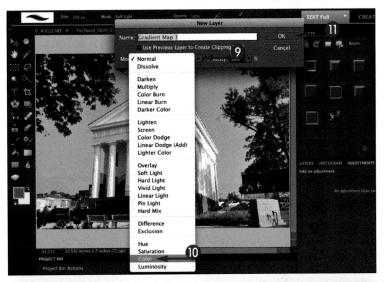

Why use an adjustment layer?

An adjustment layer allows you to change colors and tones in an image without changing the original image. You can use multiple adjustment layers and delete any or all of them without affecting the original photo. You can also change the tonal and color adjustments any number of times without changing the original photo.

How do I choose a different color after the adjustment layer is applied?

You can select a different shade for the sepia-toned photo, or change it to another color altogether, even after applying the gradient map. Double-click the gradient map thumbnail in the Adjustments panel. The Gradient Map dialog box appears. Click inside the gradient in the Gradient Map dialog box to open the Gradient Editor. Double-click the sepia color stop to open the Color Picker. Click another color in the color field and then click **OK**. Click **OK** to close the Gradient Editor, and again to close the Gradient Map dialog box.

Remove Blemishes with One Click

Photoshop Elements can help you hide blemishes easily. You can use the Spot Healing Brush to clear blemishes or even smooth out wrinkles and freckles with one click. Adjust the size of the brush for each imperfection and Photoshop Elements makes them vanish with each click.

Remove Blemishes with One Click

- ① Open a photo in the Standard Edit workspace and duplicate the Background layer as described in the section "Duplicate the Background Layer," earlier in this chapter.
- Click the **Zoom** tool () and zoom in to the area with blemishes.
- 3 Click the Spot Healing Brush (
 ■).
- Click the Size arrow and move the slider to adjust the size of the brush.

Note: The brush size should be just slightly larger than the blemish.

(5) Click a blemish or small imperfection to make it blend with the rest of the skin.

Note: You can click and drag on slightly larger imperfections.

Repeat Steps 4 and 5 until all the imperfections are removed.

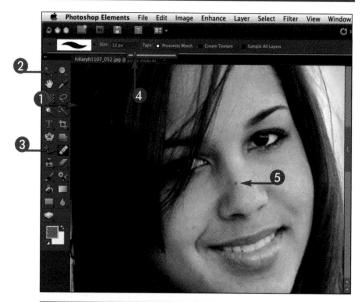

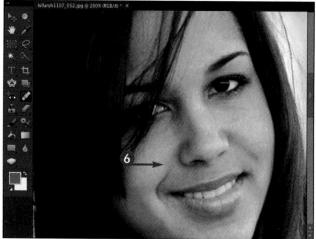

The Skin Tone Adjustment in Photoshop Elements brings out more natural skin colors in photos of people. Although the changes are subtle and depend on the individual photo, most images can be quickly improved with enhanced skin tone.

Fix Skin Tone

- ① Open a photo in the Standard Edit workspace and duplicate the Background layer as described in the section "Duplicate the Background Layer," earlier in this chapter.
- Click Enhance.
- Click Adjust Color.
- Click Adjust Color for Skin Tone.

The Adjust Color for Skin Tone dialog box appears.

- Make sure that **Preview** is checked (
- Click an area of skin.
 Photoshop Elements makes an automatic correction.
- You can click and drag the Tan, Blush, or Temperature sliders to fine-tune the adjustment.
- Click OK.

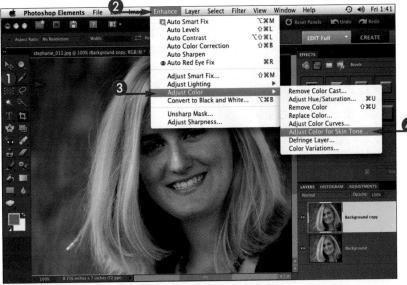

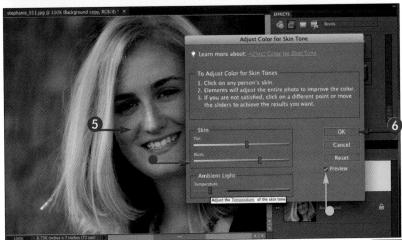

Adjust a Photo before Applying Filters

You can increase the artistic look of your image by first cropping it and adjusting the highlights and shadows. You can crop out distracting elements in the original photo using the Crop tool to focus on the area of interest. You can also lighten overly dark areas before transforming a photo into a sketch or painting. The artistic effects of the filters are generally more visible on lighter areas.

Adjust a Photo before Applying Filters

- Open a photo in the Standard Edit workspace.
- ② Click the **Crop** tool (**3**).
- 3 Click and drag across the photo to select the area to keep.
- 4 Click and drag the corner handles to adjust the area.
- **⑤** Click the **Commit** button (**☑**).

The photo appears cropped in the window.

- **6** Click **Enhance**.
- Olick Adjust Lighting.
- 8 Click Shadows/Highlights.

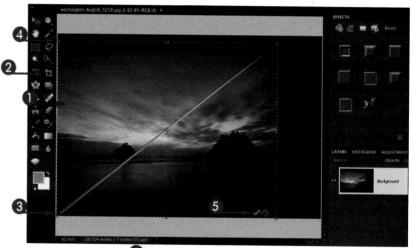

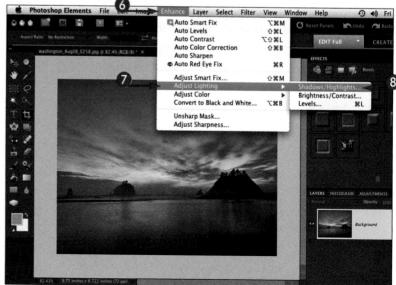

The Shadows/Highlights dialog box appears.

- Click and drag the Lighten Shadows slider to the right to see more detail in the shadows.
- Click and drag the **Midtone**Contrast slider slightly to the right to increase the contrasts.
- The dark areas of the photo appear lighter than the original, showing more details.

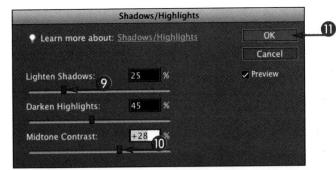

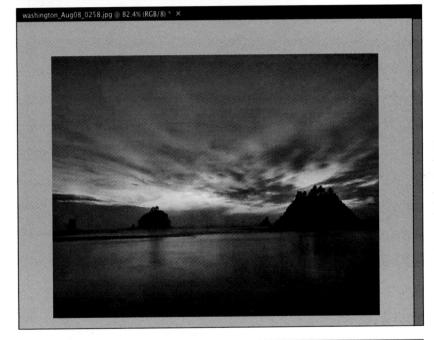

When I drag the Lighten Shadows slider, why do my photos look washed out?

Dark shadows may look good on a photograph; however, they become dark, blurred areas when applying an artistic filter. You are changing the image from a photo into a sketch or a painting, so you want the filters to affect all the areas.

Does the file size affect the way the filters work?

Yes. Because the filters modify the individual pixels in the photo, a large file with more pixels has more data to be changed. The filter requires not only more computer memory, RAM, to work on a large file, but it also takes more time for the filter effect to appear on-screen and to be applied to the image. When you click a filter in the Filter Gallery, allow the preview screen time to redraw the filtered image. The larger your image size, the slower the filter.

Convert a Photo into a Sketch

You can turn a photograph into a sketch in a variety of ways using Photoshop Elements. The following technique shows one way. You create multiple effects layers within the Filter Gallery. Each time you change the order in which you apply the filters, reposition the effects layers, or change the slider settings, your sketch has a different style.

Convert a Photo into a Sketch

- ① Open a photo in the Standard Edit workspace and adjust it as described in the previous section, "Adjust a Photo before Applying Filters."
- 2 Click Enhance.
- Click Adjust Color.
- Click Remove Color.

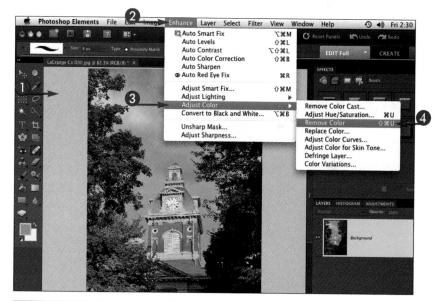

The image changes to a black-and-white photo.

- 6 Click the Effects icon ().
- Click Brush Strokes.

The Filter Gallery dialog box opens.

- Click here to view the thumbnails.
- (8) Click the **Dark Strokes** thumbnail.
- Olick and drag the sliders to make details visible.
- Olick the **New Effect Layer** icon (a) to add a new effects layer.

- Click the **Angled Strokes** thumbnail to change the layer
 effect.
- Click and drag the sliders to change the strokes.
- Repeat Steps 10 to 12, if necessary, to increase the effect.
- (14) Click **OK** to apply the filters.

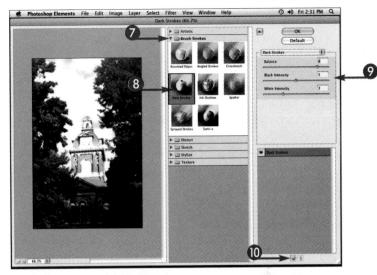

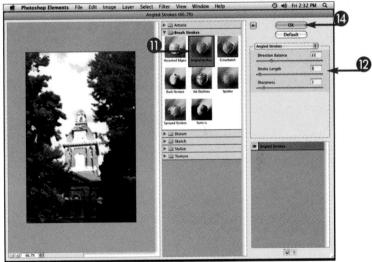

Can I use any of the other Brush Strokes filters?

Yes. Click the **New Effect Layer** icon (a) and then click any of the other Brush Strokes thumbnails. Each time you add a different brush stroke layer or duplicate an effects layer by highlighting it and clicking the **New Effect Layer** icon (a), your image has a different look.

What happens if I change the order of the effects layers?

You can click an effects layer in the Filter Gallery dialog box and drag it to a different position in the order of the layers. Because the effects are cumulative, the look changes when you change the order. You can also add as many effects layers as your computer's memory allows.

Convert a Photo into a Painting

Just as with converting a photo into a sketch, as described in the previous section, there are many ways to change a photo into a painting. You can make your artistic rendering look like a watercolor or an oil painting, and each time you change a particular filter or the order of the layers, the overall painting takes on a new appearance.

Convert a Photo into a Painting

- Open a photo in the Standard Edit workspace and adjust it as described in the section "Adjust a Photo before Applying Filters," earlier in this chapter.
- Click Filter.
- Click Artistic.
- 4 Click Dry Brush.

The Filter Gallery dialog box appears.

- 5 Click and drag the sliders to adjust the appearance for your photo.
- Click the New Effect Layer icon (a) to add a new effects layer.

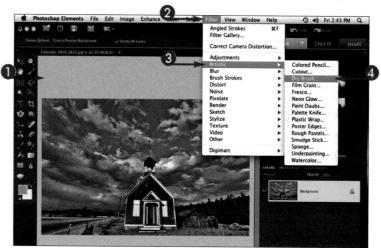

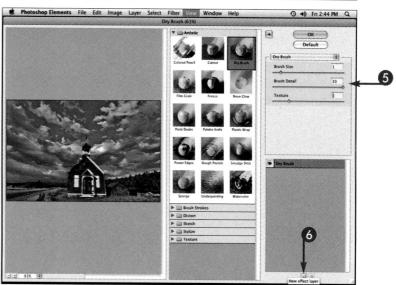

A new effects layer is added with the Dry Brush filter applied.

- Click here to view the thumbnails.
- **(8)** Click here and select **Texturizer**.
- Olick here and select Canvas.
- Oclick and drag the sliders to adjust the appearance.
- Click OK to apply the filters.

The filters are applied to the photo, giving it the appearance of an image painted on canvas.

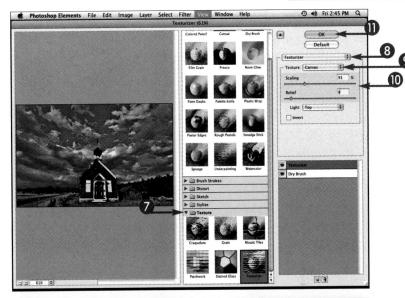

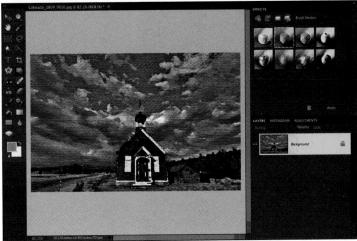

Why does my painting lack detail when I use the Dry Brush?

Filters such as the Dry Brush and Palette Knife can change a photo dramatically depending on the size of the brush stroke.

If you apply the filters at the default settings, the stroke size can be too high or the stroke detail too low. Click the effects layer in the Filter Gallery and adjust the sliders.

When I apply the Texturizer, I get a pattern over the image. How can I remove it?

The Texturizer filter applies a texture in the form of a pattern over the image. Click the **Undo** arrow (a) and then click **Filter** and **Filter**

Gallery. The previous settings should be visible. Try sliding the **Scaling** slider for the Texturizer filter all the way to the right, to 200%. Click **OK**. The pattern should not be so obvious.

Create a Digital Photo Collage

Although creating a page filled with different photos can be automated using the Create tab, you can manually put together a collage easily in Photoshop Elements. This allows for far more precision and options than the template does. Open the photos you want to use. Click and drag the open photos onto the background. The various photos are added as different layers. You can resize them by clicking and dragging their transformation handles and reposition them by dragging them around the page.

Create a Digital Photo Collage

- Launch Photoshop Elements in the Standard Edit workspace.
- Click File.
- Click New.
- Click Blank File.

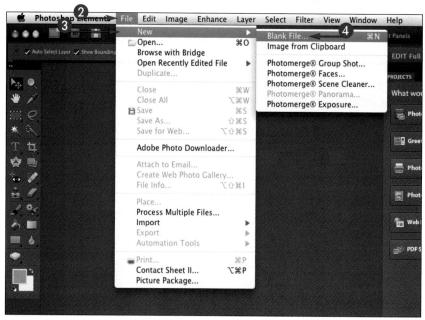

The New dialog box appears.

- Type a name for the collage.
- **6** Type the width and height for the final size of the image.
- Type 300 in the Resolution field.

Note: See Chapter 15 for more information on resolution.

Click OK.

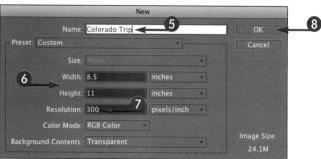

A new blank page filled with white appears.

Click Bridge () to open the photo browser.

The Bridge photo browser opens.

- Press and hold (Ctrl) as you click the photos to include in the collage.
- Click File.
- Click Open With.
- Click Adobe Photoshop Elements 8.

Can I change the color of the background?

Yes. Scroll to the bottom of the Layers panel. Click the Background layer to highlight it. Click **Edit** and then **Fill Layer** to open the Fill Layer dialog box. Click the **Use** arrow and select **Color** to open the Color Picker. Click a color in the Color Picker and click **OK** to close the dialog box. Click **OK** in the Fill Layer dialog box to apply the color to the background.

What else can I use as a background?

You can use any of the patterns included with Photoshop Elements to have a textured background for your photo collage. Click **Edit** and then **Fill Layer** to open the Fill Layer dialog box. Click the **Use** arrow and select **Pattern**. Click the **Custom Pattern** arrow and select a pattern from the list. Click **OK** in the Fill Layer dialog box to apply the pattern to the background.

Create a Digital Photo Collage (continued)

Photo collages can include the entire photo or a selection from a photo. You can make the selection in the open photo using any selection tools. Click the selection with the Move tool and drag it over the blank page in the Project Bin. When you release the mouse, only the selection is added as a separate layer.

Create a Digital Photo Collage (continued)

The selected photos appear in the Project Bin.

- (Click the **Move** tool ().
- (5) Click a photo in the Project Bin to open it in the main window.
- Click the photo in the main window, drag it over the blank page file in the Project Bin, and release the mouse.

The blank page opens with the photo as a top layer.

- Select Auto Select Layer (changes to).
- Press and hold Shift as you click and drag a corner handle to shrink the photo to fit on the page.

- Click the center of the photo to move it into position on the page.
- ② Click the Commit button (☑) to apply the transformation.

- Repeat Steps 15 to 20 until all the photos are on the blank background.
- Click each photo and then click and drag the handles to make further changes.

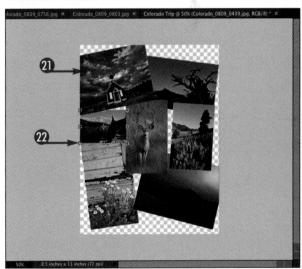

How can I rotate a photo as shown in the illustration?

Using the **Move** tool (), click one of the photos in the collage to open the transformation handles. Position the mouse cursor just outside a corner handle (changes to C). Click and drag to rotate the photo.

Layers add to the file size. After you finish moving the photos and adding any styles, you can flatten the image to make one smaller file. Click the **More** icon (=) on the Layers panel. Select **Flatten**

Image. Photoshop Elements combines all the layers into one Background layer. Click **File** and then **Save As** and save the collage with a new name.

Create a Digital Panorama

Because the human eye can see more than what can be captured in one photo frame, you can let your viewer see a more natural scene by creating a panoramic image from multiple photographs. Photoshop Elements makes combining the photos relatively quick.

Some suggestions for taking the photos: Use a tripod and keep the camera level. Shoot sequentially from left to right as the images will sit together in a natural panorama in the browser. Keep the same focal length for all the shots. In other words, do not zoom the photos differently. Keep the same exposure for all the shots. Overlap each photo with the previous one by 20 to 30 percent.

Create a Digital Panorama

- Open Photoshop Elements in the Standard Edit workspace.
- 2 If you have already selected your photos in Bridge or they are open in the Project Bin, you can begin Photomerge.
- Click File.
- Click New.
- Click Photomerge Panorama.

Photoshop Elements opens all the files.

- The Photomerge dialog box appears with the open images listed in the data field. You can also just select a folder that you already know has the photos for the panorama.
- You can click **Browse** to add other photos.
- Click OK.

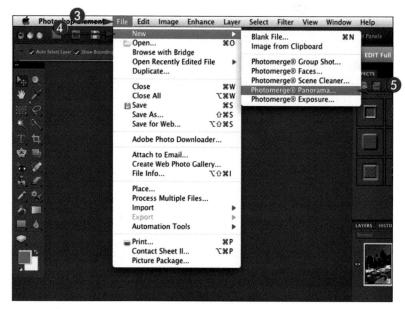

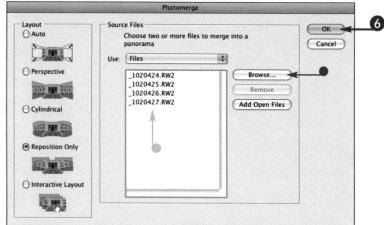

Photoshop Elements attempts to merge all the photos.

Click and drag to reposition the photos to see if the photomerge improves.

Note: You can click and drag any thumbnails in the lightbox into the work area to add them to the photomerae.

Photoshop Elements merges the photos into a panorama.

- 8 Click the **Crop** tool ().
- Olick and drag to crop off the uneven edges.
- Click the Commit button (☑) to finish the crop.

The final version of the panorama appears.

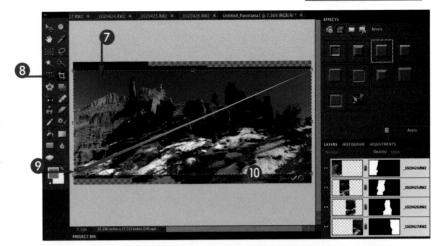

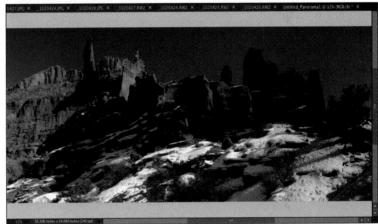

What format should I use to shoot a panorama?

If you normally use the RAW format when taking photographs, you can change to the JPEG format when taking photos used as panels in a panorama. Each RAW photo must first be converted before it can be

used, making the process unnecessarily long. Remember to return your camera to the RAW format after you finish shooting the panorama.

How many photos do I need to make a panorama?

Take as many or as few photos as you need to capture the scene. Just make sure to allow an overlap of about 20 to

30 percent for each shot to give Photoshop Elements areas to line up in the merge process.

Understanding Type Layers

When you add text to a photo or even to a blank new layer, Photoshop Elements adds a special kind of layer called a type layer. The type layer contains vector-based text and is noted with a T in the layer thumbnail in the Layers panel.

What Is Vector-Based Text?

When you type with a **Type** tool (**11**), you enter text as vectors rather than pixels. Vectors are graphics composed of lines and curves and are defined mathematically by their geometric characteristics. Unlike pixels that make up a photo layer, the shapes or letters on a vector-based layer can be sized and printed at any resolution and never lose detail or show jagged lines.

Two Ways to Add Text

You can add a single line of text by selecting the **Type** tool (), clicking in the image to place an insertion point, and typing the letters. To add a paragraph of text with automatic returns, click and drag a rectangle to create a text box and then type the letters in the text box; the lines automatically wrap to fit in the box.

Three Ways to Commit the Type Layer

To commit the type layer, click the **Commit** button () in the Options bar. The type layer is automatically committed if you select another tool or if you click elsewhere in the image away from the text or text box.

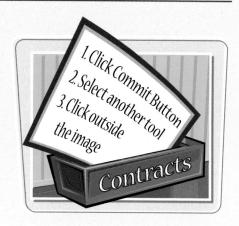

Change the Text on a Type Layer

As long as the text is on a type layer, and the layer thumbnail in the Layers panel has a T on it, you can reselect the text with the Type tool () and edit the letters or the text color. You can also change the text orientation from horizontal to vertical and even warp the type using the options in the Options bar.

Convert a Type Layer

Converting a type layer into a pixel-based image layer is called simplifying or rendering the layer. After the layer is simplified, you can no longer edit the letters to change the words because the text is now an image just like another photo layer.

Add Styles to a Type Layer

You can add styles to the text on a type layer, such as bevels or drop shadows; however, you cannot add filters or effects without converting the vector-based text into pixels. If you change the text on a type laver, all the styles are applied to the new text. Although you can change the color of the text on a type layer, you must convert the layer to pixels to color the individual letters differently.

How to Simplify a Type Layer

To simplify a type layer, click Simplify Layer from the Laver menu or from the menu that appears when you click the More icon (on the Layers panel. You can also simplify a type layer by highlighting the layer in the Layers panel and double-clicking a filter or an effect thumbnail from the Styles and Effects panel.

Add and Edit Text

When you add type to an image, the Type tool creates a separate type layer with a T in the layer thumbnail. The individual letters or the complete text on a type layer can be edited with the Type tool at any time.

Add and Edit Text

- Open a photo or a new blank document in the Standard Edit workspace.
- ② Click the **Type** tool (**11**).
- Click here and select a font family.
- 4 Click here and select a font style.
- 6 Click here and select a font size.
- 6 Click in the image to set an insertion point.
- **7** Type the text.
- Photoshop Elements uses the text you typed as the layer name.
- Olick the type to place the insertion point where you want to add more text.

You can also click and drag to select the text to change.

Note: If you changed tools after committing the text, click the **Type** tool () again.

- Type the text.
- Click the Commit button (☑). The layer name changes to the revised text.

Move and Resize Type to Fit a Photo

Special Projects for Photoshop Elements chapter

You can move the text in the image even after committing it to the layer. You can also resize the text visually without changing the font size in the Type tool Options bar.

Move and Resize Type to Fit a Photo

- Open a photo or a new blank document in the Standard Edit workspace and add text as described in the previous section, "Add and Edit Text."
- Click the Move tool (Mars).
 A transformation box appears around the text.
- 3 Click and drag in the center of the box to move the text.
- Click and drag on the anchor points of the transformation box to resize or reshape the text.
- **⑤** Click the **Commit** button (**☑**).

Add Text and Match the Color to the Photo

You can transform any photo into a greeting card by adding text. The resulting image is often more interesting when the text color matches an area in the photo.

Add Text and Match the Color to the Photo

- Open a photo in the Standard Edit workspace and add text as described in the section "Add and Edit Text," earlier in this chapter.
- Click the Type tool ().
- 3 Click the type layer to highlight it.
- Click here and select a new font.
- You can also select a new font style or size.

The new font is automatically applied.

6 Click here to open the Color Picker for the text.

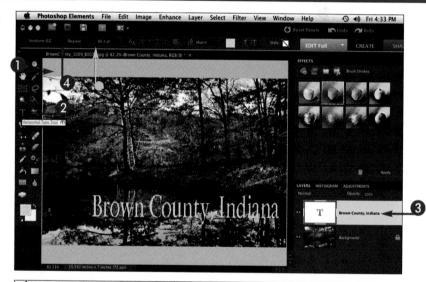

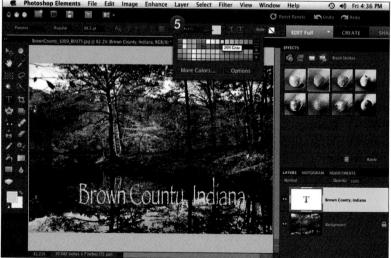

Special Projects for Photoshop Elements

The Color Picker appears.

- Click OK.

Should I duplicate the Background layer before adding type?

Not necessarily. The Type tool () automatically adds the type to a separate type layer so your original Background layer is not altered until you flatten all the layers into one.

Can I also change the color of the text with the Foreground color box?

Yes. As long as the Type tool is selected, and the type layer is highlighted in the Layers panel, you can click either the Foreground color box or the Color thumbnail in the Type tool Options bar to open the Color Picture of the total page 1 has a type layer.

Options bar to open the Color Picker and change the color of the text on a type layer.

Rotate Text

With your text on a separate type layer, you can rotate the text to fit your image. You can freely rotate the text or constrain the rotation by specifying the degree amount in the Options bar.

Rotate Text

- Open a photo or a new blank document in the Standard Edit workspace and add text as described in the section "Add and Edit Text," earlier in this chapter.
- 2 Click the Move tool ().
 A transformation box appears around the text.
- ③ Position the mouse cursor just outside a corner anchor (尽 changes to ☼) and click once just outside the corner anchor.

The Options bar changes.

- Click here and enter the degree of rotation.
- The text rotates.

You can also click and drag to rotate the text freely to suit your photo.

⑤ Click the **Commit** button (**☑**).

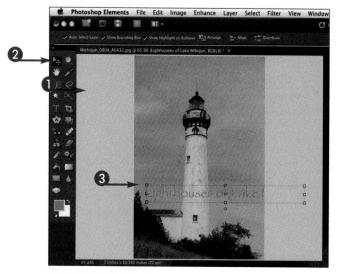

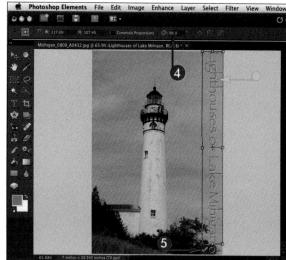

Special Projects for Photoshop Elements

You can warp text to make the letters wrap around a cylindrical form or just to stylize the text. The Warp Text dialog box and the adjustment sliders help you transform the text to any shape you want.

Warp Text

- 1 Open a photo or a new blank document in the Standard Edit workspace and add text as described in the section "Add and Edit Text," earlier in this chapter.
- 2 Click the Warp icon ().
 The Warp Text dialog box appears.
- 3 Click here and select a style.
- The default warp values are applied to the text.
- 4 Click and drag the sliders to adjust the warp.
- 6 Click OK.
- The text warps.

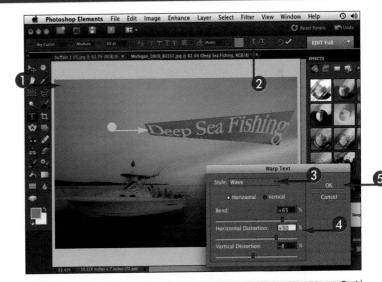

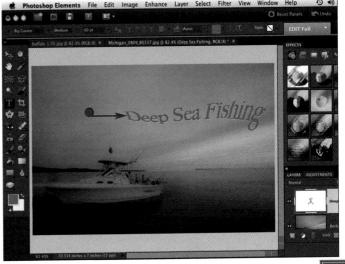

Stylize Text

Add style to any text on a Type layer by clicking one of the Layer Styles in the Styles and Effects panel. You can apply multiple styles as these are cumulative and you can customize the style by editing the Style Settings.

Stylize Text

- Open a photo or a new blank document in the Standard Editing workspace and add text as described in the previous section, "Warp Text."
- ② Click the Layer Styles icon (图).
- Click here and select Photographic Effects.
- 4 Click a photographic effect thumbnail.

The style is applied to the type layer.

- 6 Click here and select **Bevels**.
- 6 Click a Bevels thumbnail.

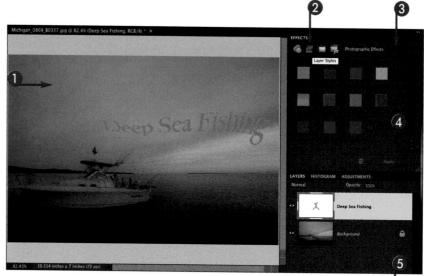

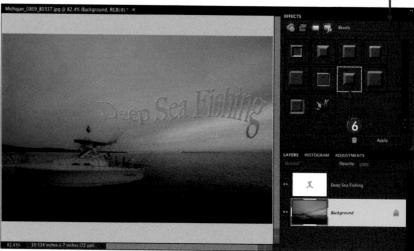

Special Projects for Photoshop Elements

- The Bevel style is applied to the type layer.
- **Double-click the Layer Styles** icon ().

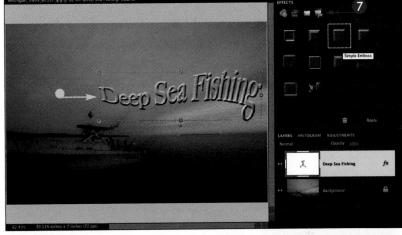

The Style Settings dialog box appears.

Click and drag the available options and sliders to adjust the style.

Note: The available sliders depend on what layer styles are applied, and not all have editable settings.

Click OK.

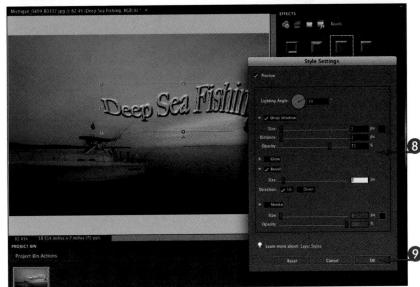

How do I remove the type layer?

You can remove the type layer by clicking and dragging the layer over the Layers panel's trash can icon (). You can also click the layer to highlight it, click the Move tool (), and then press Backspace . Click Yes in the dialog box that appears.

Can I remove the styles but leave the type layer?

Yes. Click the Layer Styles icon () next to the type layer and drag it over the Layers panel's trash can icon (a). All the applied styles are removed, and the type layer remains as editable type on the layer.

A	В
abstract images, 79	background
accessories	in collage, 305
camera bags, 18	distracting elements in, 9, 67
card readers, 17	Background layer, duplicating, 272, 286
cleaning supplies, 19	backlighting, 48, 82
external flash unit, 17	balance, creating a sense of, 64
filters, 19	banding lines on prints, 241
higher-capacity memory cards, 16	barrel distortion, 33
laptops, 16	basic controls, learning, 88
lenses, 17	batteries
memory card cases, 18	charging, 86
photo storage devices, 16	described, 15
for travel, 18	disposable, 15
tripods, 18	rechargeable, 15
ACDSee, editing photos with, 135	Bicubic Sharper (Photoshop Elements), 235
active autofocus systems, 54	Bicubic Smoother (Photoshop Elements), 235
active layers, 274	black and white photos
adjustment layers	colorizing with Photoshop Elements, 292–293
adding, 272	converting a color photo to, 222
advantages of using, 295	described, 105
Adobe Gamma software, 205	blemishes, removing, 296
Adobe Photoshop Services, ordering prints from, 251	blending layers, 275
advanced non-SLR camera, 14	blower brush, 19
perture	blowouts, 115
adjusting, 28	blurring motion, 29
depth of field affected by, 73	blurry pictures, 35, 91
described, 27	BMP (Bitmap) file format, 209
setting, 27	books, photo, 246
aperture priority mode, 30, 73	borderless photos, warnings when printing, 241
APO (apochromatic), 34	built-in vibration reduction feature on cameras, 35
archiving photos, 226–227	buying printers, 236
area of photo to edit, selecting, 282–283	
aspherical lens, 33	C
attaching images to e-mail, 264–265	
audience, considering, 62	calibrating monitors, 204–205
auto (program) mode, 30	camera bags, 18
autofocus	camera settings
active autofocus systems, 54	choosing, 8
failure of, 55	color, camera settings kept consistent for consisten
multipoint autofocus systems, 55	239
passive autofocus systems, 55	camera shake, 116
outomatic focus mode, 58	camera-to-subject distance, 28
outomatic white balance, 45	cantile images 8
	CAUTILE ILLIANCE X

card reader	color temperature
described, 17	adjusting, 170–173, 177
transferring pictures from camera to computer with, 9	when to change, 173
cases for memory cards, 18	colorcasts, avoiding undesirable, 117
Cat 5 cable, 23	colorimeter, 205
CD	ColorMunki, 205
archiving photos to, 20, 226–227	compact digital cameras
labeling, 227	close-up setting, 39
slide shows created on, 5	described, 14
CF (CompactFlash), 15	macro setting, 39
charge-coupled device (CCD), 7	sensors, 36
checkerboard background, changing, 281	CompactFlash (CF), 15
choosing a camera	comparative view, selecting, 215
advanced non-SLR, 14	compensation, flash, 50
batteries, 15	complementary metal-oxide semiconductor (CMOS), 7
compact, 14	composing image, 8
digital SLR, 14	composition. See also rules of composition
exposure modes, 15	audience, considering, 62
lens considerations, 15	contrast, 69
scene modes, 15	controlling, 68–69
storage media, 15	creative, 78-79
circular polarizer filter, 19	depth of field, 68
cleaning supplies, 19	evaluating elements in scene, 62
clipping, 111	exposure, creative use of, 63
closed eyes, reviewing image for, 9	focus, selecting, 68
close-up focus mode, 58	in LCD, 57, 63
close-up (macro) photography, 124–125	light, creative use of, 63
CMYK color system, 238	occasion, considering, 62
collage	perspective, 69
background, choosing, 305	point of view, 69
background color, changing, 305	simplicity in, 63
file size and, 307	space, 69
Photoshop Elements used to create, 247, 304–307	symmetrical compositions, 64
	tone, 69
printing, 247	verifying, 9
rotating photos in, 307	in viewfinder, 57
color	visualizing, 62–63
camera setting kept consistent for consistent, 239	compression with telephoto lens, 34
creative use of, 104–105	computer. See also monitor
evaluating, 95	disconnecting camera/card reader from, 93
filters, 19	system requirements for, 20
fine-tuning, 97	transferring pictures to, 9
light and, 42, 44–45	
for sepia-toned photos, 295	connection for photo printers, 23
setting monitor, 239	contact sheets, creating, 228–229
of text, 314–315	contrast
color management, 238–239	described, 69
	evaluating, 95 fine-tuning 97
	1111e-10111119. 97

Cookie Cutter tool (Photoshop Elements), 280–281 copyright adding, 254–255 moving, 255 sizing, 255 Corel Paint Shop Pro, 135 cost of photo printers, 23 Create tab (Photoshop Elements), 246–247 crooked photos, straightening, 276–279 cropping images described, 164–165 in Photoshop Elements, 216–217 before printing, 235 as shapes, 280–281 cross light, 48 customization layer styles, 290 Panel view (Photoshop Elements), 268–271 D darkroom (digital), 20–21 date and time, setting, 87	digital photography advantages of, 4–5 e-mail message, sharing pictures in an, 5 everyday tasks simplified with, 4 improving your photography skills with, 4 online, sharing pictures, 5 reasons for using, 4–5 sharing information with, 4 slide shows, creating, 5 digital SLR camera, 14 digital workflow camera settings, choosing, 8 capture images, 8 composing image, 8 composition, verifying, 9 computer, transferring pictures to, 9 described, 8 editing images, 10, 133 evaluating photos, 132 exposure, verifying, 9 importing photos, 132 LCD, using, 9
date and time setting 87	LCD, using, 9
depth of field	memory card, clearing, 11
aperture affecting, 73	organizing digital negatives, 11
and close-up (macro) photography, 125	printing images, 10, 133
and composition, 68	sharing images, 10, 133
described, 28	storing digital negatives, 11
experimenting with, 72–73	white balance, checking, 8 digital zoom, 37, 118
and landscape mode, 73	digital-specific lenses, 37
and portrait mode, 73	direct printing, 22
subject, focusing on, 73	disconnecting camera/card reader from computer, 93
viewer focus, controlling, 72	disposable batteries, 15
design principles balance, creating a sense of, 64	distance of flash, 50
lines, symbolic significance of, 65	distortion with wide-angle lens, 33
shapes, focusing attention with, 65	distracting background elements, 9
subject placement, 65	dots per inch (DPI), 231
symmetrical compositions, 64	drag-and-drop used to attach images to e-mail, 264
diffuser, 19	dual layer (DL) DVD, 20 DVD
digital cameras	archiving photos to, 20, 226–227
adjusting to, 89	labeling, 227
how it works, 6–7	slide shows created on, 5
digital noise	dye sublimation printers, 22, 237
adjusting, 182–185 described, 26, 110	dynamic range, 115
reducing, 119	
tips for changing, 185	

E	e-mail
eBay, photographing products for, 122–123	Attach button used to add images to, 265
ED (extra-low dispersion), 34	attaching images to, 264
editing photos. See also Photoshop Elements	drag-and-drop used to attach images to, 264
with ACDSee, 135	embedding images, 264
with Auto Adjust button, 200–201	multiple images, attaching, 265
color temperature, adjusting, 170–173	resizing images before attaching to, 265
on computer before printing, 234	sending images with, 264–265
with Corel Paint Shop Pro, 135	sharing pictures in, 5
cropping images, 164–165	e-mail address appearing in photo gallery, 261
described, 133	embedding images in e-mail, 264
effects, applying, 194–197	enlargements, 234
with Enhance button, 198–199	evaluating photos, 62, 94-95, 106-107, 132
exposure, adjusting, 166–169	everyday shooting, sharpness in, 75
	everyday tasks simplified with digital photography, 4
global changes, 152–153 with iPhoto, 134	EXIF (Exchangeable Image File) format, 136
local changes, 153	experimenting
	with depth of field, 72–73
noise, adjusting, 182–185	with flash, 80
options for, 134	exposure
with Photo Mechanic, 135	adjusting, 102, 166-169
with Photoshop Lightroom, 135	creative use of, 63
red eye, removing, 186–189, 220	evaluating, 94
retouching spots on photos, 190–191	fine-tuning, 97
retouching spots on your subject, 192–193	verifying, 9
rotating images, 156–159	exposure modes
saturation, adjusting, 178–181	aperture priority mode, 30
sharpness, adjusting, 182–185	auto (program) mode, 30
straightening images, 160–163	described, 15, 30
tint, adjusting, 174–177	manual mode, 31
before using online photo services, 250	shutter priority mode, 31
with Windows Live Photo Gallery, 134	subject mode, 31
with Zoom tool, 154–155	exposure values (EV), 50
editing text, 311, 312	external flash, 17
effects	external hard drives, 21
applying, 194–197, 291	extra-low dispersion (ED), 34
described, 291	extreme close-ups, sharpness in, 75
memory needed for, 291	Eye-One, 205
removing, 291	Lyc-one, 203
effects layers, 301	_
electronic flash, 43	F
electronic photo sharing	fast film, 26
copyright to protect photo, adding, 254–255	feathering, 285
e-mail, sending an image with, 264–265	file formats used in Photoshop Elements, 209
JPEG saved for Internet, 256–257	file size
photo gallery, creating a Web, 260-263	and collage, 307
previewing an image in a Web browser, 258-259	before printing, 235

fill flash, 51, 80	flattering light, waiting for, 81
fill layers, adding, 273	fluorescent light, 43
fill light, 49	focal length
film speed, 26	changing, 28
Filter Gallery	described, 32
advantages of, 288	focus
applying filters, 289	active autofocus systems, 54
deleting filters, 289	automatic mode, 58
described, 289	close-up mode, 58
disadvantages of, 289	fixed focus systems, 54
rearranging filters, 289	landscape mode, 58
using, 288	macro mode, 58
viewing filters, 289	moving subjects, 59
filters	multipoint autofocus systems, 55
adjusting a photo before applying, 298–299	for off-center subject, 55–57
adjustment layer, filter applied as, 287	passive autofocus systems, 55
color, 19	point of focus, choosing, 59
creative, 19	selecting, 68, 77
described, 19	tips, 59
diffuser, 19	frame, filling, 66
graduated, 19	freezing motion, 29
image size and, 299	front lighting, 47
in Photoshop Elements, 287–289, 298–299	f-stop, 27
polarizing, 19	full frame sensors, 38
separate layers, using filters on, 287	
skylight, 19	G
types of, 287	
ÚV, 19	GIF (Graphics Interchange Format) file format, 209
finding images using tags, 146–147	global changes, 152–153
fine-tuning camera settings, 96–97	glossy paper, 243
FireWire (IEEE 1394), 23	graduated filters, 19
firework displays, 127	gray background, sizing, 279
fixed focus systems, 54	gray card, 44
flash	greeting cards
compensation, 50	creating, 248–249
described, 50	text, adding, 249
distance, 50	uses for, 249
experimenting with, 80	
external, 17	Н
fill, 51	
fine-tuning, 97	hard drive archiving, 21
	hard light, 46
outdoors, 51	hiding layers, 274
warming up flash pictures, 83	higher-capacity memory cards, 16
flash mount, 17	high-key scenes, 113
flash sensor, 91	histogram
flattening	described, 111
images, 307	high-key scenes, 113
layers, 273	

low-key scenes, 113 troubleshooting with, 111–113 home printers, 232 hot shoe, 17 hue, 285 hueyPRO, 205	flagging images in, 141 importing photos into, 138 noise, adjusting, 182–183 organizing photos with, 11 red eye, removing, 186–187 retouching spots on photos, 190–191
IEEE 1394 (FireWire), 23 image compression, 257 image editing programs, 10, 21, 130–131 image format, setting, 87 image layers, adding, 272 image quality resolution and, 7 setting, 87 image graph tion, 270, 271, 274	retouching spots on your subject, 192–193 rotating images, 156–157 saturation, adjusting, 178–179 sharpness, adjusting, 182–183 slide shows, creating, 5 sorting images using tags, 148 straightening images, 160–161 tagging images in, 143–144 tint, adjusting, 174–175 zooming in, 154 ISO (International Organization for Standardization), 26
image resolution, 230–231, 234 image sensor array, 6	
image sensors, 6–7	IDEC (laint Photographic Exports Croup) file format
image size, setting, 87	JPEG (Joint Photographic Experts Group) file format compression, selecting amount of, 257
Imperfections, removing, 296 importing photos	described, 209
described, 132	Internet, JPEG format for use on, 256–257
to your browser, 138–139	panorama, creating a digital, 309
improving your photography skills with digital	Fanciana , a sam 8 a 4 9 a 7
photography, 4	K
in-camera settings, 101	
indoor light, 42–43	Kelvin (K) scale, 44
inkjet printers	Kodak EasyShare gallery, 249
advantages of, 232	Kodakgallery.com, 233
best image resolution for printing, 231	_
described, 22, 236	L
disadvantages of, 232	labeling CDs/DVDs, 227
printing on, 232	LaCie, 205
International Color Consortium (ICC), 205	landscape mode, 58, 73
Internet, putting photo gallery on, 263	laptops, 16
iPhoto	layer masks, 273
color temperature, adjusting, 170–171	layer styles
Constrain option, 165	customizing, 290
cropping images, 164	described, 290
editing photos with, 134	removing, 291
effects, applying, 194–195	types of, 290
Enhance button, 198–199	layers. See also type layers
exposure, adjusting, 166–167	active, 274
Eyedropper tool, 171, 174	adjustment layers, adding, 272
finding images using tags, 147	Background layer, duplicating, 272, 286

blending, 275		at sunrise, 42	
deleting, 275		at sunset, 43	
fill layers, adding, 273		tungsten, 43	
flattening, 273		white balance, 45	
hiding, 274		light meters, 44	
image layers, adding, 2	72	light quality	
linking, 275		backlighting, 48	
merging, 273, 275		cross light, 48	
opacity, changing, 275		described, 46	
protecting, 275		fill light, 49	
renaming, 274		front lighting, 47	
shape layers, adding, 27	13	hard light, 46	
using, 272–275	,		
Layers panel (Photoshop Eler	nents\ 274_275	reflectors, 49	
LCD	ielis), 274–275	side lighting, 48	
composing shots in, 57,	90	soft light, 47	
		top lighting, 48	
evaluating your photos	011, 63, 106, 107	light trails, capturing, 83	
using, 9		lightness, 285	
LD (low dispersion), 34		linear polarizer filter, 19	
ens pen, 19		lines, symbolic significance of, 65	
ens-cleaning cloth, 19		linking layers, 275	
enses		local changes, 153	
accessory, 17		low-key scenes, 113	
choosing, 15			
digital-specific, 37		M	
four-thirds system, 37		macro lenses, 39	
macro, 39			
magnification, 36		macro mode, 58, 124–125	
optical zoom, 15		macro photography, 124–125	
step-down rings for, 17		macro setting, 39	
step-up rings for, 17		magnification, 36	
evel, making sure a photo is,	163	manual, camera, 105	
ight		manual mode, 31	
blowouts, 115		manual white balance, 45	
candlelight, 43		matte paper, 243	
close-up (macro) photog	graphy, 125	measuring light, 44–45	
and color, 42, 44-45		memory card	
creative use of, 63		cases for, 18	
described, 42		CF (CompactFlash), 15	
eBay, photographing pro	oducts for, 123	clearing, 11	
with electronic flash, 43		deleting images from, 11	
flattering light, waiting fo	or, 81	described, 15	
fluorescent, 43	•	formatting, 86, 91	
indoor, 42–43		higher-capacity, 16	
measuring, 44–45		inserting and formatting, 86	
midday, 42		SD (Secure Digital), 15	
modifying, 80–81		SDHC (Secure Digital High Capacity),	15

memory media, printing directly from, 22	as part of digital workflow, 132
memory needed for effects, 291	with Photo Organizer, 11
merging layers, 273, 275	with Photoshop Elements, 11
metadata, 136	with Windows Live Photo Gallery, 11
midday light, 42	orientation, choosing, 66
modifying light, 80–81	original image, changes made to copy and not, 11
monitor	outdoor flash, 51
calibrating, 204–205	outdoor photography, 51
colors, setting, 239	overexposure
described, 21	reviewing image for, 9
display, matching prints to, 238-239	warning, 112–113
evaluating your photos on, 106, 107	
profiling, 204–205	P
resolution, 230	<u>-</u>
multipoint autofocus systems, 55	painting, converting a photo into a, 302–303
manipolitic ductorocus systems, so	pan using slow shutter speed, 82
	pan-blurs, 29
N	Panel view (Photoshop Elements), 268–271
night mode setting, 126	panels and toolbars in Photoshop Elements, 271
night photography (without flash), 126	panorama, creating a digital, 308–309
Nik, Inc., 287	Pantone, 205
noise	paper for printing
adjusting, 182–185	choosing, 242–243
described, 26, 110	size of, 23
reducing, 119	type, choosing, 242–243
tips for changing, 185	parallax, 38, 89
	passive autofocus systems, 55
0	personalizing metadata, 136
	perspective, 69
occasion, considering, 62	photo gallery
off-center subject, 55–57	creating, 260–263
online, sharing pictures, 5	e-mail address appearing in, 261
online commercial photo lab, printing at, 233, 234	Internet, putting on, 263
online photo services	thumbnails on each page, determining number of, 261
Adobe Photoshop Services, ordering prints from, 251	uploading, 263
advantages of, 251	viewing in Web browser, 263
editing photos before using, 250	photo kiosk, printing at, 233, 234
ordering items from, 251	photo lab, printing at, 234
Photoshop Elements, ordering prints from, 250	Photo Mechanic, 135
setting up an account with, 251	Photo Organizer, 11
using, 250	photo organizer programs, 11
OnOne, 287	photo storage devices, 16
opacity, changing, 275	photographer, taking multiple pictures to become a better,
optical zoom, 15, 37	Photoshop Elements. See also Quick Fix workspace
ordering items from online photo services, 251	archiving photos to CD/DVD, 226–227
organizing digital negatives, 11	area of photo to edit, selecting, 282–283
organizing photos	Background layer, duplicating, 286
with image editing program, 131	buckground layer, adplicating, 200
with iPhoto, 11	

Bicubic Sharper, 235	picture package, printing one photo as traditional, 244-245
Bicubic Smoother, 235	pixel, 6
black-and-white photos, colorizing, 292-293	pixels per inch (PPI), 231
blemishes, removing, 296	PNC (Portable Notwork Craphics) file formet 200
books, creating, 246	PNG (Portable Network Graphics) file format, 209
checkerboard background, changing, 281	point of focus, choosing, 59
collages, creating, 247, 304–307	point of view, 69
comparative view selecting 215	polarizing filters, 19
comparative view, selecting, 215	portrait mode, 73
Cookie Cutter tool, 280–281	power connectors for travel, 18
Create tab, 246–247	preparing photos for printing, 234–235
cropping images, 216–217	previewing an image in a Web browser, 258–259
described, 130	print dialog boxes, 239
editing photos with, 135	printers
effects, 291	buying, 236
e-mail, sending an image with, 264–265	choosing, 22–23, 236–237
file formats used in, 209	connection, 23
filters, 287–289	cost, 23
galleries, creating, 247	described, 22
gray background, sizing, 279	direct printing, 22
greeting cards, creating, 248–249	due sublimation 22 277
imperfections, removing, 296	dye sublimation, 22, 237
layer styles, 290–291	inkjet, 22, 236
layers, using, 272–275	memory media, printing directly from, 22
Layers panel, 274–275	paper size, 23
	paper type, choosing, 242–243
moving around images, 213	quality of print, 23, 237
ordering prints from, 250	resolution, 230, 237
organizing photos with, 11	settings, optimizing, 240–243
painting, converting a photo into a, 302–303	speed, 22, 237
Panel view, customizing, 268–271	types of, 236
panels and toolbars, viewing, 271	printing
panorama, creating a digital, 308–309	books, 246
photo gallery, creating a Web, 260-263	borderless photos, warnings when printing, 241
Quick Fix workspace, 206–209, 218–219	collages, 247
red eyes, fixing, 220	considerations for, 232
resampling images in, 235	cropping images before, 235
rotating images, 214	described, 10, 133
Save for Web command, 256–257	editing photos on computer before, 234
sepia-toned photo, creating, 294–295	enlargements, choosing photos for, 234
sketch, converting a photo into a, 300–301	file size of images before, 235
skin tone, adjusting, 297	on home printers 272
slideshows, creating, 5, 247	on home printers, 232
straightening crooked photos, 276–279	image resolution setting for, 234
type layers, 310–319	on inkjet photo printers, 231, 232
	monitor display, matching prints to, 238–239
whitening teeth, 284–285	multiple sizes of photos, 244–245
zooming in and out, 212	at online commercial photo lab, 233, 234
Photoshop Lightroom, 135	options for, 232–233
Photoworks.com, 233	paper for, choosing, 242–243

at photo kiosk, 233, 234	resolution
at photo lab, 234	described, 7, 230
picture package, printing one photo as	image, 230-231, 234
traditional, 244–245	and image quality, 7
preparing photos for, 234–235	monitor, 230
	and print quality, 23
resampling images before, 235	printer, 230, 237
steps for, 240–243	retouching spots on photos, 190–191
text, adding, 245	retouching spots on your subject, 192–193
using online photo printing service, 250-251	
profiling monitors, 204–205	reviewing image
prosumer digital cameras, 14	for closed eyes, 9
protecting layers, 275	on LCD monitor, 89
PSD (Photoshop Document) file format, 209	for overexposure, 9
	for underexposure, 9
0	RGB color system, 238
Q	rotating
quality of print, 23, 237	images, 156–159, 214
Quick Fix workspace (Photoshop Elements)	photos in collage, 307
all open photos, viewing, 207	text, 316
Auto Color button, 218	rule of thirds, 67
Auto Contrast button, 218	rules of composition
Auto Levels button, 218	background, checking for distractions in, 67
Auto Sharpen button, 218	described, 66
automatic fixes, trying, 219	frame, filling, 66
black and white, converting a color photo to, 222	orientation, choosing, 66
opening, 206	subject, framing, 67
opening a photo to use in, 208–209	Subject, Iraning, 07
Red Eye button, 218, 220	
Smart Fix button, 218	S
tools, accessing, 207	saturation
undoing changes in 221	adjusting, 178–181
undoing changes in, 221	described, 285
using, 207	evaluating, 95
view, changing, 207	fine-tuning, 97
R	when to change, 181
rating images, 140	scene modes, 15
RAW file format, 92, 107, 137, 209, 210–211	scene settings
	changing images with, 102–103
rechargeable batteries, 15	creative use of, 104–105
recurring problems, identifying, 94	described, 100
red eye, removing, 186–189, 220	saving, 105
reflectors, 49, 81	when to use, 100
renaming layers, 274	SD (Secure Digital) memory cards, 15
rendering type layers, 311	SDHC (Secure Digital High Capacity) memory cards, 15
resampling images before printing, 235	selecting specific areas of photo to edit, 282-283
resizing images before attaching to e-mail, 265	selective focus, 77
resizing text, 313	

sensors clean, keeping, 191 compact digital cameras, 36 full frame, 38 sepia-toned photo color for, choosing, 295 Photoshop Elements used to create, 294–295 setting up a digital camera batteries, charging, 86	showing action with, 76 Shutter Priority, 76 stopping action with, 76 side lighting, 48 simplicity in composition, 63 simplifying type layers, 311 sizing copyright, 255 sketch, converting a photo into a, 300–301
date and time, setting, 87 described, 86 image format, setting, 87 image quality, setting, 87 image size, setting, 87 memory card, inserting and formatting, 86	skin tone, adjusting, 297 skylight filters, 19 SLD (super-low dispersion), 34 sleep mode, 90 slideshow creation on CDs, 5 with iPhoto, 5
white balance, setting, 87 shape layers, adding, 273 shapes cropping photos as, 280–281 focusing attention with, 65	with Photoshop Elements, 5, 247 soft light, 47 software for image editing, 10, 21, 130–131 sorting images using tags, 148–149
sharing images copyright to protect photo, adding, 254–255 described, 10, 133 e-mail, sending an image with, 264–265 JPEG saved for Internet, 256–257 photo gallery, creating a Web, 260–263 previewing an image in a Web browser, 258–259	space, 69 speed, printer, 22, 237 steady, keeping your camera, 116, 126 step-down rings for lenses, 17 step-up rings for lenses, 17 stopping action with shutter speed, 76 stops, 26 storage media, 15
sharpness adjusting, 182–185 evaluating, 95 in everyday shooting, 75 in extreme close-ups, 75 limited area of, 75 maximizing overall, 74 maximizing up close, 74 tips for changing, 185	storing digital negatives, 11 straightening images, 160–163, 276–279 streaks on prints, 241 stylizing text, 311, 318–319 subject focusing on, 73 framing, 67 placement, 65 subject mode, 31
shutter, 29 shutter lag, 89, 114 shutter priority mode, 31, 76 shutter release button, 90 shutter speed	sunrise, 42 sunset, 43 symmetrical compositions, 64 system requirements, 20
blurring motion, 29 changing, 76 described, 29, 76 freezing motion, 29 pan-blurs, 29 setting, 29	tagging images, 140, 142–145 teeth, whitening, 284–285 telephoto lens, 34

basic controls, learning, 88 described, 88 digital cameras, adjusting to, 89 LCD, composing shots in, 89 reviewing pictures on LCD monitor, 89 taking, 88 viewfinder, composing shots in, 89 text	removing, 319 rendering, 311 resizing text, 313 rotating text, 316 simplifying, 311 styles, adding, 311 stylizing text, 318–319 vector-based text, 310 warping text, 317
adding, 310, 312	
color of, 314–315	U
editing, 311, 312	underexposure, 9
in greeting cards, 249	unfixable photo problems, 110
moving, 313 printing, 245	uploading photo gallery, 263
resizing, 313	USB cable for printer connection, 23
rotating, 316	UV filters, 19
stylizing, 318–319	**
vector-based, 310	V
warping, 317	vector-based text, 310
thumbnails on each page of photo gallery, determining	viewer focus, controlling, 72
number of, 261	viewfinder, 38, 57, 89
Tiff (Tagged Image) file format, 209	viewing metadata, 136 visualizing composition, 62–63
time and date, setting, 87	visualizing composition, 62-65
tint, adjusting, 174–177	187
tone, 69	W
top lighting, 48 transferring pictures to your computer, 9, 92–93	warming up flash pictures, 83
travel accessories, 18	warping text, 317
tripods, 18	watercolor-type paper, 243
troubleshooting	Web browser, previewing an image in, 258–259 white balance
blowouts, 115	automatic, 45
colorcasts, avoiding undesirable, 117	checking, 8
digital noise, reducing, 119	experimenting with, 117
digital zoom, avoid using, 118	manual, 45
first photos, 90–91	setting, 45, 87
shutter lag, 114	whitening teeth, 284–285
steady, keeping your camera, 116	wide-angle lens, 33
tungsten light, 43	Windows Live Photo Gallery
type layers	Auto Adjust button, 200–201
adding, 273	color temperature, adjusting, 172–173
adding text, 310, 312 color of text, 314–315	cropping images, 165
committing, 310	effects, applying, 196–197
converting, 311	exposure, adjusting, 168–169
editing text, 311, 312	finding images using tags, 146
moving text, 313	importing photos into, 139

noise, adjusting, 184–185 organizing photos with, 11 red eye, removing, 188–189 reviewing images in, 141 rotating images, 158–159 saturation, adjusting, 180–181 sharpness, adjusting, 184–185 sorting images using tags, 148 straightening images, 162–163 tagging images in, 142–143 tint, adjusting, 176–177 zooming in, 154

X
X-Rite, 205

Z
zoom
digital, 37
in and out, zooming, 212
LCD display, 9
optical, 37
zoom lens, 35
Zoom tool, 154–155

There's a Visual book for every learning level...

Simplified

The place to start if you're new to computers. Full color.

- Creating Web Pages
- Digital Photography
- Internet
- Mac OS

- Windows

Teach Yourself VISU

Get beginning to intermediate-level training in a variety of topics. Full color.

- Access
- Bridge
- Chess
- Computers
- Crocheting
- Digital Photography
- Dog training
- Dreamweaver
- Excel
- Flash
- Golf

- Guitar
- Handspinning
- HTML
- iLife
- iPhoto
- · Jewelry Making & Beading
- Knitting
- · Mac OS
- Office
- Photoshop
- Photoshop Elements

- Piano
- Poker
- PowerPoint
- Quilting
- Scrapbooking
- Sewing
- Windows
- Wireless Networking
- Word

op 100 Simplified Tips & Trie

Tips and techniques to take your skills beyond the basics. Full color.

- Digital Photography
- eBav
- Excel
- Google

- Internet
- Mac OS
- Office
- Photoshop

- Photoshop Elements
- PowerPoint
- Windows

...all designed for visual learners—just like you!

Master VISUALLY®

Your complete visual reference. Two-color interior.

- · 3ds Max
- Creating Web Pages · Dreamweaver and Flash
- Excel
- Excel VBA Programming
- · iPod and iTunes
- · Mac OS
- Office
- Optimizing PC Performance
- Photoshop Elements
- QuickBooks
- Ouicken
- Windows
- · Windows Mobile
- Windows Server

Visual Blueprint

Where to go for professional-level programming instruction. Two-color interior.

- Aiax
- ASP.NET 2.0
- Excel Data Analysis
- Excel Pivot Tables
- Excel Programming
- HTML JavaScript
- Mambo
- PHP & MySQL
- SEO

- Ubuntu Linux
- Vista Sidebar
- Visual Basic
- XML

Visual Encyclopedia e

Your A to Z reference of tools and techniques. Full color.

- Dreamweaver
- Excel
- Mac OS

- Photoshop
- Windows

Visual Quick Tips

Shortcuts, tricks, and techniques for getting more done in less time. Full color.

- Crochet
- Digital
- Photography
- Excel
- Internet

- iPod & iTunes
- Knitting
- Mac OS
- MySpace
- Office

- PowerPoint
- Windows
- Wireless Networking

Want instruction in other topics?

Check out these All designed for visual learners—just like you!

978-0-470-43638-7

978-0-470-50386-7

978-0-470-10150-6

For a complete listing of *Teach Yourself VISUALLY*™ titles and other Visual books, go to wiley.com/go/visual